EDWARD DAVIS THAYER
COLLECTION

STARBUCK'S NECK, EDGARTOWN

FOLK ART IN AMERICA

A PERSONAL VIEW

by Adele Earnest

Schiffer Publishing Ltd

Box E, Exton, Pennsylvania 19341

Photographs on pages 17,20,21,131,135,142,143,163,166,167,170, and 171 by Judith E. Riddell.

Printed in the United States of America.
ISBN: 0-88740-020-5
Published by Schiffer Publishing Limited, Box E, Exton, Pennsylvania 19341

This book may be purchased from the publisher.
Please include $1.50 postage.
Try your bookstore first.

Table of Contents

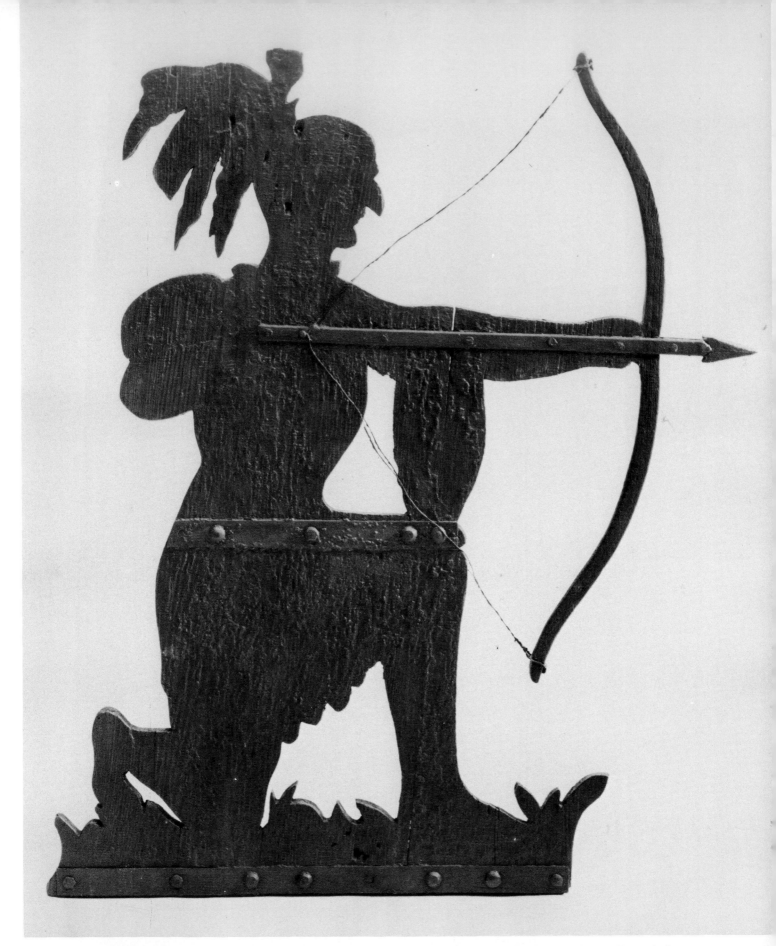

Indian Weathervane. Wood. Fredonia, New York c. 1820. (Photograph courtesy Henry Francis du Pont Winterthur Museum)

Author's Note

The sculptural folk arts are featured in this book simply because they happen to have attracted my attention more than the pictorial or the fabric arts.

A number of the objects illustrated may have found new homes since leaving my acquaintance. If so, I will be happy to hear from the new owners and set the record straight.

This book is written mainly to thank and to record the legion of friends, collectors, and museum-gallery directors who have recognized the importance of folk art in the history of American Art, and have offered every courtesy to me in the preparation of these pages.

Also may I scribe a special tribute to those men and women and angels who founded the Museum of American Folk Art and, incidentaly - made possible this book.

A.E.
Stony Point, N.Y.
June 1984

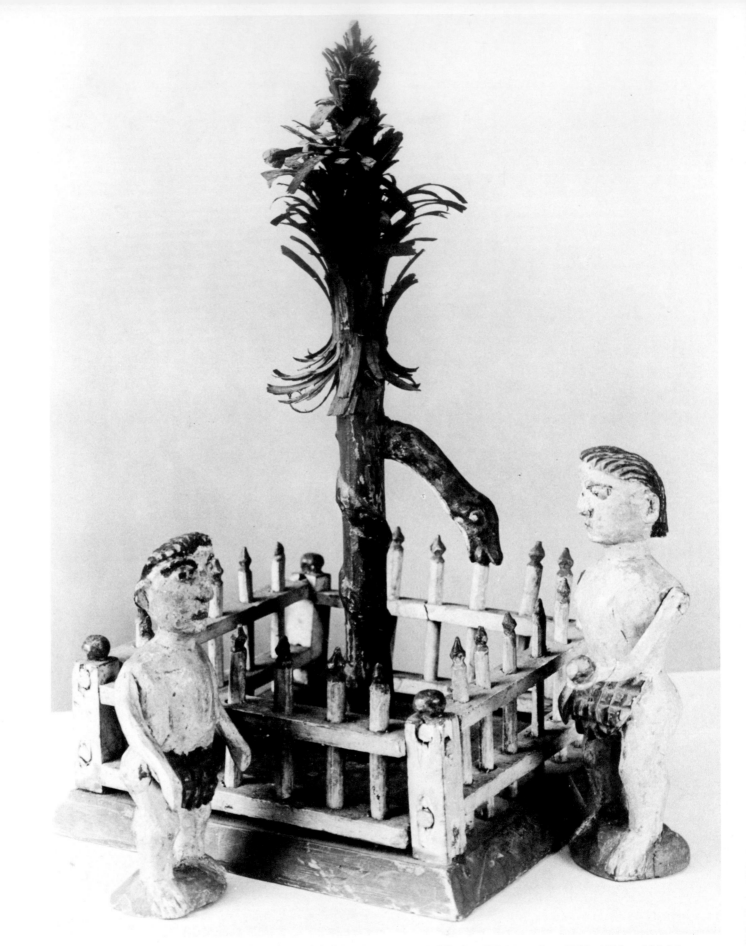

Adam and Eve in the Gardon of Eden. Carved by Wilhelm Schimmel c. 1880. (Abby Aldrich Rockefeller Folk Art Collection. Williamsburg, Virginia)

Chapter 1

The Cumberland Valley

It all started in Carlisle, Pennsylvania, my passion for folk art. There, in the beautiful Cumberland Valley, where the green fields lie flat and tidy between the hills, a happy conjunction of natural and human events took place.

Pennsylvania farmers, called Pennsylvania Dutch (Deutsch) in the early days, settled there. As newcomers, they brought their customs, their crafts, their mystical religions, and their strong sense of the seasons and the community. The valley provided their new life with the raw materials - rich soil, forests, springs, iron ore, and clay pits. In 1927 the Potters, the Smiths, the Millers, the Schwenkfelters, and the Flowers still lived there, and for a while, the Earnests.

Joel Earnest studied law at the Dickinson Law School. I was director of the Community Theater, in nearby Harrisburg.

Every Saturday we took time off from our jobs, went to market in the morning, went antique-hunting in the afternoon. Market day in Pennsylvania is a joy. The local farmers and their wives bring fresh, homegrown vegetables and arrange them prettily on tables along with flowers, smoked ham, brown eggs, golden cakes, fresh horse-radish, and honey-in-the-comb. A trade of goods or services was as acceptable as cash. Five quarts of snow peas might be traded for a bean pot or a pint of dried corn for a sunbonnet. (The farmers grew what they needed and sold or swapped what was left over.)

Once a day, another happy event was the railroad train that ran up the tracks on the main street, delivered its cargo and politely backed out again.

Afternoons on Saturday Joel and I reconnoitered for antiques with which to furnish our new home. Several parlor shops were located in the proper stone residences that lined up tight against the sidewalks and against each other with an occasional walkway in between. (Gardens were located in the rear.)

The Penrose Antique Shop situated on High Street catered to the carriage trade, called "tourist trade" by the natives. The Comp brothers' parlorshop on Railroad Avenue became our favorite. There, for the first time I saw folk art, called simply "antiques".

The Comp brothers had a perfect combination. The older brother, a photographer, drove his horse and buggy up and down the local country roads within a five mile radius of town. He turned up with his equipment at weddings, christenings, house-raisings, and farm sales. Although willing to be paid in coin, other exchanges were acceptable. He had a fondness for local redware pottery plates, especially when decorated with tulips and birds. Antique toys he liked, and carved animals and birds, especially those painted red, yellow, and green.

The younger brother, Roy, attended sales as far away as Pennypackers Auction House in Reading. There Roy picked up information on the prices of antiques sold to city folk. Roy learned that a rooster, a fat one carved by an old-timer named Schimmel, could bring as much as seventy-five dollars. Little parrots and eagles sold for forty or fifty dollars a piece. Once Roy found a big eagle. And a "Garden of Eden" passed through his hands. (Schimmel frequented Bloser's Barn just up the road from Carlisle, from Comp's. Old Schimmel died in the Cumberland Valley Alms House (1817-1890).

The Comp shop was tiny, stuffy, never aired. We took a deep breath of fresh air before entering. But the antiques piled helter skelter were wonderful: old wood candle lanterns, Noah's arks, spice boxes, toys, fraktur work, burl bowls, trains, Lehn ware.

Pottery and chalkware figures were kept in a blue corner cupboard. I like the chalkware, the thin plaster figures which followed Staffordshire designs. According to Roy, the little animals, birds, and figurines painted so gaily were sold by

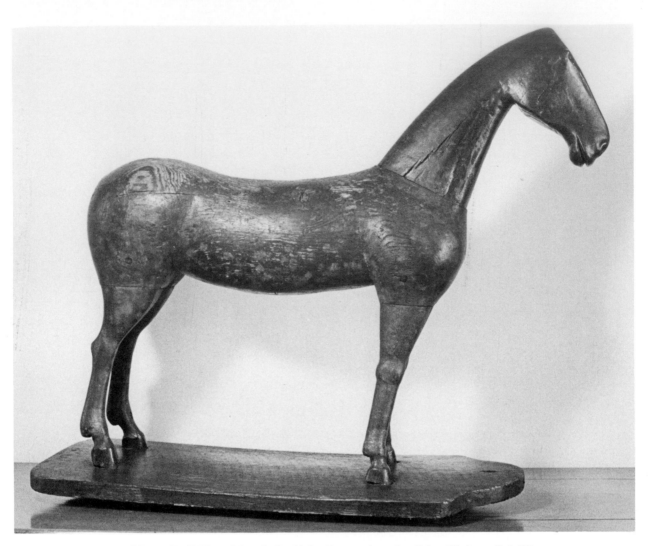

Horse Pull Toy. Wood. Carlisle, Pennsylvania. (Mrs. Holger Cahill)

peddlers going from door to door. These attractive and decorative figures the average housewife could afford. The small chalk had sold for fifteen or twenty-five cents. Roy asked fifteen or twenty-five dollars.

On our first visit we bought a brace of Conestoga Wagon bells which we didn't need. But their merry sound conjured up those great red and blue wagons that rumbled past Lancaster, over the mountains, and on to the Ohio River to open up the West, the Natchez Trail, the Chisholm, and the Santa Fe. One Saturday when we arrived at Comp's the house was being reshingled. We bought two iron eagle snow stops off the roof although we didn't have a roof.

Two treasures from the Comp house are well known: the large, handsome Cumberland Valley carved horse in the Dorothy Miller (Mrs. Holger Cahill) collection, and a smaller companion piece, a pull-toy, in the Cordelia Hamilton collection. The Penrose Antique Shop, the one with the plate glass window, was entirely different. It was immaculate with its Chippendale chairs and its Stiegal glass and spatterware china.

One Saturday night, events brought us close to both shops. After dinner at the Penn-Harris Hotel in Harrisburg, the head waiter followed us out of the dining room. He had heard our talk about antiques, and he introduced himself as a part-time antique dealer as well as a part-time headwaiter.

Actually as we discovered later, Mr. Williams was also a part-time minister whose real mission in life was to help his fellow black men and women

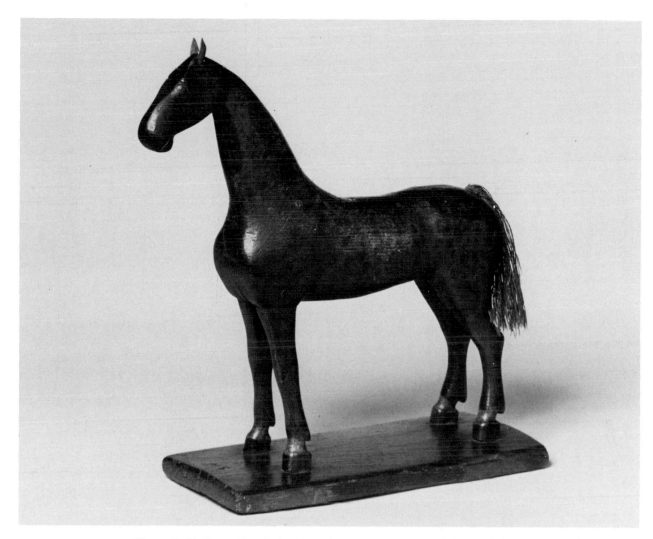

Horse Pull Toy. Wood. Carlisle, Pennsylvania. (Cordelia Hamilton)

migrate north of the Mason-Dixon line where education and employment were on a higher level than in the South. He told us how whole families were being trucked North via Harper's Ferry, past Gettysburg, to the Cumberland hills where they lived in shelter near Carlisle, until work, yard work, or house work could be found. Their possessions were meager, but a few brought valuables, given or not given by former employees. No one asked questions. They needed a contact in Carlisle where they could sell their few holdings. The Penrose Antique Shop proved to be a perfect outlet for their Sheffield candlesticks, lace shawls, and bits of jewelry. The Comp brothers bought their rag dolls and jumping jack toys.

At the Penn Harris Hotel, in Mr. Williams dressing room, a placard hung on the wall:

"Fourscore and seven years ago our fathers brought forth on this continent a new nation conceived in liberty and dedicated to the proposition that all men are created equal."
Abraham Lincoln
Gettysburg November 19, 1863

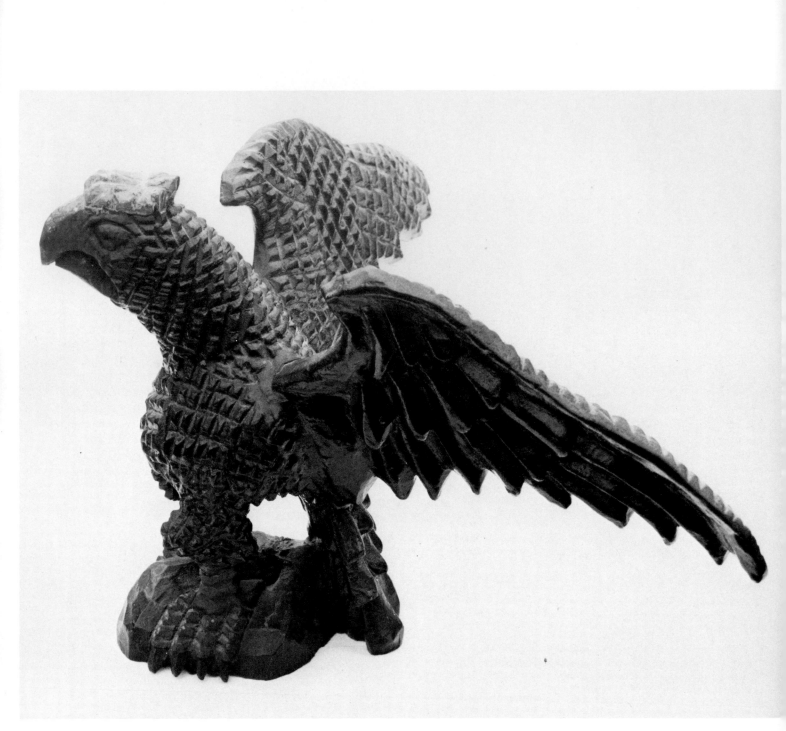

Eagle. Carved by Wilhelm Schimmel. (Harry T. Peters Jr.)

Chapter 2

Hattie's House

The adventures of Carlisle we enjoyed but we learned little of the significance of the local arts until we met Hattie Brunner. Hattie's informed enthusiasm swept up everyone in her loving pursuit of the "Pennsylvania Dutch stuff."

Hattie lived in Reinholz, a village northeast of Harrisburg in the Lebanon Valley of Lancaster County. Her home, situated at a crossroads in the middle of wide open fields, will go down in history because Hattie Brunner lived there. We discovered Hattie after we had moved to Harrisburg where Joel practiced law with his new degree and I continued my work with the Harrisburg Community Theater, which had enlarged its program by being affiliated with the Schubert's as a "try-out" out-of-town center for new plays.

Before driving over on a Saturday we always phoned to be sure Hattie was home, not away at a local house sale or auction. Her welcome as we clanged the door bell was memorable. Up went her arms, her apron flying, "Ai! Yai! Earnest und frau!" First we must sit and share a glass of elderberry wine, cookies, and gossip. "Have you heard of the fake chalk coming out of Pottstown? At the last Pennypacker auction some foreigner from New York City bought up all the frakturs. Paid too much. The name, a woman, Halpert!"

Social pleasantries over, we were shown about the house which never looked like a shop and wasn't. It was a home, neat, and aglow from scrubbing. Two large curly maple cupboards held whatever she wanted to show. Some pieces might be for sale, some not - at least not then. Hattie's house attracted the leading collectors of the day: Joe C. Kindig II, George Horace Lorimer, Cornelius Weygant, George Himmelreich, and Titus C. Geesey. (Never heard her mention H.F. du Pont of Winterthur.) Her regular and favorite clients had first choice for important treasures. She knew and we knew that the Earnests were low on the list.

One corner cupboard held her toleware: coffee pots, trays, creamers, sugars, and match boxes. All were early examples decorated with freehand, freeform designs. The late pieces, those stenciled with floral and fruit decorations, she didn't touch!

A second cupboard held her prized redware pottery: plates in slip trace or slip engraved with tulip, rose, lily, and pomegranate motifs. I was somewhat familiar with those decorative designs because ancestors on my father's side had shipped to America from the Rhenish Palatinate region in the early eighteen hundreds, when an English land company offered passage to America via Holland, away from the continued religious persecution of Protestant groups, and the ravages of local wars and taxes. I knew that the images on tinware, pottery, fraktur, and furniture were more than decoration. They were metaphors of things spiritual.

Hattie added her own lore to the subject at hand. The three-lobed tulip represented the trinity; the six-lobed tulip meant protection from all harm.

One Easter we joined Hattie for a chicken and waffle dinner. Hattie loved Easter, and Easter lilies. The lily meant Spring, rebirth, resurrection after the seeming death of Winter. Life's cycle is easy for farm folk to understand. They see the miracle of Spring every year.

For dessert at Easter we had one of Hattie's famous pies. She baked her fruit pies and her shoo-fly pie in the large, common redware pottery plates with the squiggly yellow slip lines and the pressed edges. These she kept lined up in the kitchen cupboard. (All cracks in the pottery were age cracks!)

Upstairs at Hattie's house in a little hall bedroom she kept her birds: stuffed cloth birds, sewing birds, chalk birds, pecking-board birds, ceramic water-whistle birds, and an occasional carving by Aaron Mountz, Schockschnitzler Simmons, and Schimmel. Wildfowl decoy birds didn't interest her or anyone else at the time.

Framed frakturs lined the walls upstairs: birth certificates, baptismal records, and house bless-

Tulpehochen Fraktur. Conrad Weiser

Two Tigers. Carved by Augustus Aaron Wilson. c. 1930. Portland, Maine. From the Robert Laurent Collection. (Alastair B. Martin)

ings. Record keeping was basic to the Pennsylvania way of life. Often the minister, the school teacher, and the record-keeper were one and the same. The vital statistics, written in the tradition of medieval, continental script, were usually surrounded by elaborate border decorations of starcrossed flowers, ever-blooming potted plants, benevolent birds, animals, and angels. Thus, joyous creations surrounded the facts of life on paper, as they surrounded life in reality.

One of Hattie's frakturs I still have: one with the cross-legged angel and red wings. Although the name of the practitioner of this design has never been authenticated, I do know that the "prediger" (minister) who baptized the child was Andrew Schulz, Governor of Pennsylvania from 1823 to 1829.

A most important fraktur Joel and I found in Carlisle. It was from Tulpehochen, the home of famous Conrad Weiser, special envoy to the Six Nation Indians and friend of Benjamin Franklin and Conrad Beisel, founder of Ephrata Cloisters. Very generously Hattie arranged for us to show the fraktur to the collector, Titus C. Geesey, who purchased it. Even at that time, Mr. Geesey was building a collection to give to the Philadelphia Museum of Art.

We should never have sold that fraktur. At the time we did not know that one of Joel's ancestors,

John Earnest, had married a grand-daughter of Conrad Weiser. The story of the Weiser family is one of the great chronicles of American history.

On June 13, 1710 several boatloads of refugees from the German Palatinate anchored in New York harbor after a devastating six months at sea. The travellers, under the leadership of John Conrad Weiser, had embarked at the invitation of a Mohawk Indian Chief who had voyaged to London to ask aid of Queen Ann against French aggression from Canada. The Chief heard of the plight of the German refugees on the continent, and offered refuge to the complete strangers on Indian territory, in New York State, near Schoharie Township. The offer was accepted, but due to the unbelieveably avaricious and dishonorable Robert Livingston, landlord of Livingston Manor up the Hudson, most of the newcomers were sidetracked into becoming his indentured servants.

After years of struggle, the German emigrants learned of the fair fields of Pennsylvania and the freedom and justice accorded people. A party of sixty families united and cut a road from Schoharie to the sources of the Susquehanna River, over which they carried or floated their household goods down to the mouth of the Swatara Creek and driving their cattle overland, thence to Tulpehochen.

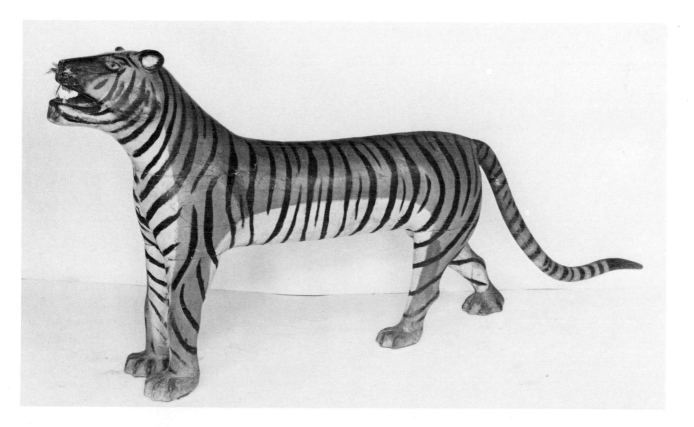

The elder Weiser did not join them for many years. But one of his 16 children, Conrad Weiser, established his home in Tulpehochen, and founded the town of Reading.

John Conrad Weiser died and was buried in Tulpehochen in 1746. The son said of the father, "Never was the torch of freedom more gallantly carried."

Spring was the peak time for the Earnests and Hattie to attend local auctions. The farmers' cash supply is low after an unproductive winter, yet it is necessary to buy seed, feed, and fertilizer as soon as frost is out of the ground. On one momentous morning, we picked up Hattie and took her to a sale at Miller's Barn in Dillsburg. A chest of drawers attracted Joel. It was not appealing at first sight - the chest had obviously come out of a chicken coop. The sides were still splattered with chicken droppings. But the three full drawers and the top half drawers were decorated with calligraphy. On the lowest drawer was scribed a name, a place, and a legible date, 1824. Joel whispered loudly, "If someone went to all that trouble to record something over a hundred years ago, it seems proper to pay attention." Hattie agreed to stay off the bidding if we kept away from an early, inlaid maple stock Kentucky rifle she wanted for her husband, Raymond.

We bought the chest for $297.50, and loaded it on the back of our Dussenberg with me. Hattie sat in front with Joel and her rifle. We were a triumphant crew!

To this day the chest has not been "restored", just cleaned. I like it the way it is. The rat holes in the upper-half drawers are still filled with the "original" flour and water paste. The legend, painted in the arcaded panel on the first long drawer reads: "Jonathan Otto 1824". On the second long drawer, "Mahantango Tounschip". On the lowest drawer, the largest panel reads,

"Schuykill County Len 17 tag April 1824."

All the panels are framed with strong color markings in sawtooth stripes and dots. A four petal flower or rosette marks the end of each panel. And a small angel head graces the ends of the lowest arcade. Reeded edging ornaments the top. The stiles and the sides are ornamented with sponge work, dots, and swirls.

Jonathan Otto was the son of William Otto, and a grandson of Heinrich Otto, famed fraktur artist. (Did William Otto make this chest for his son, Jonathan, to commemorate his birth?)

Research has yet to discover who made and decorated the Mahantongo Valley furniture. Neither has it been ascertained whether the cabinet maker and the painter were one and the same. The names scribed on the chests have been verified as residents of the valley. Most importantly, it is agreed that the Mahantango decorated furniture represents the epitome of folk art.

The Earnests were grateful for Hattie's guidance during those early years. But it should be recorded that the Brunner reputation for grass roots in Pennsylvania antiques had been established long before our Hattie came on the scene. Previously there had been another Hattie, "alte" Hattie, who is said to have been as hearty and embulant as her daughter-in-law. Young Hattie, the Hattie we knew, had been the local cleaning girl, Hattie Klapp, before she married alte Hattie's son Raymond. Raymond ran the Brunner feed and grain store that had been built adjacent to their house. Young Hattie helped out and discovered she loved the antique business. She learned quickly by proximity to "alte" Hattie.

Our Hattie Brunner died August 1, 1982 at the age of ninety-three. Hattie's house was indeed a happy crossroads where people, knowledge, love, history, and art came together.

Chapter 3

New York City in the 1930's

Edith Gregor Halpert and Holger Cahill.

In October 1929 the stock market crash shook the foundations of the American business community and the private lives of most families. Joel had been working for the State Department of Labor and Industry in Harrisburg. When the Depression hit, he was asked to go to New York City and join a law firm that specialized in city bankruptcies.

We moved to New York City, where we rented a small apartment in Greenwich Village. Most of our antiques were left behind, stored in Harrisburg, and we sold our beloved Dussenberg roadster. Joel disliked his new job; he had a preference for people rather than statistics. Fortunately for all concerned, he was rescued in 1934 by the newly-elected Mayor Fiorello H. LaGuardia. The "Little Flower" had been voted into office partly because of his promise to help the working man find a way out of financial trouble. Major LaGuardia organized the Emergency Relief Bureau and offered Joel the post of Administrative Assistant.

This new position placed Joel in contact with the programs which the Federal Government also sponsored to aid unemployment. In 1933 the Works Progress Administration (known familiarly as the W.P.A.) was created to validate projects for the unemployed, including artists. Murals were commissioned for high school auditoriums, and for post offices and other public buildings. Statuary appeared on empty spaces in city parks. Many work projects were devised to maintain skills for artists who lacked commissions from the business community.

In 1935 the government initiated one of its most important research programs and publications, the *Index of American Design*, organized under the direction of Holger Cahill. Unemployed artists were hired to draw, paint, and record in watercolor rendering the regional/local crafts and folk arts from thirty-five states. Not only was the project a lifesaver for unemployed artists, but the publication itself became a standard reference for

collectors. Many objects so skillfully presented in the illustrations have disappeared, leaving no other record. All folk art enthusiasts are grateful to Holger Cahill for his early recognition of the importance of our folk art in the history of American art.

Several other fortuitous events convened to augment these vital steps. A key figure was Edith Gregor Halpert, whom we met shortly after our arrival in New York City.

The move to the big city had not changed our pleasurable habit of looking for antiques on Saturday afternoons. We tried Second and Third Avenue antique shops, and Greenwich Avenue, where the sidewalks were stacked with secondhand merchandise, mostly Victorian and European. Because of the Depression many householders were forced to sell their belongings to raise cash.

In our wanderings we did discover two delightful shops and two delightful gentlemen: Harry Stone on Madison Avenue, and Harry Shaw Newman on Lexington Avenue. Although they specialized in paintings and prints rather than the three dimensional objects we enjoyed, both men recommended one person. "Try Edith Gregor Halpert."

We located the Halpert Gallery on the ground floor of a private house on West 13th Street. As we entered, a middle-aged lady at a desk nodded. Contemporary paintings lined the walls. One weathered wood arrow weathervane was mounted flat over a door. It looked attractive but uncomfortable in a fixed position. On a shelf stood an amusing small carved soldier with rotating paddle arms.

Joel remembered Hattie Brunner's irate comment about that New York foreigner by the name of Halpert who had snatched all those Pennsylvania frakturs at a Pennypacker auction. He asked to see some. The lady responded, "Fraktur birth certificates are rarely found in New York City."

We mentioned the fact that we were from Pennsylvania and had found a Tulpehochen

fraktur for Mr. Titus C. Gessey, the collector.

That did it. The lady rose majestically. Maybe we didn't look like big spenders, but we might be purveyors of antiques, known informally as "pickers".

During the next few years we did find and sell several Pennsylvania items to the Halpert Gallery. At the time we did not know that Abby Aldrich Rockefeller was one of Halpert's best clients. Neither did we know that a lady by the name of Electra Havermeyer Webb dropped in from time to time.

The Halpert saga is well known. Her gallery propelled the chain of events that brought folk art into the consciousness of contemporary artists and the museum world.

Edith Gregor Halpert established the first recognized American folk art gallery in New York City in 1929 on 13th Street. In 1924 one previous exhibition of folk art had been organized by Henry Schnakenberg under the supervision of Juliana Force at the Studio Club on West 8th Street, the location of the original Whitney Museum.

As far back as 1913 Hamilton Easter Field, editor of "Arts" magazine, had established a "School of Painting and Sculpture" in Ogunquit, Maine. During the summer season his students roamed the neighboring Maine towns and antique shops where they saw and liked native nineteenth century paintings and carvings. They even bought some and took them home as furnishings for their studios. These students included: Robert Laurent, Alexander Brook, Yasau Kuniyoshi, Bernard Karfoil, and William Zorach among others.

When Field died in 1922, Robert Laurent took over the property and continued the school. Laurent, an avid collector of folk art, was the original owner of the famed *Man With Grapes* and the *Two Tigers* carved by Augustus Aaron Wilson. In 1926 Edith and her husband, Sam Halpert, (a painter) visited Ogunquit with Holger Cahill and his wife, Dorothy Miller. The combination made history. Cahill had his first glimpse of the historical and cultural significance of folk art. Four years later, in 1930, Holger Cahill organized and presented the first major museum show of eighty-three folk art paintings, "American Primitives" at the Newark Museum, in New Jersey. The following year, in 1931, he presented "American Folk Sculpture" at the same museum. The exhibition included eagles, ship figureheads, cigar store figures, weathervanes, carvings by Schimmel, chalk ware, Pennsylvania iron stove plates, the Baroom figure *Man With Grapes,* and wildfowl decoys from the Joel Barber collection. An impressive presentation. The catalogue stated:

Folk art usually has not much to do with the fashionable art of its period. It is never the product of art movements but comes out of craft traditions plus that personal something of the rare craftsman who is an artist by nature if not training.

...It goes straight to the fundamentals of art - rhythm, design, balance, proportion which the folk artist feels instinctively.*

In 1932 Holger Cahill prepared the catalogue and the exhibition of one hundred and seventy-three objects for the prestigious *Museum of Modern Art,* in New York City. The show was called: "American Folk Art. The Art of the Common Man in America. 1750 - 1900."

These exhibitions helped to lay the basis for the 1935 publication of the *Index of American Design.* Meanwhile Edith Halpert discovered a promotional and logical connection between folk art and her stable of contemporary painters. The flat, patterned shapes, dominant in early American portraits, had much in common with the abstract movement popular in contemporary art. She called the nineteenth century American primitive paintings the "ancestors" of contemporary art to the advantage of all parties.

Several critics of Halpert's day suggested that all art is abstract to some degree, and the simplified planes so admired in early "primitive" or "naive" painting might have resulted from lack of expertise rather than from choice.

*"American Folk Sculpture: The Work of 18th and 19th Century Craftsmen". (The Newark Museum, Newark, New Jersey 1931), page 13.

Pennsylvania Chalk Watch Holder.

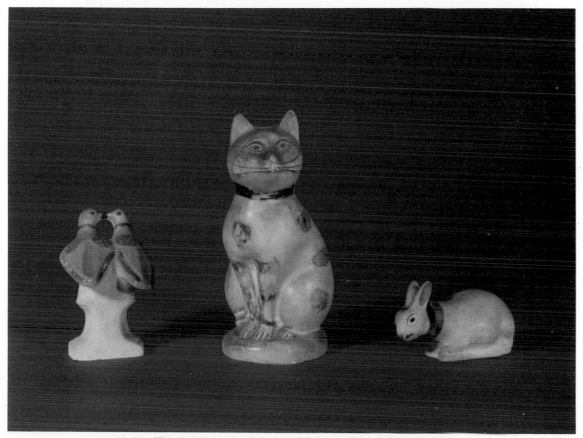

Three Chalk Figures. (Cat, lovebirds, and nodding rabbit)

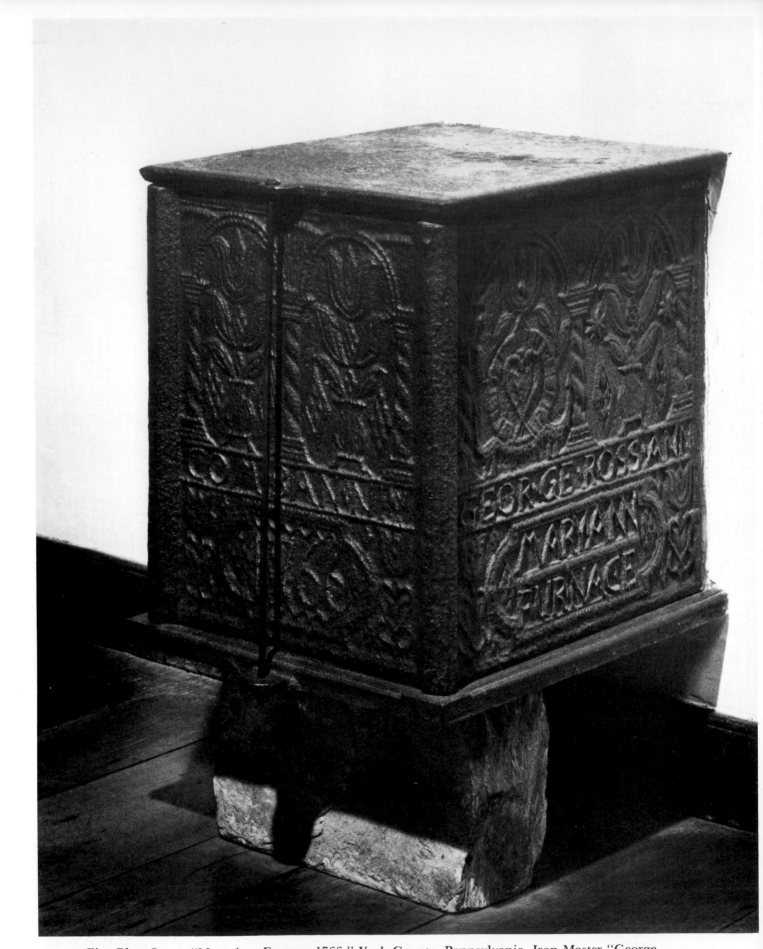

Five-Plate Stove. "Mary Ann Furnace 1766." York County, Pennsylvania. Iron Master "George Ross." (Photograph courtesy Henry Francis du Pont Winterthur Museum)

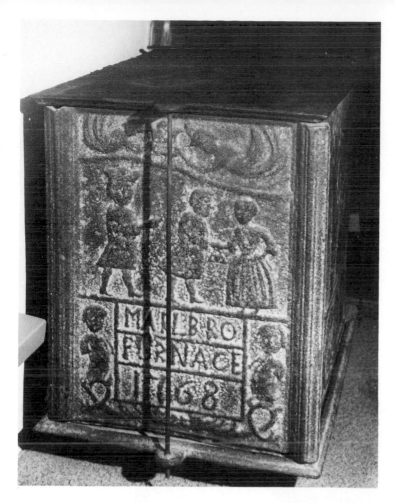

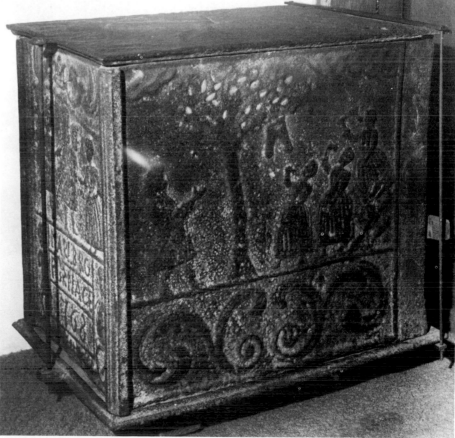

Five-Plate Stove. "Marlbro Furnace 1768" Cedar Creek, Virginia. Front panel and Side panel.
(Adele Earnest)

Wood Watch Holder.

Coffee Pot. Japanned Tin. c. 1825 by Augustus Filley, Lansingburg, New York. (Patricia and Edward Henderson)

Quilt pattern from Pennsylvania

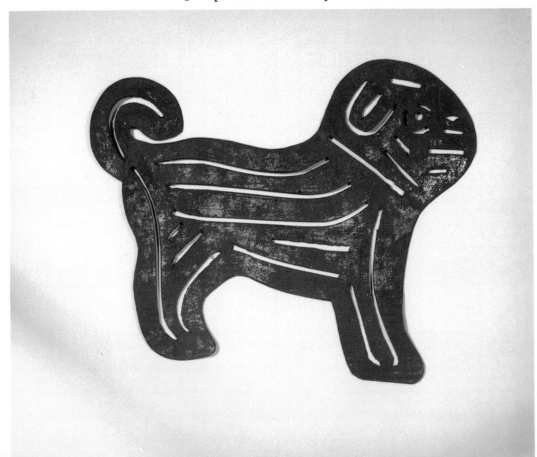

Fraktur, Birth Certificate. Heidelburg Taunschip. 1804. By "Cross-legged Angel" artist. (Adele Earnest)

Jonathan Otto Chest.

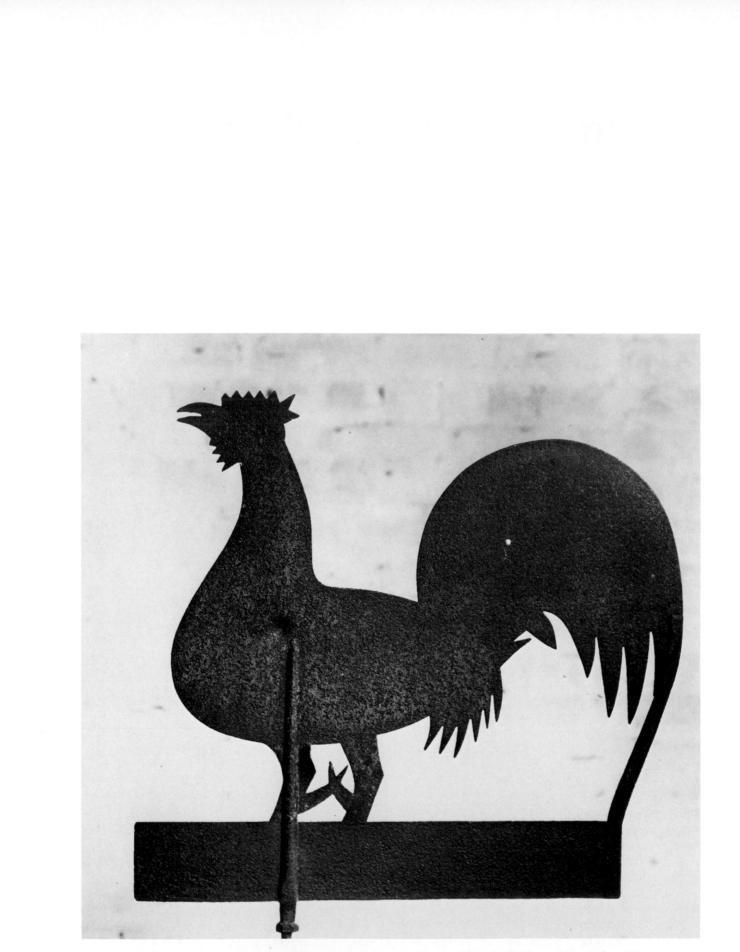

Rooster Weathervane. Iron. (Photograph courtesy Henry Francis du Pont Winterthur Museum)

Chapter 4

Christmas in Pennsylvania

Five Plate Stoves. Henry Francis duPont & Winterthur Museum.

During those first years in New York City we did get back to Pennsylvania to visit, to escape the man-made world of the city and to feast our eyes on space, earth, and old friends. Every Christmas we returned to Harrisburg, to the residence of Joel's parents, Mr. and Mrs. William H. Earnest. No one celebrates Christmas more enthusiastically, visually, and gastronomically than the Pennsylvania German. Joel's father was descended from early Pennsylvania settlers. The grandfather spoke with such a strong "Deutsch" accent I could barely understand him.

Every year a commodious Earnest dining table was given over to the Christmas "putz" - the recreation of a Pennsylvania farm village. From the attic the "putz" was brought downstairs, unpacked lovingly, and the cardboard buildings unfolded. First to be placed in the tableau was the "stone" barn, the biggest structure, then the "stone" house, and the white church, and the corner store. Little carved animals - cows, horses, chickens, dogs, and little people took their proper places. Sand was brought in by Grandpa Earnest to indicate the farm yard and the driveways. Small, rectangular red stone blocks marked the walkways. Green sponge trees and hedges took their scenic positions. The final touch was snow, a dusting of white mica flakes.

The Christmas tree itself was relegated to the front parlor window, where the lights could be seen from the street. Topped by the Star of Bethlehem and decorated with colored blown glass balls and bells, small candles, and angels - lots of angels - the tree gave a lovely light.

Joel's father, a lawyer, had served Dauphin County as Senator in the State Capital for eighteen years. On Christmas Day, in the morning, young and middle-aged men appeared at the door bearing gifts. During a long and productive life Senator Earnest had arranged scholarships for many deserving young law students and had defended in court many a poor, victimized farmer. They remembered on Christmas Day.

During our holidays in Pennsylvania we usually made side trips to Hummelstown, where Joel's father had been born. We visited neighbors, especially the Erb Sisters, Edna and Alma. At local auctions Edna was the "penny lady". If the auctioneer "crying" the sale didn't get a bid, the article was knocked down to Edna for a penny. (There was no auction "minimum"). Rarely did the sisters get treasures, but they did pick up local gossip. They also ran a corner store that featured penny candy, pickles, pretzels, flour, molasses, hay forks and brooms, plus in winter, a hot, wood burning stove surrounded by three comfortable rocking chairs, and one "giggle chair". Their pretzels I enjoyed especially because they came from Lititz, the Pennsylvania town where my father, Robert Eichler, was born. His ancestors, also of German heritage, had come to America from the German Palatinate in the early nineteenth century, and had settled in the Moravian community of Lititz, where they started a pretzel bakery. Originally they had settled in Germantown, but the English folk in Penn's colony were nervous about the influx of so many Germans. The Eichlers moved on to Lancaster County where they received a tract of land from Thomas and Richard Penn.

One Christmas the Erb girls found a delightful present for Joel's father, an early Harrisburg print "Gedruckt und zuhaben der Gustav S. Peters." Peters was the first to popularize color prints.

The picture portrayed the two roads of life: one, the rocky road which leads up to Heaven and to eternal bliss; the other, a slippery, rocky road which descends to Hell, and the fiery furnace, tended by the devil and Father Time with his ominous scythe. In the print only three travellers ascend the road to Heaven - one is a black man. The road to Hell is crowded.

Senator Earnest taught a Sunday School class at the local Lutheran Church.

During the winter of 1937 Edna Erb told us of some cast iron firebacks she had heard about. They were in the cellar of an old farmhouse - up

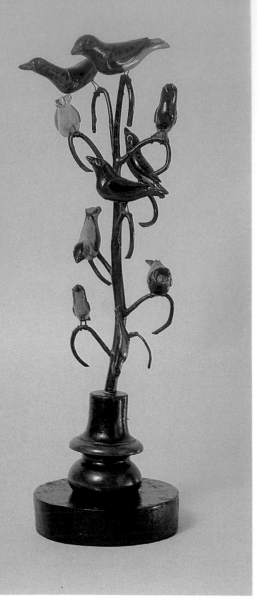

Bird Tree by Schockschnitzler Simmons
(Alastair B. Martin)

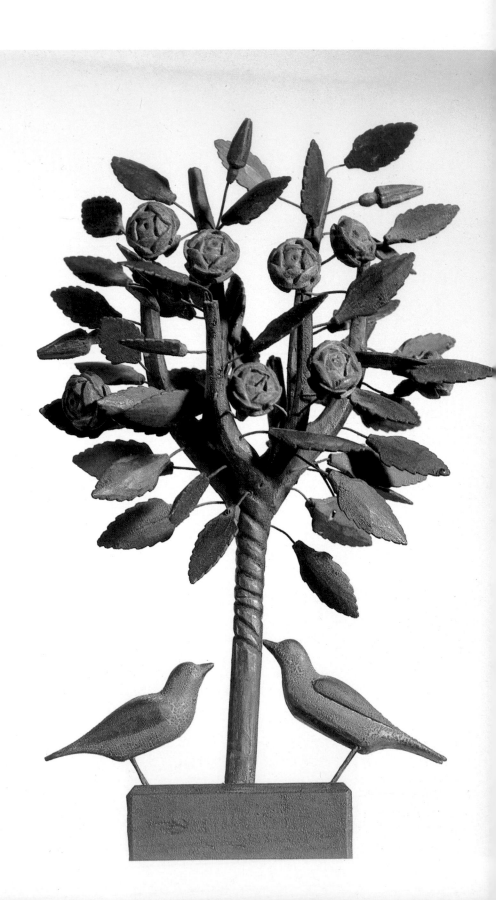

Tree of Life. Wood Carving. Ephrata-
Lancaster Region. Pennsylvania c. 1800
(Alastair B. Martin Collection)

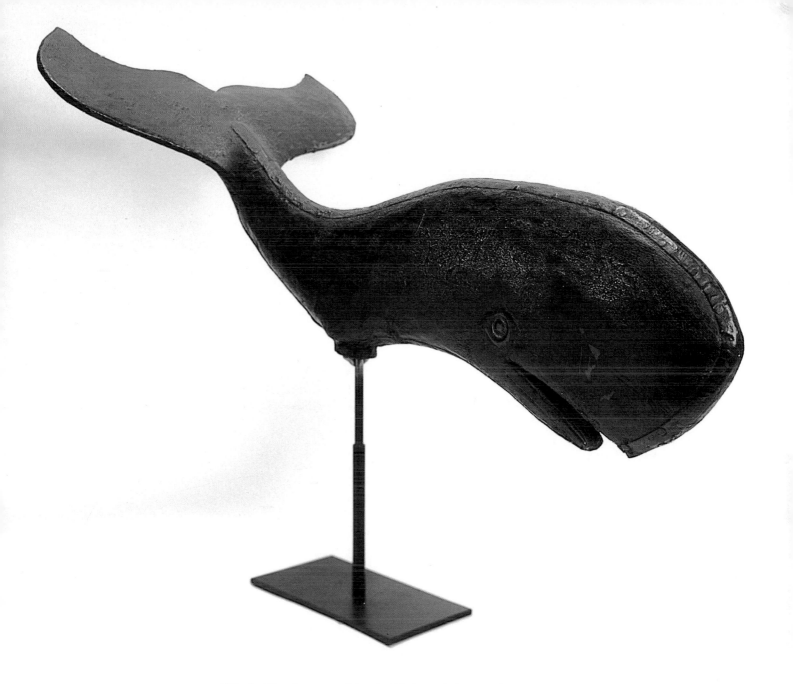

Whale Weathervane. Metal. (Alvin Friedman-Kiem)

Whale & Whalers - "Thar She Blows!" Whaling scene, carved, painted.

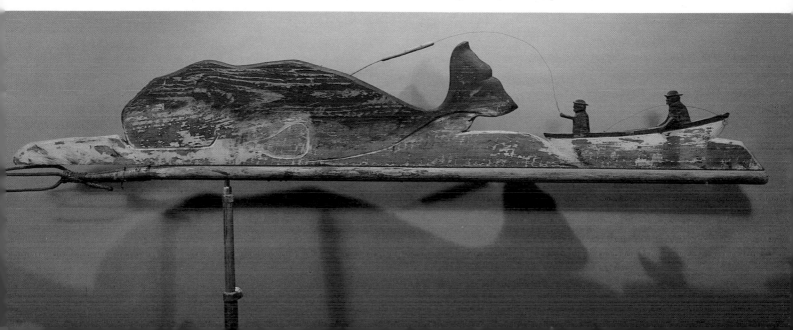

for sale. No one wanted them. Did we have a fireplace in our New York apartment? The real problem according to Edna was the weight. The plates were too heavy to carry up and out of the cellar, especially since the wood stairs had rotted.

"How many were there?" "Fifteen!"

That was too many, but Joel was intrigued. We should take a look. The report had been correct, except for the "fireback" part. The fifteen parts proved to be sections of three complete five-plate stoves. Cast in the decorative front panel of each stove was an eighteenth century date, and the name of the iron furnace where the plates were cast.

These stoves generally connected with the jamb of the open kitchen fireplace so the hot embers from the fire could be thrust in and raked out.

In 1744 Benjamin Franklin described the stoves.

The German stove is like a box, one side wanting. Tis composed of five iron plates scru'd together and fitted so that you may put fuel into it from another room...Tis a kind of oven reversed its mouth being without and body within the room that is to be warmed by it...

By the end of the eighteenth century Franklin figured out an easier device, a detached portable "Franklin Stove" which stood free of the fireplace and vented by a separate stove pipe into the main chimney flue. Franklin did not patent his invention. He believed it should be used for the "benefit of humanity."

We knew something about these stoves. The previous spring we had visited the famous Henry C. Mercer collection of antique stoves in Doylestown, Pennsylvania, and we had the definitive book on the subject, *The Bible of Iron*, published by the Bucks County Historical Society. We knew these plates were rare examples of expert craftsmanship and a way of life crucial to understanding of the 18th century.

The owner wanted the plates "out". We arranged to remove them. All fifteen plates were hoisted by an automobile crane hired from a Hershey garage. The mechanic agreed to truck the iron to our apartment in New York City. He was also good enough to carry each plate up the steps to our apartment in New York, where we joined the plates into three units and set them up in our living room. Our landlord was shocked. Would the floor hold the weight? It did. All the plates we joined, wire brushed, and oiled to clarify the figurative decorations on the panels.

A letter with photos to Mr. Henry Francis duPont at the Winterthur Museum in Delaware brought him in person to our door in Greenwich Village to see the stoves set up in our living room. He purchased the one which had been cast at the Mary Ann Furnace, located on Furnace Creek in York County, Pennsylvania. Ownership of the furnace had changed hands several times. Impressed clearly on the frontal plate is the date 1766 and the name of the owner and iron master at that date, George Ross. Ross was a Colonel in the Revolutionary Army. His furnace cast cannon and cannon shot as well as stoves.

Mr. duPont suggested that we contact Mr. Joseph Downs, curator of the American Wing at the Metropolitan Museum of Art in New York City. We did and the museum purchased the second five-plate stove which was installed in the Pennsylvania rooms of the American Wing established by Mr. and Mrs. Robert W. deForest in 1924, and still open to the public at that time. Later Mr. Downs left the Metropolitan Museum for a position at Winterthur.

We kept the third stove, the one we considered most interesting in pictorial design. Human figures are portrayed on our plates instead of the stylized flower patterns dominant on the other two stoves.

Marlbro Furnace 1768 (a Virginia furnace) is cast in the front panel of our stove. Above the date stand three human figures in semi-relief. One, a parson, is in the act of marrying a young man and a maid. All are arrayed in eighteenth century attire. The wrists of the young couple are padlocked together - a wedding symbol. The two side panels, identical castings, depict an earlier scene in the tableau. (Classical, scriptural or mythological subject matter was usually portrayed). The gentleman, the available groom, stands at one side of a tree opposite which three available ladies seem to be ringing bells. In the tree hangs a pair of man's britches!

The significance of the scene is elusive. Is this a rite of midsummer's eve, the time of the June solstice, and June weddings when love divinations match the earth's orbit, the flux of life, fertility?

It is interesting to note that one side plate from another casting of this stove was exhibited in the famous initial 1931 Newark Museum Folk Art Show. At the time the title was a "Swarm of Bees", a strange interpretation for a man's britches hanging in a tree. Perhaps the confusion arose because knowledge of the front panel, the wedding rite, was missing.

Our stove sits happily in my living room in Stony Point. It has no connection with the fireplace, but it has warm, pleasurable connections for me.

As a return courtesy after the five-plate stove

was delivered to Winterthur, Mr. duPont invited us for lunch so we could see his stove in a period setting at the museum.

On the appointed day we took the train to Wilmington, were met at the station by a chauffeur, and driven to the famous site. After welcoming courtesies, Mr. duPont escorted us through a number of the one hundred and twenty-five rooms in the museum. (No one walked up the stairs, just down the stairs. Elevators carried us up).

Mr. duPont had sought and bought only the finest antiques procurable. Each article, whether furniture, fabric, lighting, painting, china, or other accessory, was the best that could be obtained. And he consulted with the experts. His fabulous collection was amassed in the old-time tradition of the Medici when it was the practice of the merchant and papal princes to translate their wealth and power into visible worldly goods which became a monument to themselves and to an historical period of time.

Other museums dedicated to the preservation of America's heritage were established in a similar manner. Mr. duPont's personal interest centered in the life and the furnishings of the town people rather than the farm folk.

For a view of the domestic rural scene one must visit other centers. There is Electra Havemeyer Webb's *Shelburne Museum* in Vermont. Cooperstown, New York has the *Farmers Museum,* and *The Fenimore House.* In 1950 Stephen C. Clark, director of the *Singer Sewing Machine Company,* purchased four hundred folk art paintings and sculptures from the Jean and Howard Lipman Collection to form the nucleus of folk art on view in Fenimore House. Summer seminars inaugurated by Dr. Louis C. Jones have been a focal point for collectors, experts, and neophites ever since. The Henry Ford Museum and the Greenfield Village complex in Dearborn, Michigan owe their existence to one of our most popular industrialists. In the 1920s Old Sturbridge Village in Massachusetts started its re-creation under the patronage of Albert B. and J. Cheney Wells. At Colonial Williamsburg, Virginia, the many layers of colonial life in America are recreated meticulously and handsomely through the initial largesse of John D. Rockefeller, Jr.

On the memorable day of our visit to Winterthur, after we had descended the last grand staircase of the museum, we entered the private quarters where we enjoyed liquid refreshment in the solarium, replete with flowers and soft music.

Another guest joined us, Mr. Joe C. Kindig II from York, Pennsylvania. For years I had heard of Mr. Kindig, the acknowledged connoisseur of eighteenth century antiquities. Here he was in the flesh, with his long hair braided in a pigtail down the back. He was not wearing the eighteenth century knee breeches and waistcoat he favored. In casual contemporary attire he looked quite human, almost approachable.

For lunch we were served squab and corn-on-the-cob. It was May, rather early for corn, but Mr. duPont cultivated greenhouse corn and other rarities, including Mr. Kindig and an eighteenth century five-plate stove.

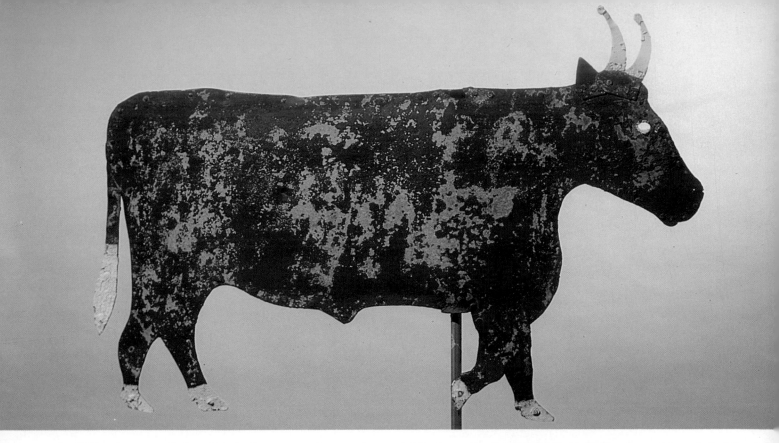

Bull Weathervane. Painted Red. Newtown, Connecticut c. 1870. From the Robert Hallock Collection. (Alastair B. Martin)

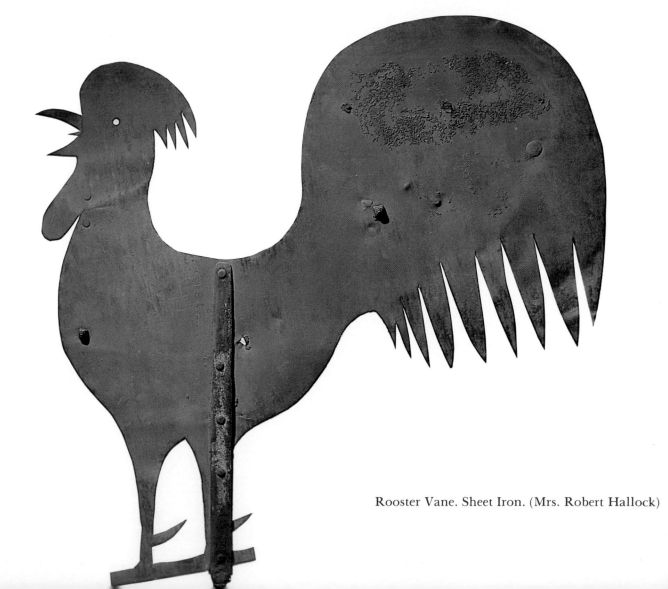

Rooster Vane. Sheet Iron. (Mrs. Robert Hallock)

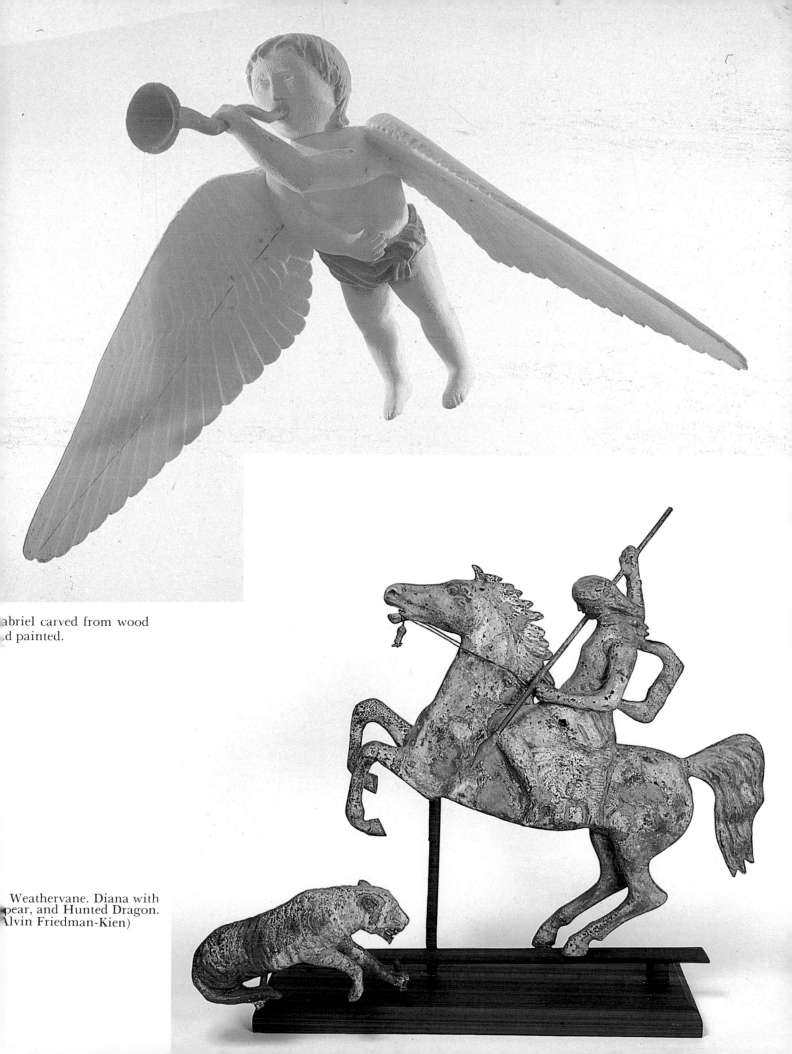

...abriel carved from wood
...d painted.

Weathervane. Diana with
...pear, and Hunted Dragon.
...lvin Friedman-Kien)

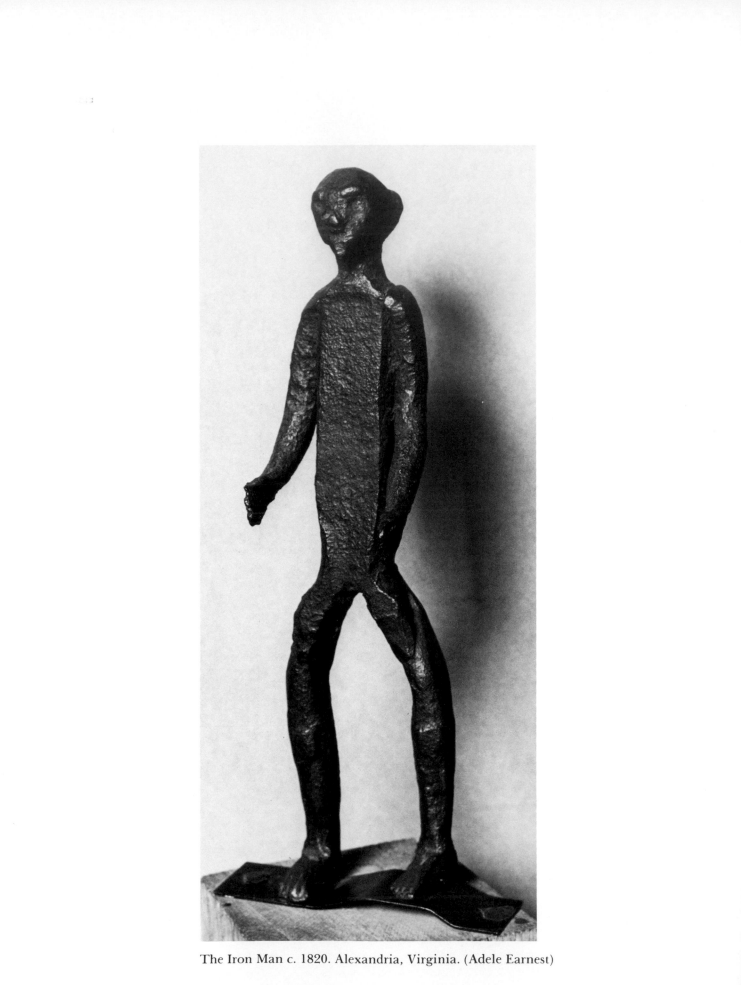

The Iron Man c. 1820. Alexandria, Virginia. (Adele Earnest)

Chapter 5

The Iron Man

During the late nineteen-thirties the after effect of the severe depression continued to occupy our nation. Mayor LaGuardia and Governor Thomas E. Dewey became convinced that state departments of Health and Welfare should be united in one overall agency. It was obvious that adequate health care was vital in an effort to keep people happy on the job and off expensive welfare programs. Joel, as director of the city's Emergency Relief Bureau, visited Washington frequently in an effort to gain congressional support for such a united program.

While visiting at the home of a congressman who lived in Virginia across the Potomac, Joel saw the "Iron Man", a sparse primitive figure, barely more than a foot tall but monumental in presence. He was told that the figure had been excavated during a rebuilding project on the estate, on land that had been a working plantation. The site indicated the remains of a blacksmith shop. Worn horseshoes, nails, broken hinges had been dug up as well as the iron man. When discovered, the workmen, frightened by the figure, turned it over to the landlord. At the close of the congressional session, Joel came home with the "Iron Man" under his arm.

Several years later, in 1968, the figure was scrutinized in my home by Colin M. Turnbull, Associate Curator of African Ethnology at *The American Museum of Natural History* in New York City. Yes, undoubtedly it was wrought by a black man, probably a slave who worked in the blacksmith shop of the plantation. The figure, an icon perhaps, was wrought from bar iron typical of the bars cast by our American colonial iron furnaces for general blacksmith work. (The site of *Marlbro Furnace* was located not far away.)

The central body of the Iron Man, the main axis, is clearly the bar iron itself. Arms and legs are wrought from separate bar units. Why had the piece been buried in the blacksmith shop? Was it because slaves had no permanent homes of their own in which to cherish keepsakes? Those who travelled north before and after the Emancipation Proclamation carried little. Few American sculptural examples of eighteenth or early nineteenth century black art have survived.

In order to allow this important key figure to be seen and enjoyed I gave *The American Museum of Natural History* permission to cast one replica, which is on permanent display. The original figure and the mold used in the casting, I have retained.

David Smith, one of our greatest twentieth century metal sculptors, visited me in Stony Point to see the "Iron Man". He was fascinated by the figure, by the technique, by the ability of anyone to forge wrought iron with such sensibility of face and attitude. The wide open arms reach out in the classic open gesture of benevolent gods and saints the world over.

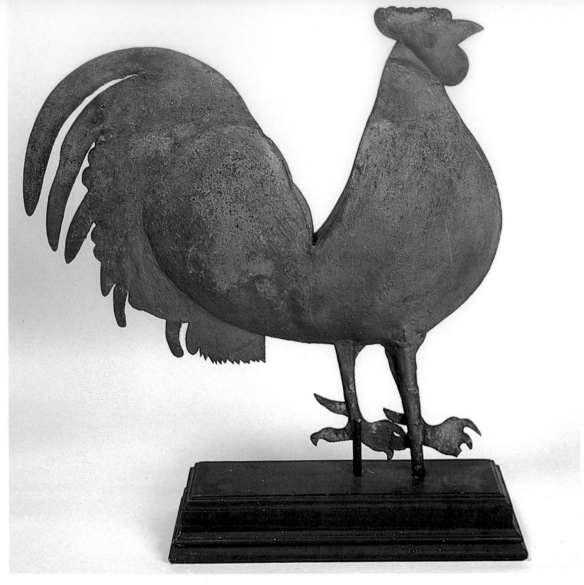

Rooster weathervane
Hog Trade Sign. Wood. (Alvin Friedman-Kien)

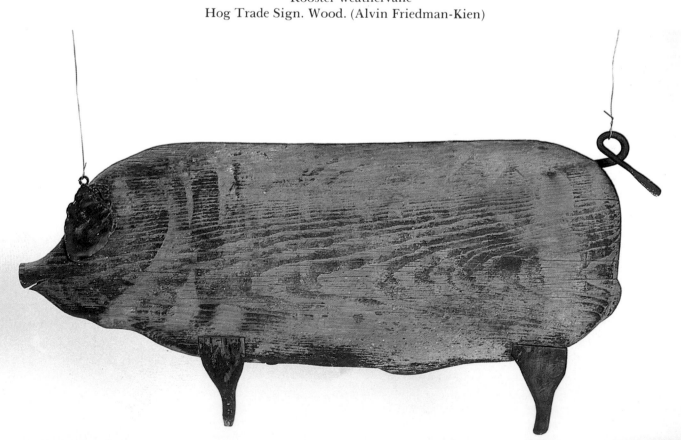

Crane sculpture.
Collection of Nina Fletcher Little

Heron

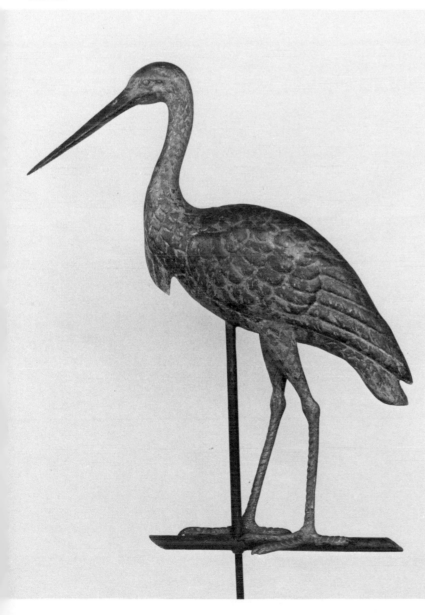

New York Discovery of Weathervanes and Weathervane - Makers

Spring in Stony Point, New York. Birds Singing.
Carving by Bernier, Biddeford, Maine

The normal course of human affairs was shaken again by America's entrance into World War II in 1942. By this date Joel and I had moved from New York City to the country in search of fields, trees, privacy, and space. Naturally enough we had found and purchased a group of old, deserted barns in Stony Point, New York, a rural town north of the city but within commuting distance. The plan was to restore and remodel the structures, one at a time, as finances permitted, into liveable and useable space.

Two of the largest buildings, "bank barns", were oriented to face the sun. The lowest level, the ground level, cut solidly into and against the north bank for protection against the winter wind. Oak and chestnut timbers framed the upper level in a post and beam construction, typical of the Hudson Valley in the mid-nineteenth century. Wide pine siding sheathed and enclosed the frame.

On use had been made of the barns for forty years. They stood forlorn and idle, crammed with old farm equipment (including an ox cart), moldy hay and bats. But we saw possibilities.

The land itself was also to our liking. A fast, clear stream and a waterfall bordered a meadow. History had left its mark in one field where during the American Revolution, General Anthony Wayne's troops had bivouacked the night before the Battle of Stony Point, on July 19, 1775. British ships had come up the Hudson River in an effort to capture West Point. Also, British troops had crossed the river by boat, from the east side, to secure a footing on the west promontory of Stony Point. General Wayne organized a hundred of our men, local farmers, who surprised the British encampment at dawn, routed them and repulsed them temporarily. Our plow unearthed in our field tangible reminders of the encounter: army belt buckles, one sword, and a cache of cannonballs.

World War II changed all our plans for a life in the country. Joel joined the United States Air

Force and within a year he was on duty overseas. The income level of families suddenly dependent on army pay shrank to mere subsistence level. Our young son, Gene, tried to trap mink along the stream. Fun, but not lucrative! One obvious answer to the financial dilemma was clear. Why not turn one of the huge, empty barns and the huge root cellar into an antique shop and gallery? The setting was perfect. I had learned a little and fortunately, a neighbor, Cordelia Hamilton, agreed to join in a hunt and search project.

Previous contacts in Pennsylvania were revisited. And we ventured northward with our station wagon to upstate New York and to New England in an effort to discover new sources. Immediately, it became apparent that furniture was too big and heavy for two dames to handle. As in the earlier days in Pennsylvania, the smaller, functional, and decorative arts appealed - the folk arts.

After several scouting trips northward, one special category of folk art revealed itself, the weathervane. (I remembered the one arrow vane displayed prominently as folk art in the Halpert "Downtown Gallery"). The more we asked and looked for vanes, the more we realized the fascinating varieties, the myriad shapes, media, techniques, and subject matter. The weathervanse recorded history as well as the way of the wind.

The first vane I purchased is still mounted above the fireplace in my living room. It is a horse vane, a jumper, made by A.L. Jewell & Co. of Waltham, Massachusetts. I knew little about weathervanes at the time, 1943, but I liked it and paid twenty-eight dollars for it. In 1984, on January 28, at Sotheby's Auction House in New York City, an adapted model of the same vane, made by the same company, sold for $34,000. One other difference - the Sotheby model did include the jumping gate. My vane does not. (Illustration figure 14)

In New England we followed the old Boston Post Road, along the coast where shore lines and deep navigable harbors had induced the Yankees to take to the sea. Rocky New England soil was not as condusive to farming as the rich limestone fields of Pennsylvania. Shipping and trade became the way of life in New England. Trade begot towns, industry, merchants, and factories, and led the way into the industrial life of the late nineteenth and twentieth centuries.

Old Bank Barns. The Earnest Home

36

We enjoyed the port cities: New Bedford, Boston, Salem and Newburyport: harbors from which Yankee ships had sailed the seven seas, including the Atlantic, the Pacific, and the Indian Oceans. Our ships set up trade routes, brought tea from China, mahogany from Central America, cotton from the South. And whale oil! A whaler out of New Bedford, gone at sea for three years, might come home laden with the rich bounty of 15,000 barrels of sperm oil, plus 800 barrels of whale oil...Over the years we, too, found bounty: a whale vane, a whale-oil shop sign, and an actual, historic carving of a whaling scene.

At other coastal ports we discovered fish vanes, mermaids, and one Triton blowing his wreathed horn. One of the oldest vanes on record is of a Triton who rode atop the Tower of the Winds, built by Andromicus for Athens, about 45 B.C. And that Triton was not just a vane. It functioned, so they say, as a combination sundial and water clock!

Cordelia Hamilton and A.E. and a wood model of a cow weathervane.

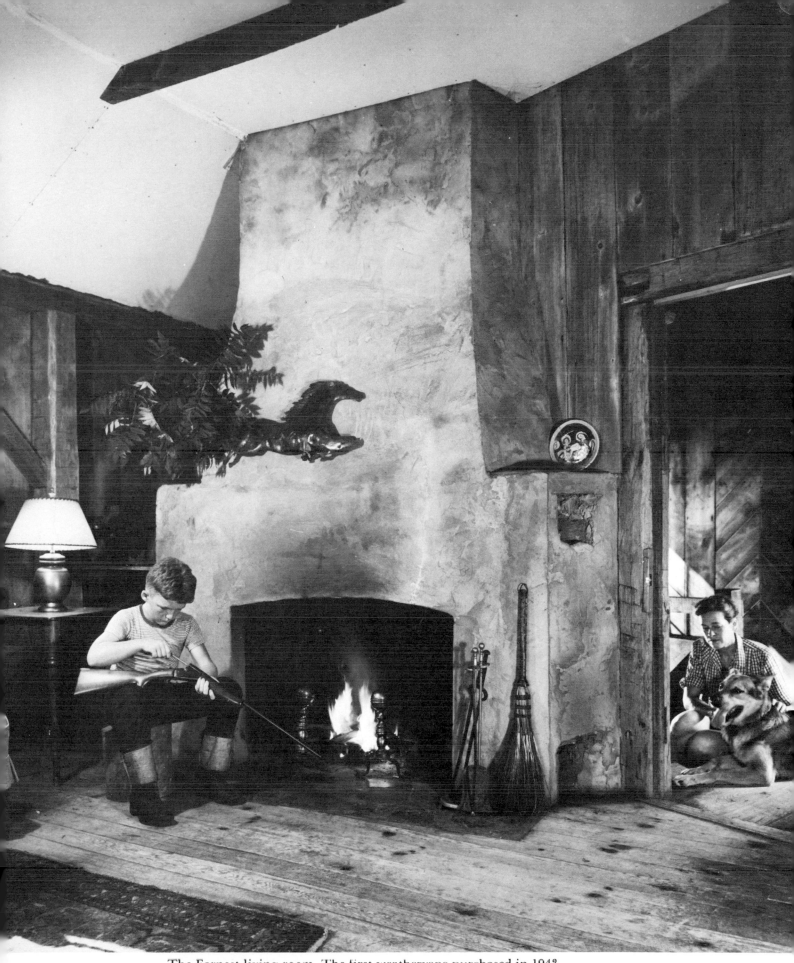

The Earnest living-room. The first weathervane purchased in 1943.

Root Cellar Art Gallery (outside)

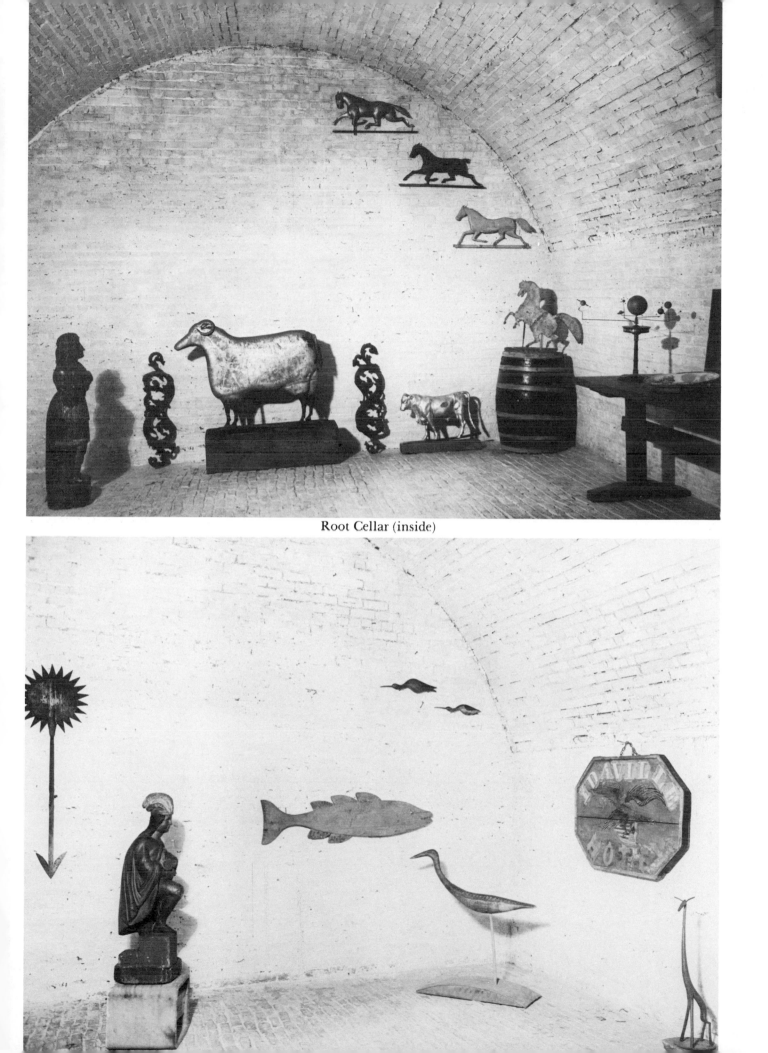

Root Cellar (inside)

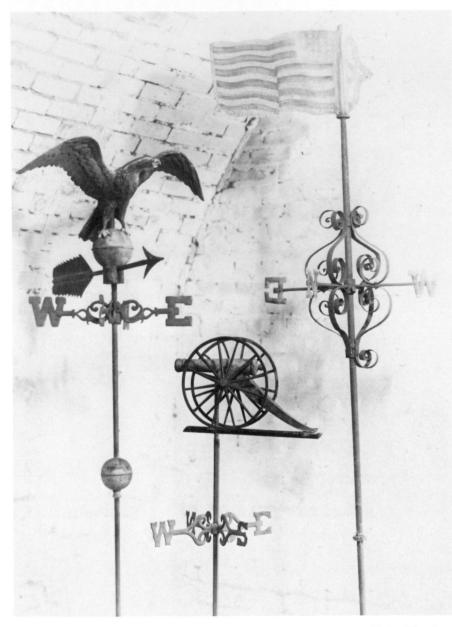

The Gallery on July 4, 1949. Flag and Cannon Weathervanes by J.W. Fiske Weathervane Co.

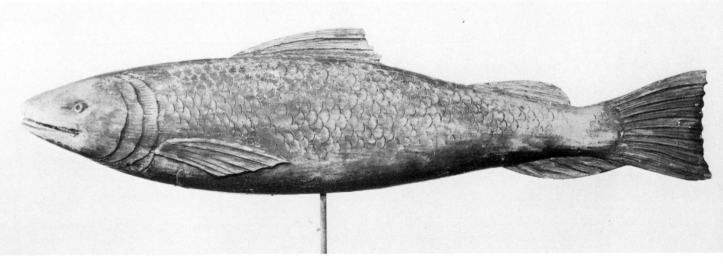

Fish Market Trade Sign. Wood. Boston

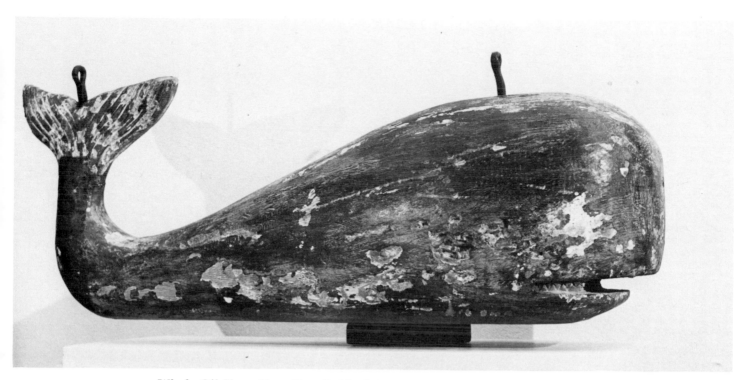

Whale Oil Shop Sign. New Bedford, Massachusetts. (Alastair B. Martin)

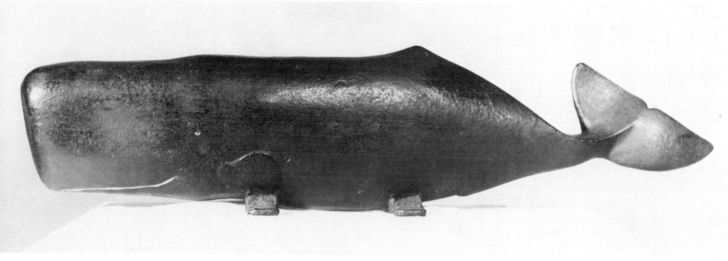

Whale Footscraper. Iron

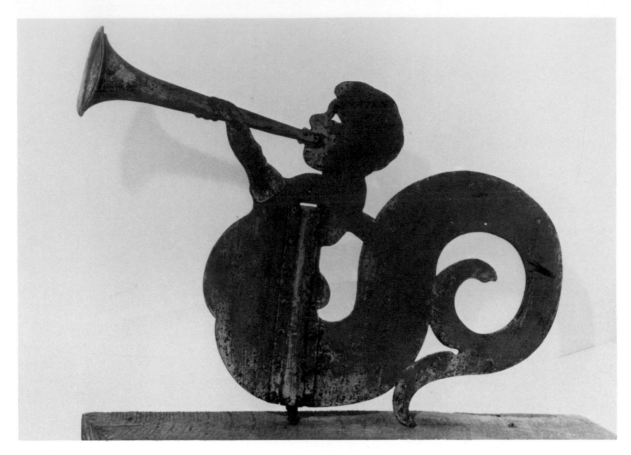

Triton Weathervane. Metal

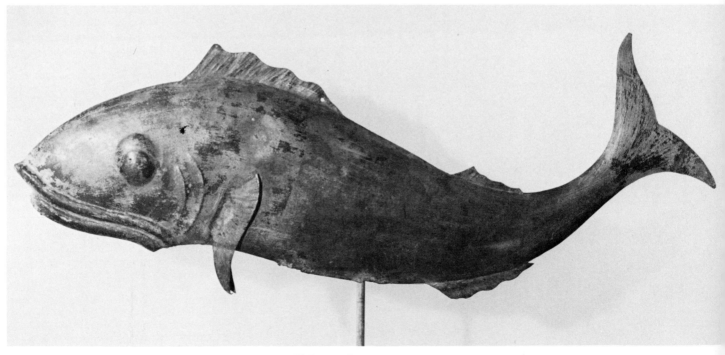

Fish weathervane

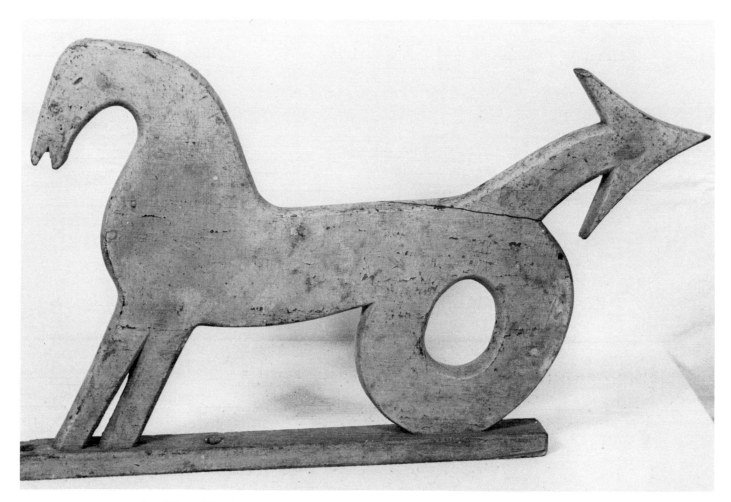

Sea Horse Weathervane. Wood. (From the Edith Gregor Halpert Collection)

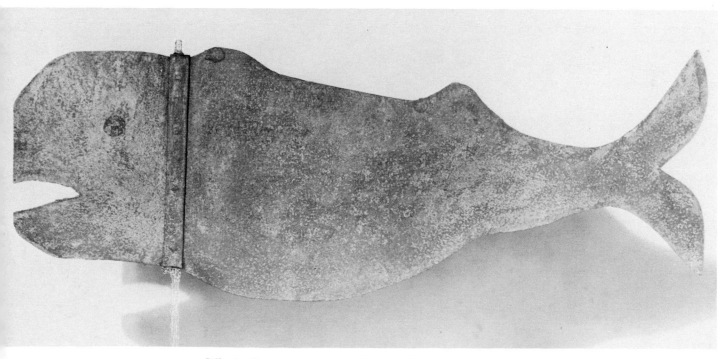

Whale Weathervane. Iron (Mystic Seaport, Connecticut)

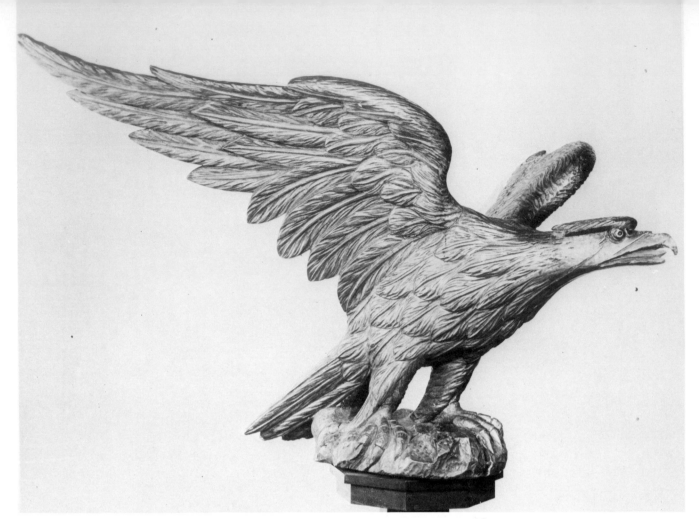

Ship Pilot House Eagle (David Rockefeller)

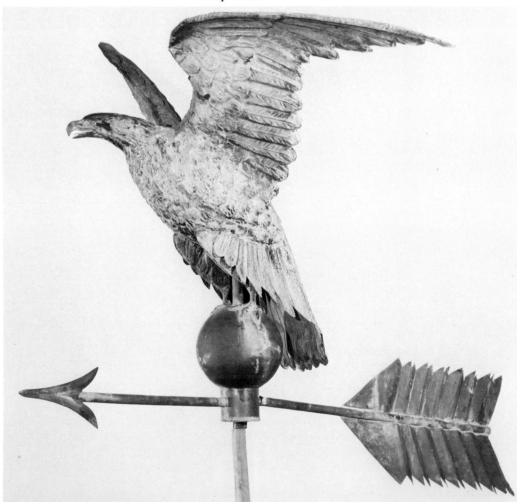

Eagle Weathervane.
Model for U.S. stamp

Eagle Weathervane. Pewter and Tin.

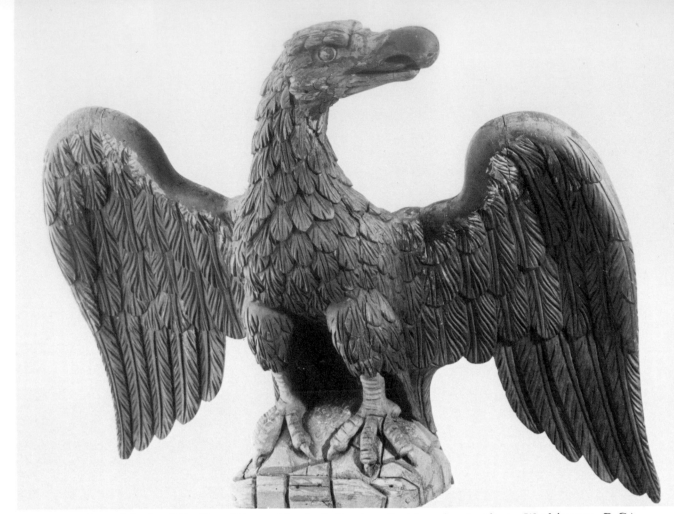

Carved Eagle. (The Van-Alstyne-Marsh Collection. Smithsonian Institute, Washington, D.C.)

Spread Eagle Ornament. Cast Iron. Central Park, New York City.

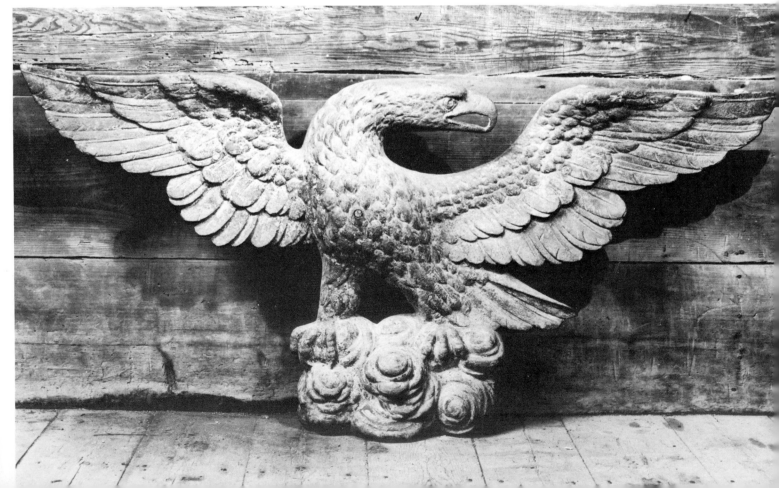

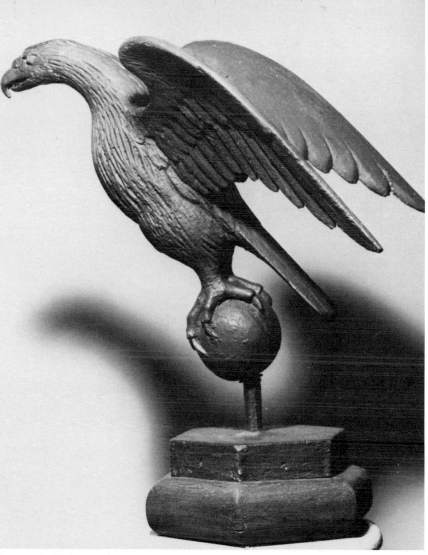

Carved Eagle. Attributed to Samuel McIntire

Bowsprit Ship Eagle. (Leonard Weisgard)

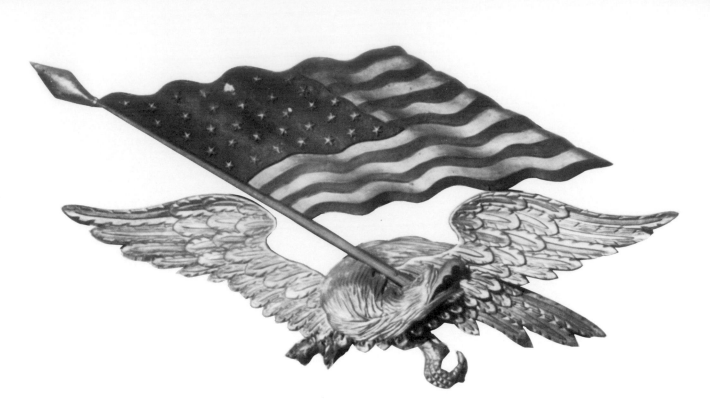

Eagle and Flag Carving Decoration from a Hudson River Steamship.

Pilot House Eagle. From Hudson River Boat "The Watt". Captained by William Westervelt

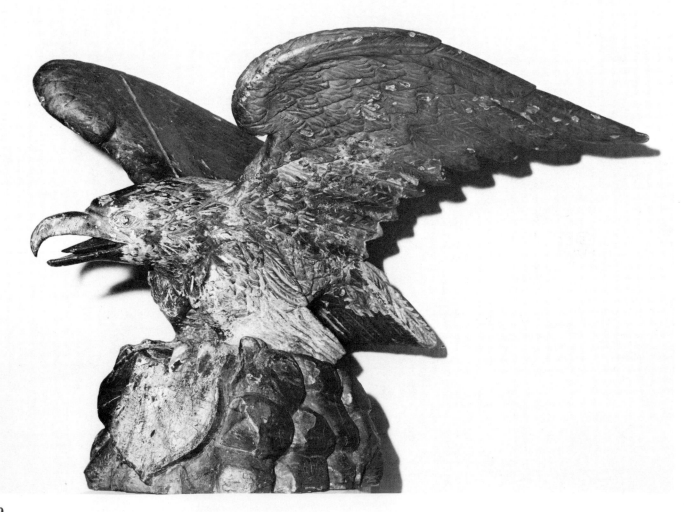

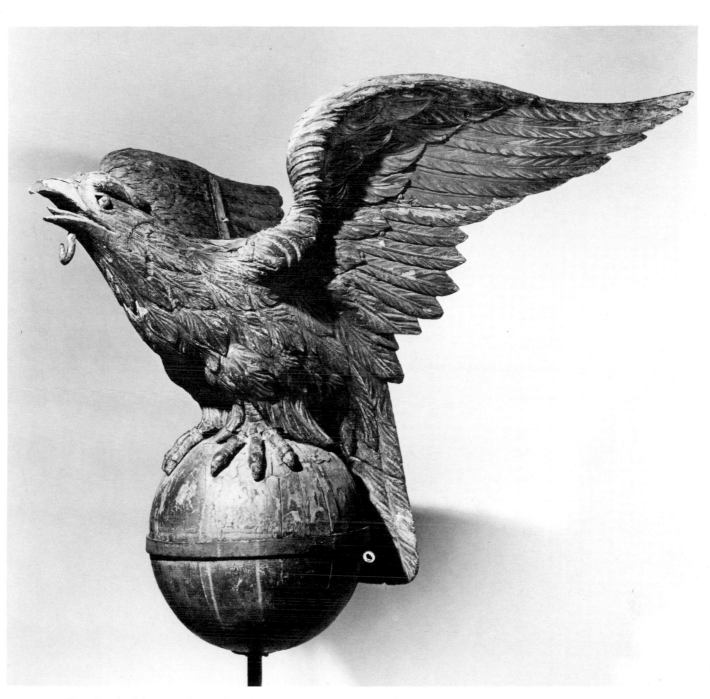

Heroic Architectural Eagle. Fraternal Order of Eagles Building. Columbia, Pennsylvania. (Museum of American Folk Art. Gift of William Engvick. Photograph: Courtesy Museum of American Folk Art)

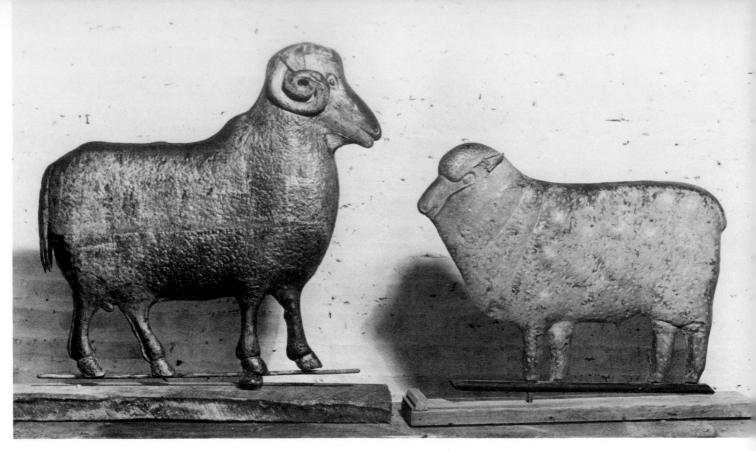

Ram and Sheep Weathervanes.

Marino Ram Weathervane. Molded copper. L.W. Cushing & Sons. (Mrs. Jacob M. Kaplan)

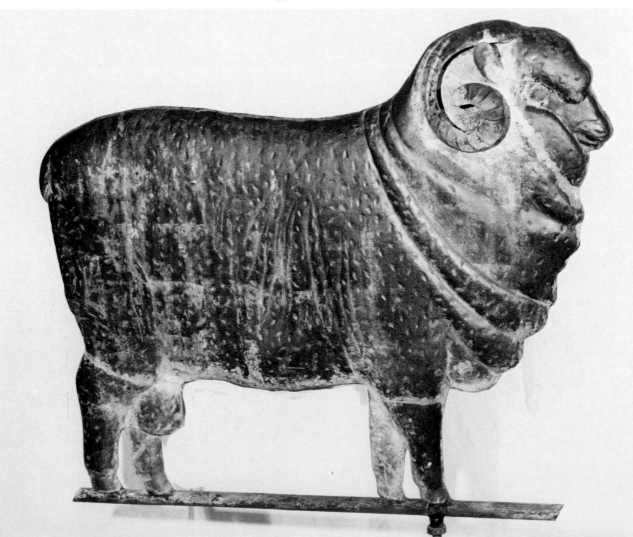

In the New England of those days we saw and brought home many arrow vanes and weather-cocks that had ridden atop barns, church spires, and public buildings. There were wood vanes, vanes of copper, iron, zinc, and lead. One year we concentrated on eagle vanes and the different interpretations. On June 20, 1782 Congress approved the use of the American bald eagle in the Great Seal of the United States. The eagle became our national symbol.

On the inland country routes we saw a menagerie of cow vanes, sheep, pigs, chickens, and trotting horses as they made their appointed rounds of North, South, East and West. Vanes often doubled as trade-signs. A sheep vane indicated a wool mill; a cow, a dairy farm; a stork, a baby doctor. Most vanes were to be seen only on high in their proper places, against the sky. Those offered in antique shops were usually discards, and ranged in price from fifty to seventy-five dollars. One dealer apologized for the high prices. He had an old weathervane catalogue, printed by J. Howard & Co. that listed vanes for thirteen dollars. The date was 1852.

Marino Sheep Weathervane. Molded copper. L.W. Cushing & Sons. (Mrs. Jacob M. Kaplan)

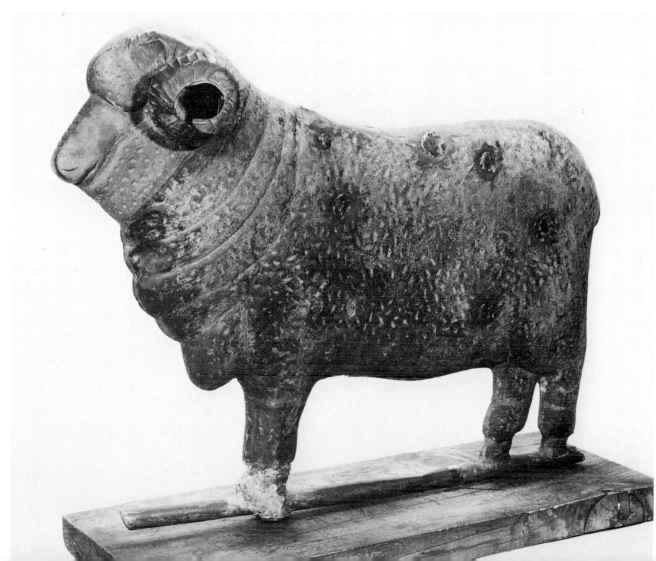

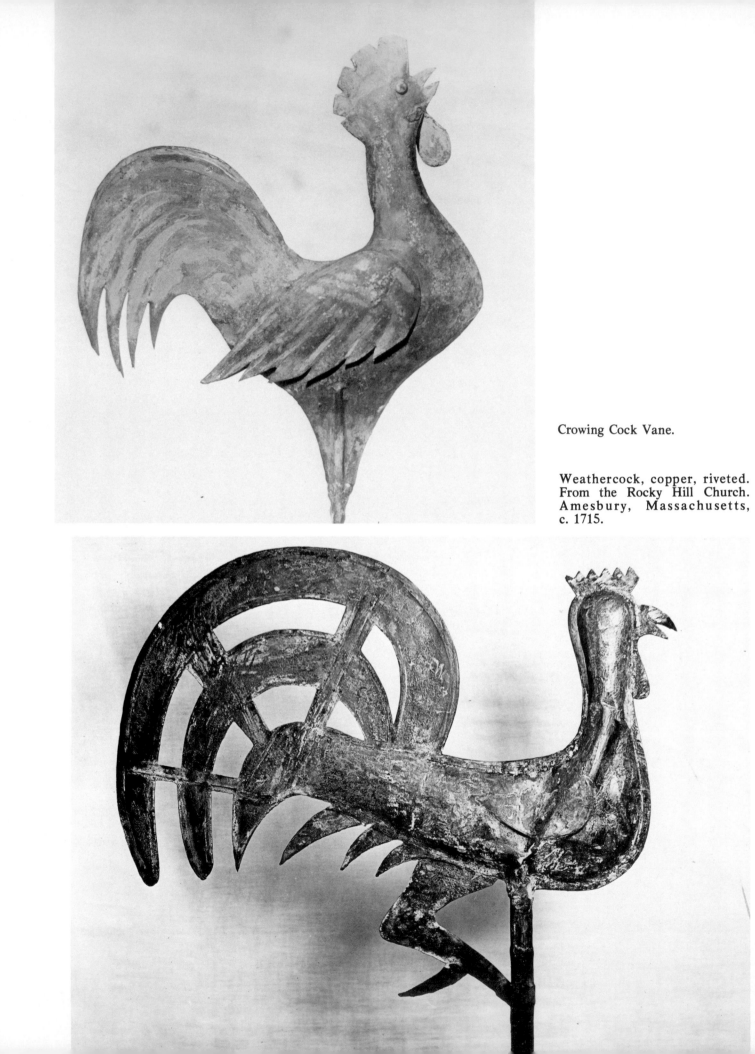

Crowing Cock Vane.

Weathercock, copper, riveted. From the Rocky Hill Church. Amesbury, Massachusetts, c. 1715.

Rooster Vane. Copper and Zinc.
By J. Howard & Co., West
Bridgewater, Massachusetts.
(Mrs. Leo Simon)

Rooster Vane. Sheet Iron. Ohio.
c. 1800. Private Collection.

Horse Vane. Iron. Attributed to Mott Iron Works. New York City. (Dan Johnson)

Horse Vane. Copper and Zinc. By J. Howard & Co., West Bridgewater, Massachusetts.

Cow Weathervane.

Bull Weathervane. (David Rockefeller)

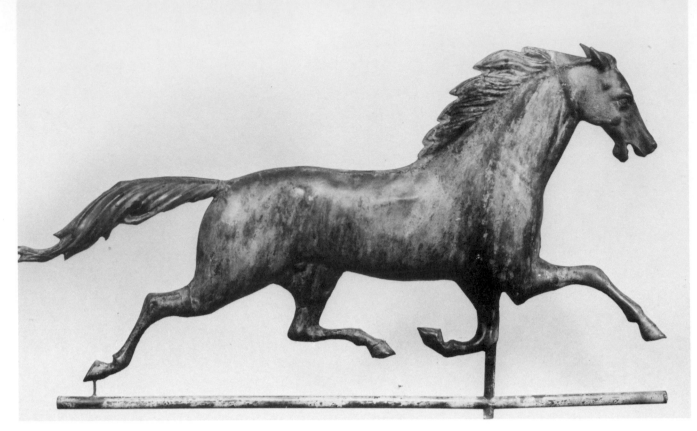

Ethan Allen Vane.

Ethan Allen Vane. A Trotter.

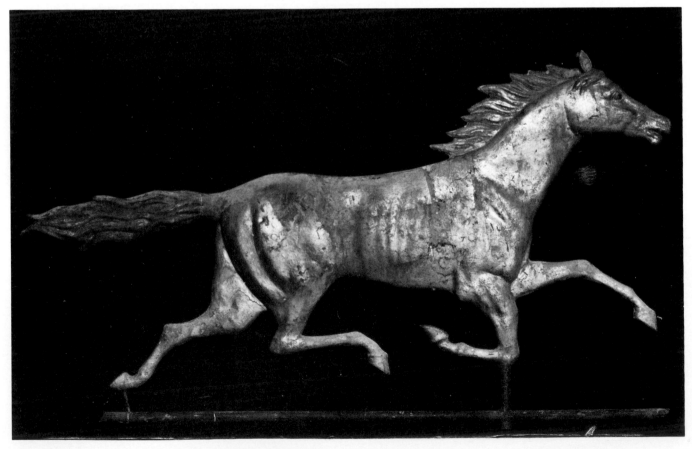

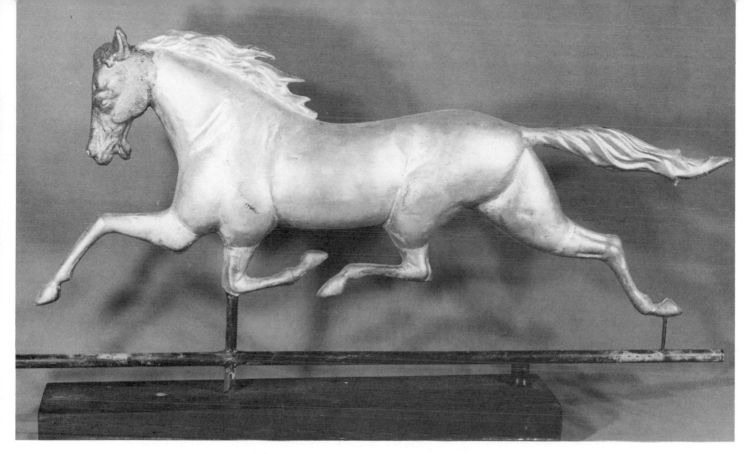

Horse Vane. The Trotter named Patcher.

Horse Vane. A pacer.

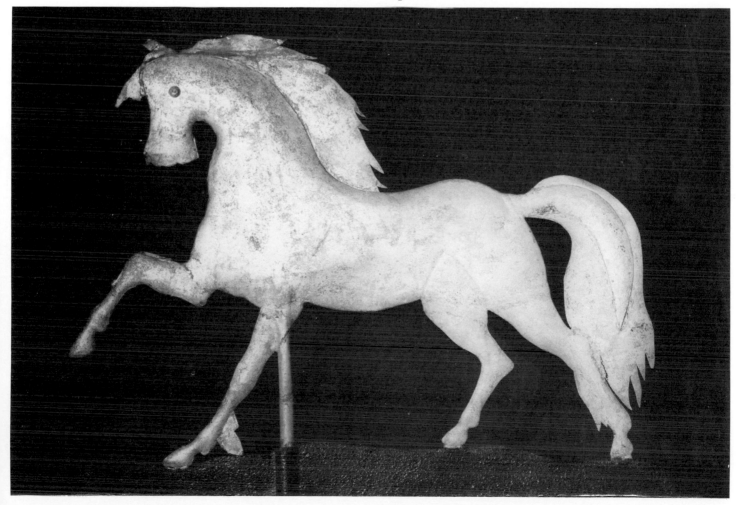

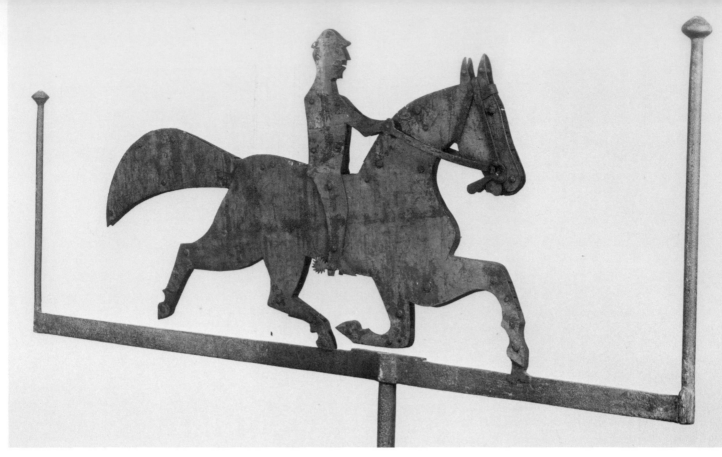

Horse and Jockey Vane. (Abby Aldrich Rockefeller Collection. Williamsburg, Virginia)

Horse Maude S. and Sulky, driven by W.W. Bair. A weathervane. (Miss L. Peabody)

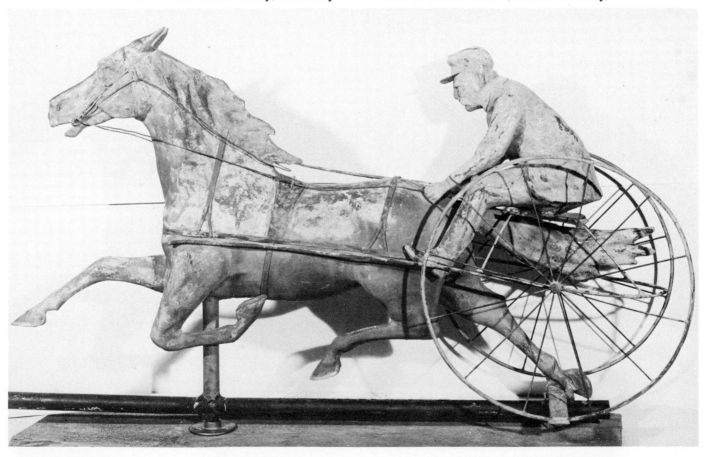

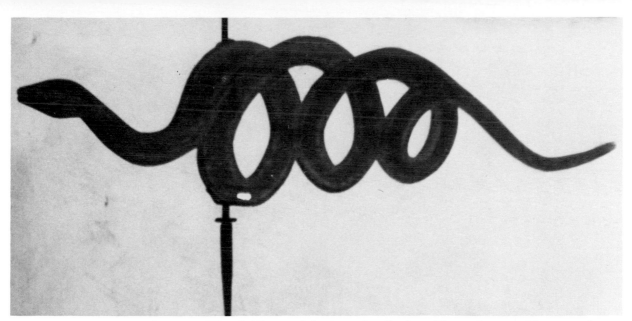

Coiled Serpent Weathervane. Wood. (Concord Antiquarian Society, Massachusetts. Photograph: Robert Eichler)

A special side trip took us to historic Concord, Massachusetts. At the "Concord Antiquarian Society" is the famous *Coiled Serpent* weathervane. It represents the slogan of our New England patriots: "Don't Tread On Me!" Jonathan Teel, one of my New England ancestors on my mother's side of the family, stood his ground with neighboring farmers on the Common in Lexington on April 19, 1775, when British troops (500 strong) under the command of General Thomas Gage, military governor of Massachusetts, marched through on their way to Concord to capture a store of ammunition. That day Captain John Parker spoke to his men, "Stand your ground. Don't fire unless fired upon, but if they mean to have a war, let it begin here."

At Concord North Bridge shots were exchanged: shots "heard around the world". The American Revolution started. The British stumbled back toward Bunker Hill.

Vanes had been missing from the scene of early Pennsylvania days. Why? Because there was no seacoast to inspire Tritons or fish, or other nautical shapes? The majority of churches built by Pennsylvania German religious sects were plain, four square houses of worship, not given to ornament. As for the barns, few trotting horses livened the landscape or the skyline in an agricultural community given over to the raising of wheat, corn, barley, and rye. Folk art is a reflection of place as well as time.

A few unique Pennsylvania vanes, one-of-a-kind, made by hand for one location at a certain time in history, have been found and honored. The most famous, the William Penn vane, is a direct descendant from the standard flag or banner insignia carried by feudal princes in England and on the Continent. In America this

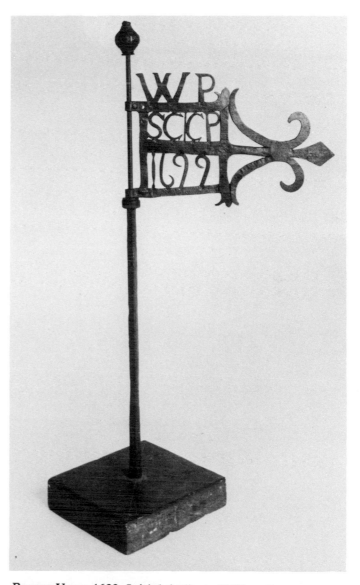

Banner Vane, 1699. Initials indicate William Penn, Samuel Carpenter, and Caleb Pusey. (Historical Society of Pennsylvania)

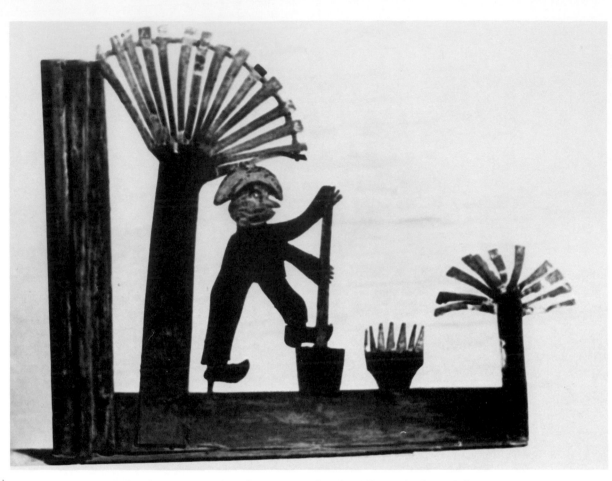

Tole Vane. Pennsylvania Farmer Planting Tree. (Barbara Johnson)

vane, this flag which had been a privileged standard of the gentry, became a symbol of democracy, a trade-mark of independence.

A rare tole (tin) vane from Pennsylvania depicts in silhouette, a farmer with spade, planting a tree. A unique double fish vane, found in Lancaster, resides today at the Shelburne Museum in Vermont. The double fish is the zodiac sign for March, the month when the shad move up the Susquehanna River to spawn.

One reason for the predominance of vanes in New York State and in New England was the concentration of weathervane companies around Boston and New York City during the mid and late nineteenth century.

The oldest known weathervane company, A.L. Jewell and Co., was located in Waltham, Massachusetts, my native town. The company, started in 1852, continued to produce vanes until 1865 when the proprietor fell off a ladder and was killed. Cushing and White purchased the business and continued until 1872 when the firm became L.W. Cushing & Sons Co.

The early weathervane companies produced and marketed the well-made, durable three-dimensional copper products which weathered

better than the wood vanes, and had more visual appeal than silhouette shapes.

The popularity of horse vanes resulted from the public passion for harness racing, the nineteenth century all-American sport that predated our enthusiasm for baseball, football, and golf. In Vermont the native Ethan Allen horse rode the rooftops. In New York State, the Goshen track winners were favored: Patchen, Black Hawk, Dexter, Goldsmith Maid, and Flora Temple.

A "company" vane does not mean what the word implies today, an assembly line, mechanical process. Most of the work was hand-done. Usually only three or four craftsmen, often members of one family, comprised a company. Usually a professional woodcarver was hired to create the original wood model. The design might be adapted from a current, popular Currier and Ives print. Then piece molds were cast from the carving: dies into which copper sheets could be hand-hammered, and soldered together to create the three-dimensional weathervane we know. Finally, the painting. In a professional job, yellow ochre was usually applied as a base coat before the final application of gold leaf.

The fact that this process allows the duplication

Double Fish Shad Weathervane. Lancaster, Pennsylvania. (Shelburne Museum)

of vanes need not condemn the copper weathervane as an impersonal factory product. Hand skills were the important factor. (A lithograph or an etching is not disparaged as "factory-made" because the print may be duplicated.)

The production of a "company" weathervane we had the opportunity of seeing first hand from two extraordinary practitioners, Mr. McMahon and Mr. Kessler.

While on a trip to Boston, Cordelia and I heard about a shed full of old weathervane parts, molds, and unsold complete vanes owned by a fellow named McMahon who lived in Chelsea. We located the gentleman, much to his surprise and ours. All we had heard was true, but the owner was not eager to discuss where or how he had assembled the motley collection. There, stacked in his shed, were boxes full of copper weathervane parts, (copper tails, legs, heads, torsos), old iron molds, and a few nearly complete vanes. It looked as if McMahon had bought a defunct weathervane company and was making the most of it. Several weathervane companies, other than L.W. Cushing, had been located near Boston. These included L. Harris & Son, W.A. Snow, and J. Howard & Co. of West Bridgewater.

Spread on a worktable in the shed lay a handsome fireman's horsecart vane complete with horse and driver, or almost complete. Two of the four wheels were missing from the cart - a situation about to be remedied.

We were impressed and asked, "Do you have any all-original vanes?" The answer was, "No, but I will have. If a piece is missing, I make an original part out of the original mold. What's the difference?"

One difference was that the McMahon soldering of the joints was not good. A professional can solder smoothly so the joint is practically invisible. McMahon's joints were lumpy, and they didn't fit.

We left Somerville empty-handed but wiser. Over the years McMahon vanes turned up frequently in the market place. His vanes were not painted, gold-leafed, or weathered by any natural process.

What happened eventually to the McMahon molds? In 1953 Edith Gregor Halpert also discovered Mr. McMahon. Evidently she bought the molds made originally by L.W. Cushing and Sons Co., of Waltham, Massachusetts. Then Mrs. Halpert went into business for herself, the business of making weathervanes. These "reproductions"

of sixteen models she offered to the public in a limited edition of twenty. The price was $500 each.

That particular Halpert venture was not a financial success. The color of the vanes was uninteresting: a monotonous, shiny coppertone, not painted, or gold leafed or weathered green by any natural process. A few enterprising dealers who purchased the vanes (at discount) tried to remedy the situation by applying a well known "greening" process. Copper sulphate and acetic acid mixed and applied with a brush produces the semblance of a weathered green coating. But this liquid application usually dribbles and streaks in a tell-tale fashion. It also rubs off.

In 1951 we saw a real professional weathervane maker at work right in New York City of all places. One day while Cordelia and I were walking downtown in Manhattan on Fulton Street, we looked up. A weathervane was mounted on top of a fire escape; a most remarkable vane, a Victorian lady just standing there blowing a horn, three flights up!

We entered a street door, and made our way up dark, narrow stairs to a closed door. A genial little man answered our knock and invited us into a huge loft that ran the length of the building. It proved to be a combination workshop and living quarters. The gentleman, Mr. Kessler, was most hospitable. No, the lady on the fire escape was not for sale. He had made her thirty years ago; she would never be for sale.

Over the next few years we became well acquainted with Charles Kessler. As a longtime devoted worker, he had inherited the E.G. Washburne Weathervane Co. When the original owner died, Mr. and Mrs. Kessler carried on the business - what was left of it. By 1930, a few great estates with livery stables in need of vanes were built anymore. Few new churches or railroad stations needed weathervanes. Most of his shop work was the repair of old vanes which had weathered badly or had blown down and needed repair. Sometimes a new shining coat of gold leaf was ordered. Mrs. Kessler was the expert who applied the gold leaf meticulously, leaf by leaf. We watched her one day.

As our acquaintance grew, Mr. Kessler discovered in the rafters several complete old vanes which had never been sold or used. These he let us buy occasionally, although he hated to part with them. Actually we preferred and often purchased the weathered, used, even slightly damaged vanes which were being returned to him. Mr. Kessler never did figure out that preference. Neither did he understand why we wanted to use a vane inside a house rather than on top of it.

The end of our relationship was tragic. It was May, the time of year we usually visited Mr. Kessler. In the spring, old customers brought vanes for repair after winter storms. We found him grief stricken. His wife had died. He blamed himself. His wife had come with him to live in the city, but she missed the country. She had loved the country. She had liked flowers. Now he wanted her to go back to the country where she had been happy. He knew we lived in the country. Could we do anything about it? I didn't know. I began to think she was still there waiting behind the curtain, waiting for us to take her back to the country.

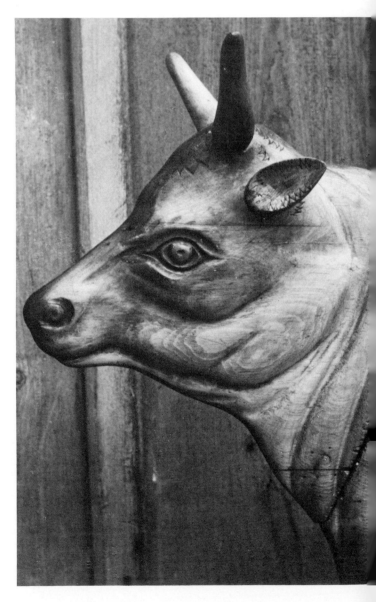

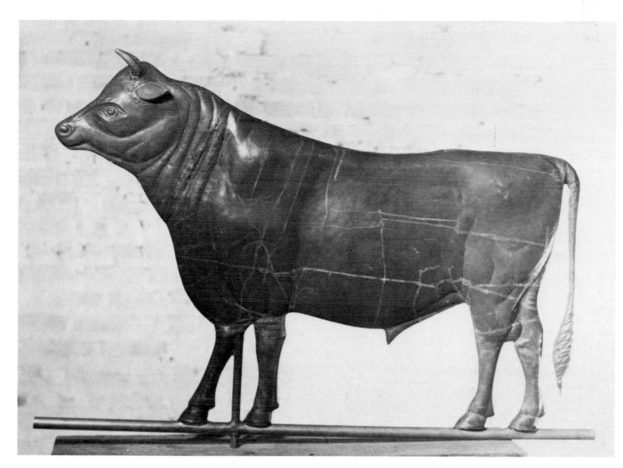

Bull Weathervane. Copper by E. G. Washburne & Co., New York City.

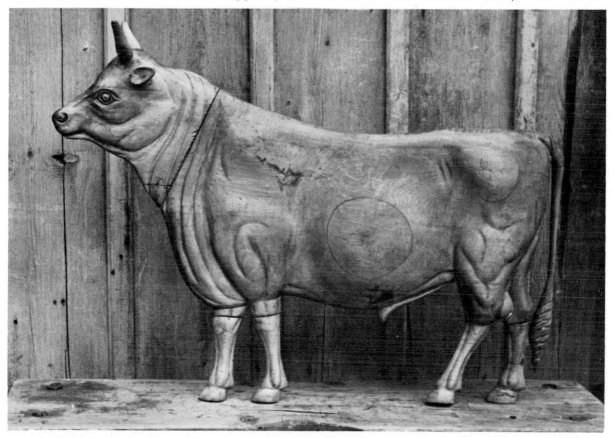

Wood Patterns for Bull Vane by E. G. Washburne & Co., New York City. (Collection Lewis Baker)

The clock on Trinity Church down the street struck twelve. I offered to go out, get some hot soup and bring it back. On the way downstairs I knocked on the door of the young man who had been Kessler's part-time helper. He told me that Mrs. Kessler was not there. She had been buried properly, but her husband was lonely and confused.

During the following weeks I phoned but received no answer. A later trip to Fulton Street found all three floors of the building empty. The chef at the corner restaurant said the weathervane company had been sold to a firm in Danvers, Massachusetts.

The lady weathervane on the fire escape was gone too.

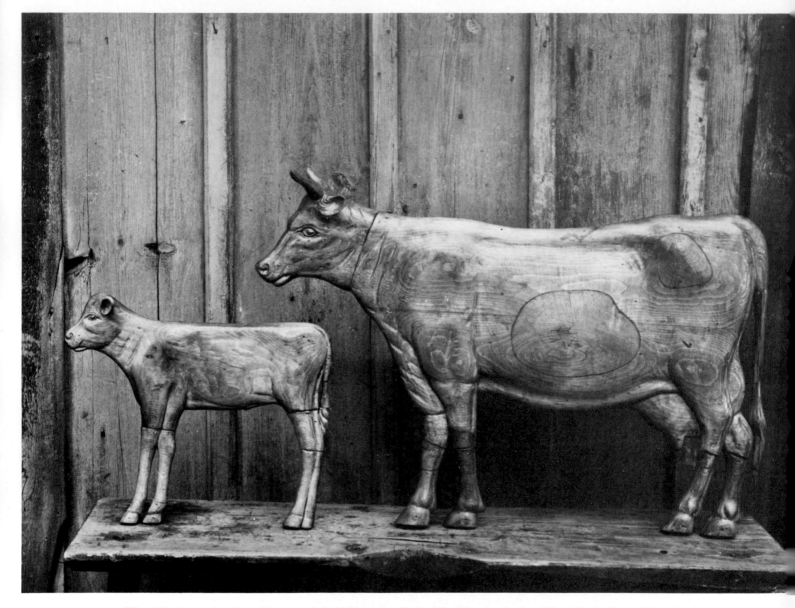

Wood Patterns for Cow Vane and Calf Vane by E.G. Washburne & Co. (New York State Historical Association, Cooperstown, New York)

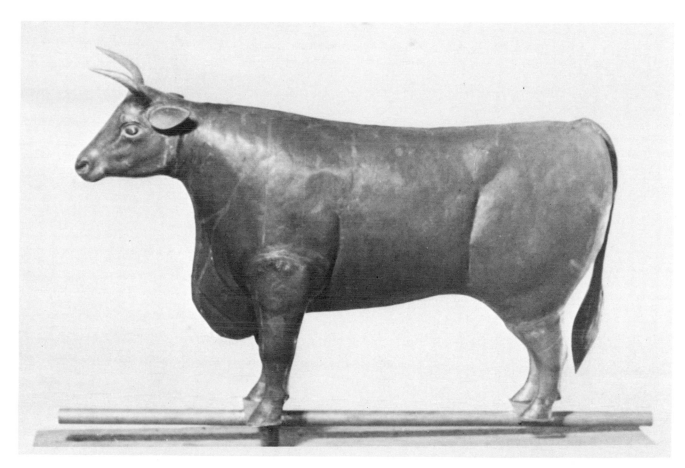

Steer Weathervane. Copper by E. G Washburne & Co.

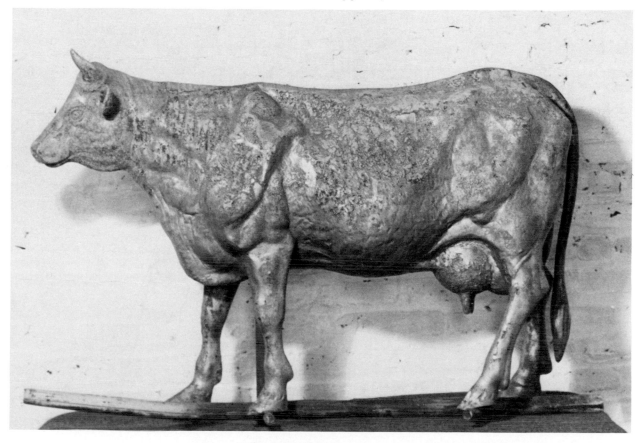

Cow Weathervane by E. G. Washburne & Co.

Plaster molds for Rooster Vane used by E. G. Washburne & Co.

Bull Weathervane. Copper by E. G. Washburne & Co.

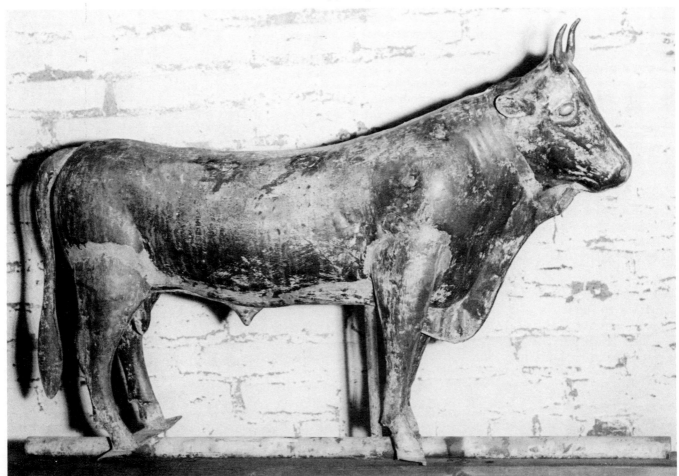

Chapter 7

Antique Shows and Collectors of the 1950's

The armistice was signed in September 1945. Our men came home and tried to adjust to normal civilian life. Joel needed rest, and he wanted to write. It seemed practical to continue our fledgling antique business, both for its income and its diversion. Since no eager public had beaten a path to our barn door in Stony Point, we decided to try entering an antique show in New York City in order to become known and to make personal contact with collectors.

In 1949 we applied for entrance into the Antiqu

In 1949 we applied for entrance into the Antique Show held annually at the 34th Street Armory in New York City. In all innocence we asked what credentials were needed as to our authenticity and solvency. Only an entrance fee was required. From Pennsylvania we garnered redware pottery, chalk figures, antique toys, and quilted petticoats. We featured weathervanes. One fabulous wood Indian vane went to Winterthur.

The day before our first antique show opened to the public we sold out to other dealers. Our prices were too low! We learned, and during the next few show years we made important contacts with collectors including: Nina Fletcher Little, William L. Warren, Carl Dreppert, Mr. and Mrs. John Riemensnyder, Mrs. Wilbur Arthur, Donald Blagden, Eve Meulendyke, and especially, Jean Lipman. Jean's authoritative book, *American Folk Art,* published in 1948, was our bible.

Also we met individual art connoisseurs who happened to like folk art. There was Dominique de Menil, one of this country's most cultivated art collectors and benefactors. Mrs. de Menil took home to Houston a unique horse weathervane and a superb circus wagon carving, "Pan", by Samuel A. Robb. In 1930, "Ringling Brothers" and "Barnum and Bailey" circus wagons had been abandoned in Bridgeport, Connecticut. It was the time of the Great Depression. Gold leaf was stripped from the wagons and sold. The life-sized carved figures of animals, and of historical or

Pan. Circus Wagon Carving by Samuel Robb, c. 1875. (Dominique de Menil)

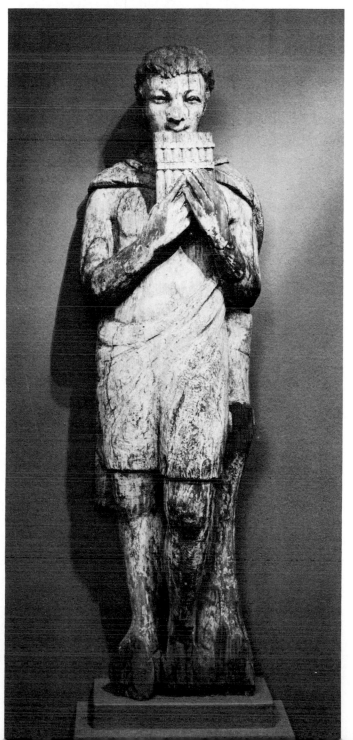

mythological characters which had decorated the sides of the parade wagons, were removed and sold, many to Mr. Warren, from whom we purchased "Pan".

Madame Gamma Walska, the widow of the famous singer, John McCormick, collected carrousel animals. Mme. Walska was a handsome, regal lady who wore extravagantly elaborate hats and floor length chiffon scarves. In Santa Barbara, California, where she lived, she created an Alice-in-Wonderland garden of neat paths, clipped yews, and carrousel figures. At night the animals were wheeled indoors. Mme. Walska purchased our carrousel lion to join the happening.

Mrs. John H. Heminway of Watch Hill, Rhode Island fell in love with our shop figure "Father Time", and hustled him off to her station wagon before a surprised Alastair Cook had a chance to buy it. In later years Mrs. Heminway presented the carving to the *Museum of American Folk Art*. The figure, about four feet tall, stands on a base inside of which is a clock mechanism. When a customer entered the shop, a cord attached to the front door activated Father Time's arm, and the scythe struck the bell. Originally the shop figure came from upstate New York, near Utica, an area settled by Germans. In the same locality, years later, we found the famous carved Centaur. On Ninth Avenue in New York City we bought old trade signs.

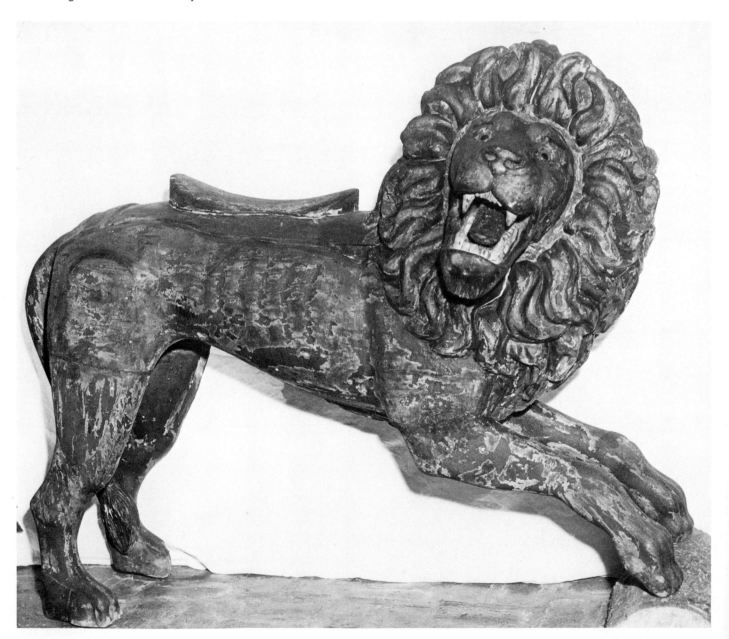

Lion, Carrousal Carving. (Madame Gamma Walska)

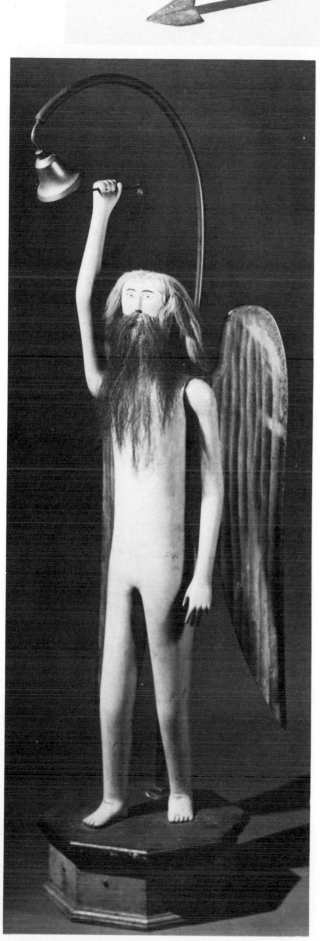

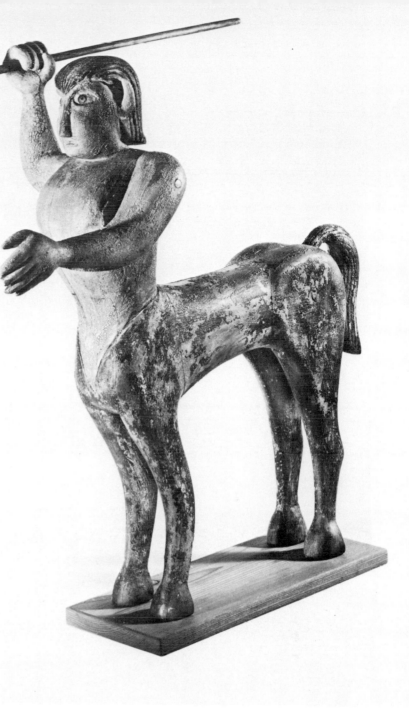

Centaur. Allegorical carving. Half man, half horse. Attributed to Mr. Dines, Utica, New York. (Alastair B. Martin)

Father Time. Wood Carving. (Museum of American Folk Art. Gift of Mrs. John H. Heminway)

Golden Fleece. Carved trade sign of Wool Merchant. (Stewart Gregory Collection)

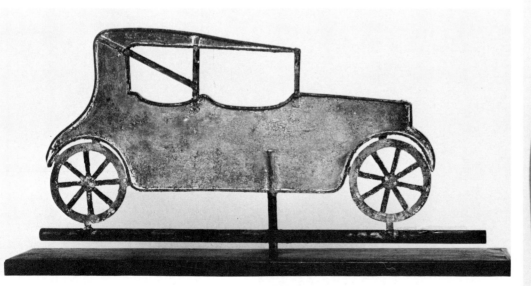

Auto Repair Shop Sign. (Richard Lippold)

Trade Sign. Paint Store.

Grape Juice Trade Sign. (Mr. and Mrs. Jacob M. Kaplan)

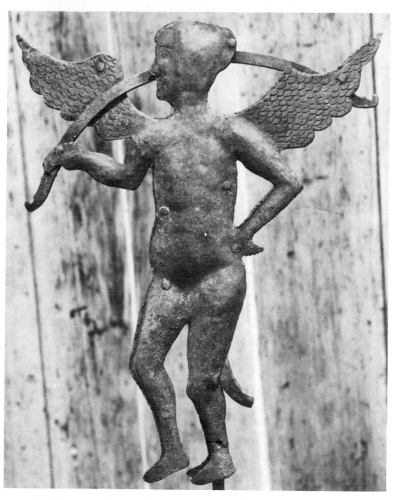

Cupid. Wrought Iron. Used at home of the Master of Cornwall Furnace, Pennsylvania. (Jean Lipman)

Dressmaker Shop Sign. Copper. Gold-leafed. (Heritage Museum, Sandwich, Massachusetts)

Trade Sign. Music Shop.

Electra Havemeyer Webb and Family. Shelburne, Vermont. (Photograph courtesy Shelburne Museum)

The most avid collector of that day, Electra Havemeyer Webb we met by way of an Armory Antique Show. Mlle. "Guvie", a tutor for Mrs. Webb's children and an expert on fabrics, visited the show and saw one of the quilted petticoats we had purchased from the Erb sisters in Pennsylvania. Several religious sects in Pennsylvania allowed their women folk to wear only "plain" clothes on the outside, but underneath it was different. Underneath, the women wore pretty colored quilted petticoats in winter. We wore the petticoats as skirts. Mlle. "Guvie" was intrigued. She asked whether we knew about Shelburne Museum. Had we met Mrs. Webb?

In the spring of 1953, a year after the Shelburne Museum had opened to the public, we were invited. That first visit, when we saw the folk art collection in *Stage Coach Inn* and the decoys in *Dorset House,* marked the beginning of a long association with Mrs. Webb during which we enjoyed her friendship and trust. She always called me "Earnest", and I guess I was.

Over the years, we took many treasures to Shelburne to show Mrs. Webb. Her decisions were immediate, based on human as well as abstract, aesthetic, or historic standards. Would the object under consideration look well, add a personal touch to a specific house or room? Questions of provenance, date, and identity of maker came later, if at all.

By 1953 Mrs. Webb had assembled some 125,000 antiques for her museum. In those early days the supply was endless, and her fortune adequate. She assembled twenty-eight buildings, old buildings which she moved to the fourteen acre site in Shelburne. The site was separated from the main highway by a creek. Mrs. Webb bought an old covered bridge, a double lane bridge, and moved it to span the creek. On the bridge hung a sign, "Gone fishing. Back Monday. Maybe."

The many buildings she transported over that bridge created a village of early homes, a schoolhouse, a tavern, a church, a store, a blacksmith shop, and great barns to keep all company. In later years, Mrs. Webb added a locomotive which she really did not need. But the Webb family had accumulated part of its fortune in the railroad business. A locomotive seemed suitable.

No project was too challenging for this blue-eyed, dynamic lady. She also moved a ship. She rescued the last side-wheeler on Lake Champlain and arranged to have it transported cross-country to a high and dry location on the museum grounds. And to keep the ship company she bought and moved the Colchester Reef lighthouse!

Electra Havemeyer Webb's passion for collecting history, art, and architecture had been kindled at an early age by her family associations.

Electra's father, Henry Osborne Havemeyer, the head of American Sugar Refining Company, had assembled the great Havemeyer collection of Rembrandts and El Grecos, many of which reside today at the Metropolitan Museum of Art in New York City.

74

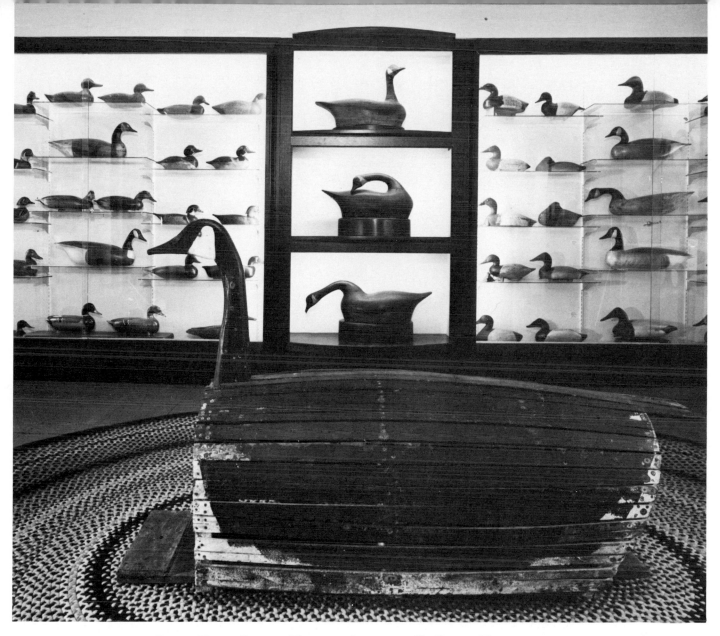

Dorset House Decoys. Photograph courtesy Shelburne Museum.

Electra's mother purchased paintings by Degas, Cezanne, and Renoir before the French Impressionists became famous. The Havemeyers had little interest in American art. They were shocked when daughter Electra brought home wood Indians and used bed quilts!

Mr. J. Watson Webb's father, Dr. William Seward Webb, ran the first railroad into the Adirondacks. In 1889 Dr. Webb journeyed across the United States in his private train, equipped with a Chickering piano, two nurses, and a library. American history fascinated him. An ancestor, General Blackley Webb, held the bible for General Washington's oath of office at our country's first presidential inauguration!

The great horseshoe shaped barn in Shelburne includes the "Park Drag" carriage in which Admiral Dewey and Dr. Webb drove around Vermont after the Battle of Manila.

The buildings we loved at Shelburne were, of course, the 1784 Stage Coach Inn with its superb sculptural folk art, and the Dorset House which contains the largest and most significant collection of wildfowl decoys in any museum. In 1952 Mrs. Webb's three sons, Samuel, Watson Jr., and Harry presented their mother with the famous Joel Barber collection of some four hundred carvings. In 1955 the museum received three hundred decoys from Richard H. Moeller, and in 1958 the entire Edward H. Mulliken collection. Through the years Mrs. Webb added decoys of her own choosing.

The Shelburne Museum is a joyful treasure house of our American heritage. We thank Electra Havemeyer Webb and her sons who have carried on the history, the responsibility, and the privilege.

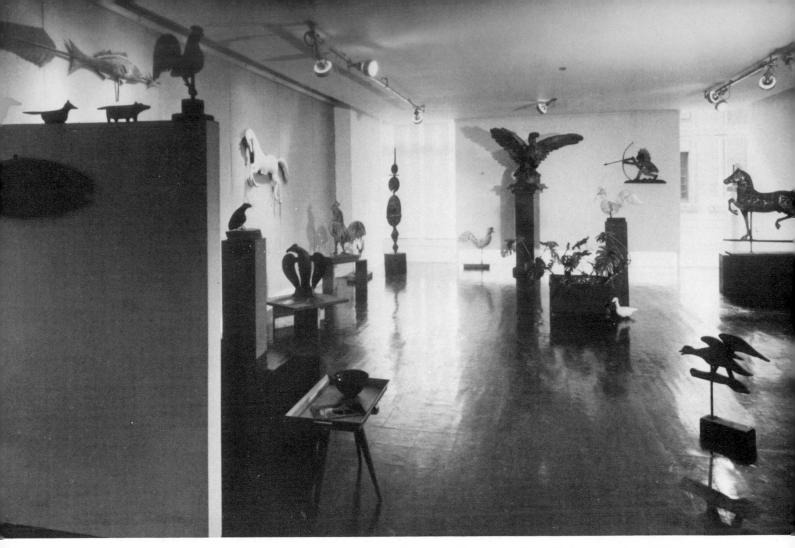

First Exhibition of American Folk Art at Willard Gallery, New York City. September 1953.

Marian Willard.

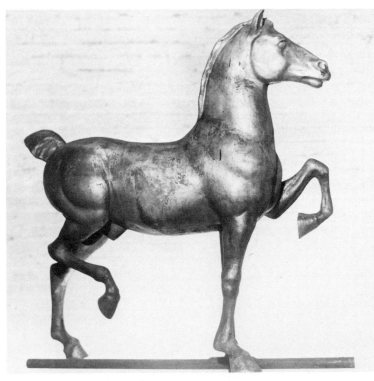

Hackney Horse Vane. Copper. Gold-leafed.
By E. G. Washburne & Co. (Joseph Verner Reed)

The Willard Gallery

The year 1952 was crucial in my private life. My husband, Joel, died suddenly.

The shock and loss made me realize the brief time all of us have to get on with what we feel is important. During the years when we had lived in Pennsylvania and in New York City and in Stony Point, it became clear that my special and natural interest lay in the discovery and presentation of folk art, rather than in the general field of antiques. So why did Cordelia and I exhibit in antique shows? We should be exhibiting folk art in an art gallery, a prestigious uptown New York City art gallery. It was important that American folk art be recognized in the history of America and American art.

The urge to take American folk art out of the general antique category and present it as an art at an art gallery was gratified more expeditiously than expected.

David Smith, the sculptor, had admired the figure, the "Iron Man", which Joel had brought home from Virginia several years ago. David suggested that we try his gallery, the Willard Gallery, located at 23 West 56th Street in Manhattan.

Marian Willard was receptive to the idea although her gallery featured contemporary artists: Richard Lippold, Mark Tobey, Morris Graves, and David Smith, among others.

We scheduled an opening exhibit of "Early American Sculpture" for September 1953 at the beginning of the Fall season. That first show included the wide range of excellent folk art available at that time. Following is a partial list of the art presented, plus what is known of provenance and present location. Not every piece was for sale.

Willard Gallery Exhibition
Sept. 28 - Oct. 17, 1953

Pig	Butcher's Trade Sign. Wood and Iron. Found in Pennsylvania. Collection of Donald Blagden. (Lost in fire. Bar Harbor, Maine)	**Cow** **Bull** **Bull Calf**	Original wood models Washburne Weathervane Company. Collection: Fenimore House, Cooperstown, New York
Codfish Weathervane	Wood. Painted Blue-Green Henniker, New Hampshire (Bought directly from barn).	**Cigar Store Indian**	
Heron Decoys	Matched pair. From Long Island, N.Y. circa 1900. Collection: Memorial Art Gallery of the University of Rochester, New York	**Horse Pull Toy**	Wood "Pull-toy" Cumberland Valley, Pennsylvania (By the carver of the Horse Pull-Toy in the Holger Cahill Collection). Collection: Cordelia Hamilton
Giraffe	Wrought Iron Figure. Collection: Lewis Baker	**Eagle Figurehead**	Collection: Seonard Weisgard
Daniel Webster	Ship Figure head Collection: State Street Trust, Boston	**Hackney Horse Weathervane**	Washburne Weathervane Co. Collection: Joseph Verner Reed
Iron Man	(Not for Sale) Virginia Early 1800's	**Ram Weathervane** **Circus Panel**	Trade Sign. Wooden Mill, New Hampshire From a Sebastion Circus Wagon

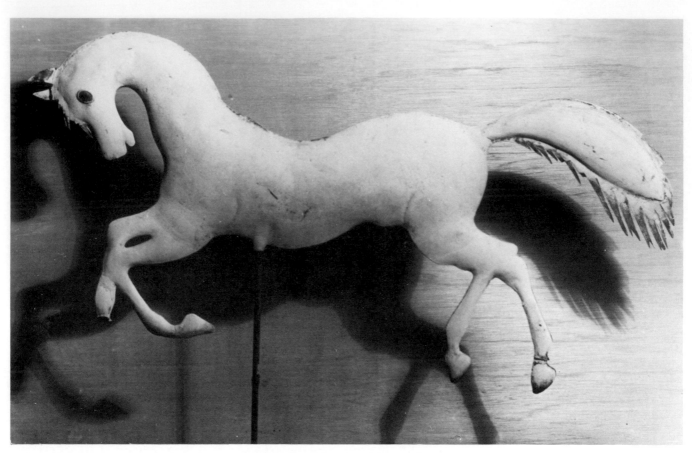

White Horse Vane. (Mrs. Leo Simon)

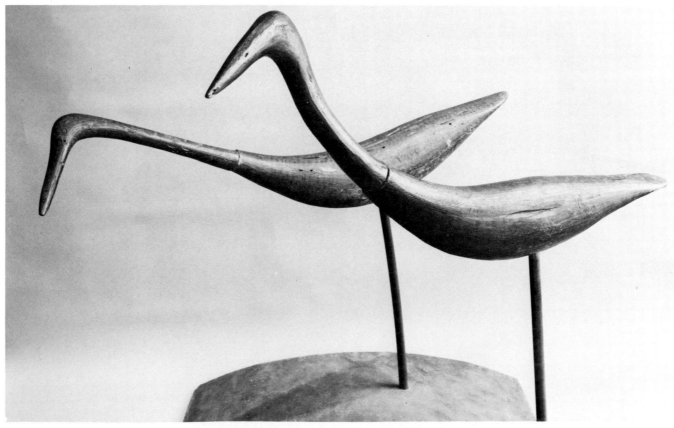

Pair of Heron Decoys. Long Island, New York. (Memorial Art Gallery. University of Rochester, New York)

Giraffe. Wrought Iron. (Louis C. Baker)

Daniel Webster. Ship Figurehead. (State Street Trust. Boston)

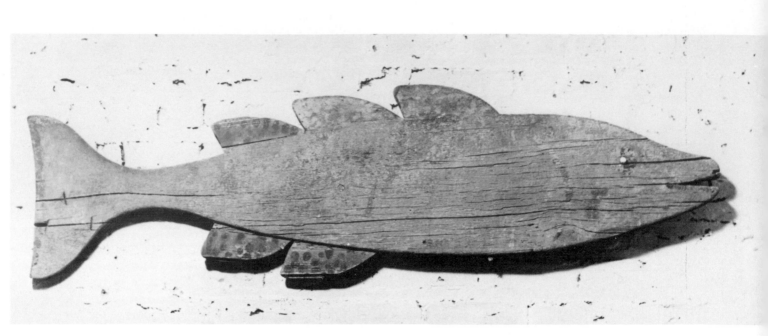

Fish Weathervane. Wood, painted blue. Henniker, New Hampshire.

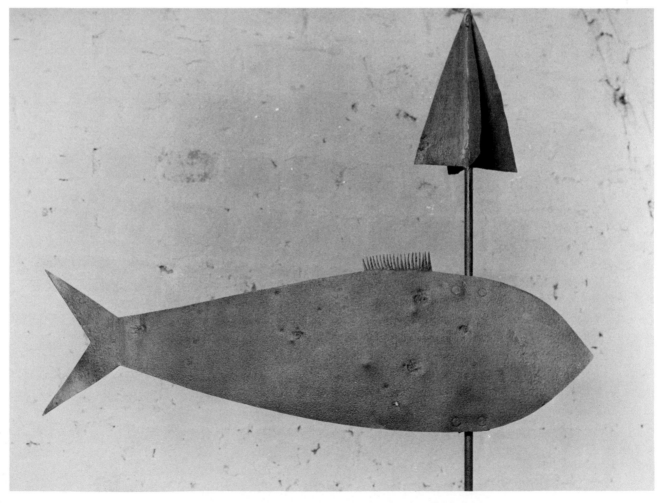

Fisherman's Trade Sign Vane. (Shelburne Museum)

Weathervane. Columbia with Flag. Stamped: Cushing and White. Waltham, Massachusetts. Pat. Sept. 12, 1865. (Alvin Friedman-Kien)

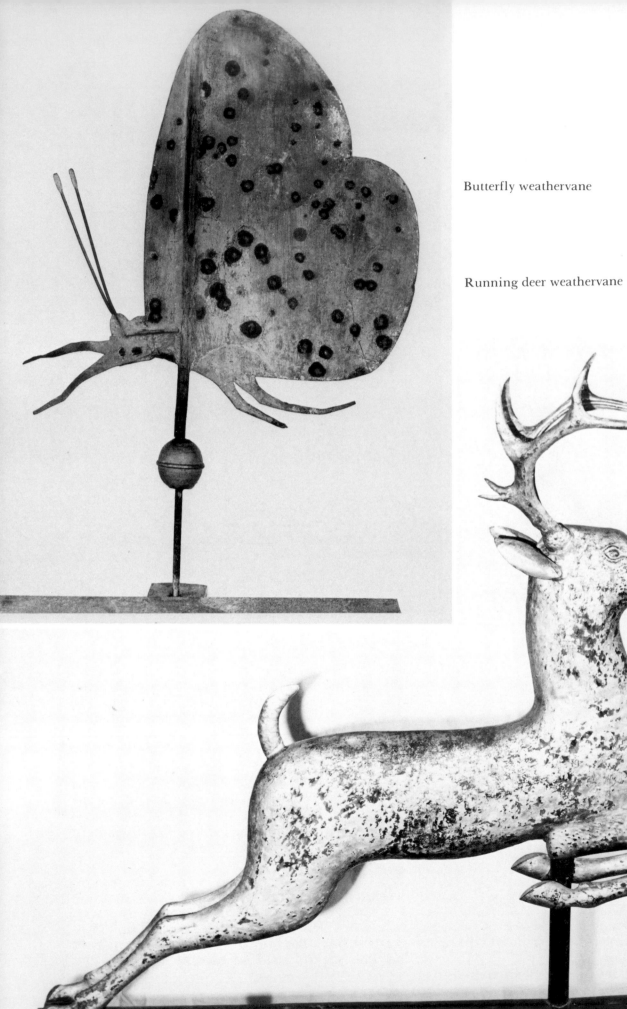

Butterfly weathervane

Running deer weathervane

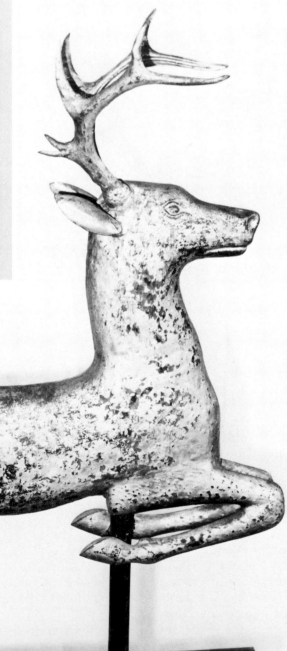

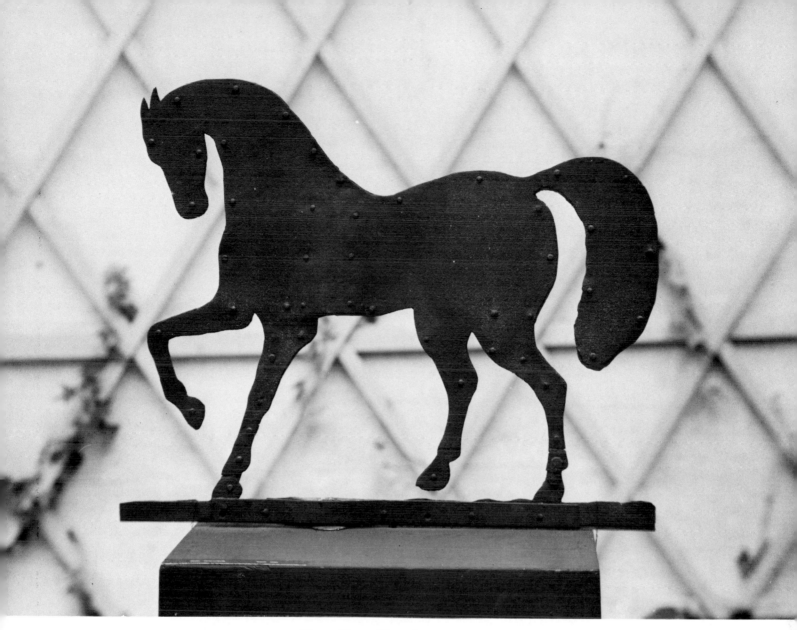

Horse Vane. Sheet Iron.

Pleased by the move of folk art from antique show to art gallery, we considered another bold step up the ladder. Why not send an exhibition of folk art on tour, not to art galleries but directly to art museums, especially in the West and Middle West where Eastern 18th and 19th century folk arts were practically unknown. Letters of inquiry brought prompt responses of acceptance for a traveling exhibition.

For the 1954-1955 season we scheduled, packaged, and shipped a comprehensive exhibition of "American Folk Sculpture" to the following museums:
California Palace of the Legion of Honor, San Francisco; Pomona College, California; Los Angeles County Museum, California; Philbrook Museum, Tulsa, Oklahoma; Fine Arts Museum, Dallas, Texas; and the International Folk Art Museum, Sante Fe, New Mexico.

The contents of the Santa Fe Museum had been given by Florence Bartlett of Chicago, but she had supplied no funds for operating expenses. I was asked to attend the opening of our traveling show and speak to members of the legislature about a state appropriation of funds for the museum.

The traveling exhibit was a "first" on the subject of eastern folk art for each museum. We included a few items shown previously at the Willard plus major acquisitions found during the intervening months. Excerpts from our brochure, printed by the California Palace of the Legion of Honor, August 21, 1954, follow:

The weathervane was one of the earliest of our arts. The pioneer settler, freed from Europe, was eager to place the brand of his own hand upon his church, his barn, his shop. He took the rude material, wood, iron, pewter, or tin and fashioned the windbar - not only to indicate the current of his time but to herald his independence.

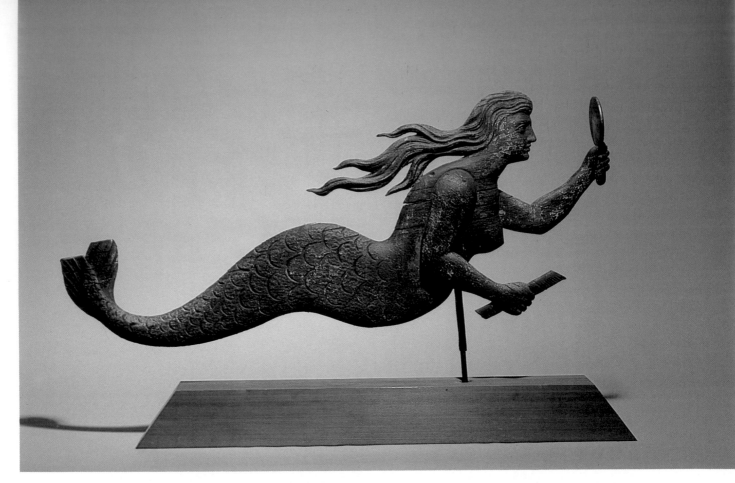

Mermaid. Carving attributed to Warren Gould Roby. c. 1850. May have been inspired by a popular ballad. *"It was Friday morn when we set sail, We were not far from land, When our captain spied a mermaid fair, With comb and glass in hand."* (Photograph courtesy of Shelburne Museum)

Two Eagles. Carved by Wilhelm Schimmel, Pennsylvania 1880. (Photograph courtesy of Shelburne Museum)

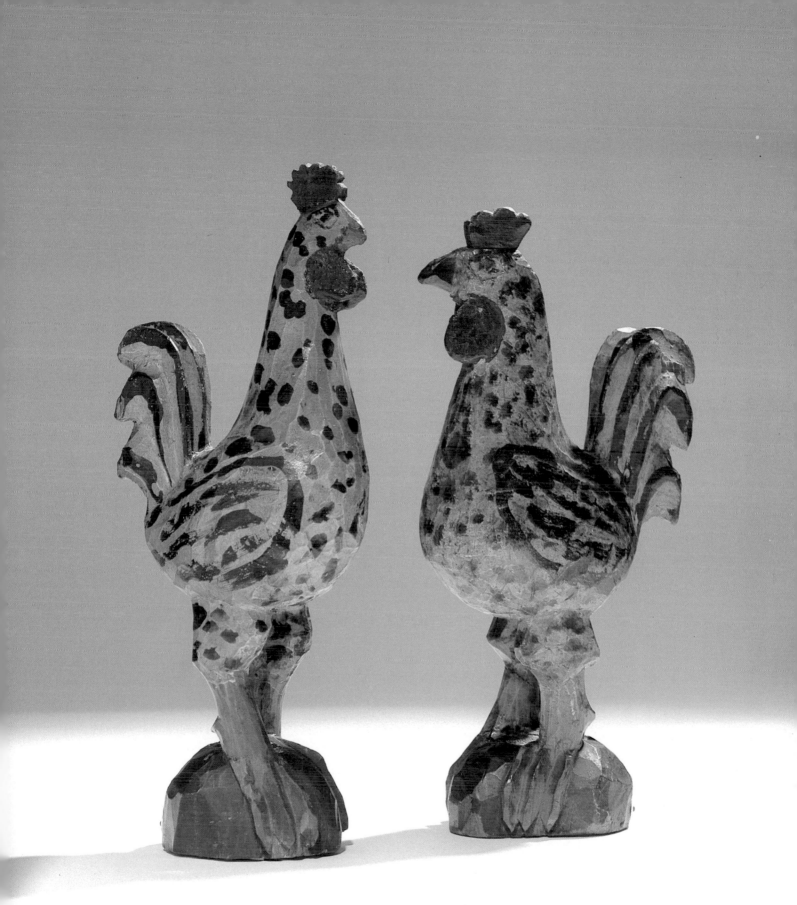

Two Roosters. Carved by Wilhelm Schimmel. Pennsylvania 1880.(Photograph courtesy of Shelburne Museum

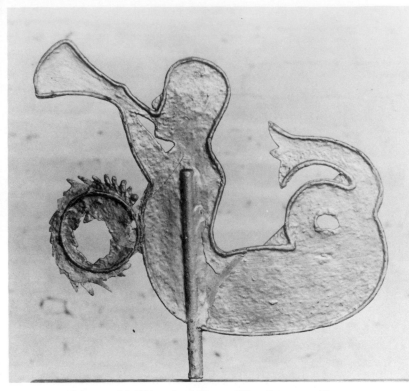

Triton with Wreathed Horn. Weathervane. From Newburyport, Massachusetts. (Shelburne Museum)

His arts were not called sculpture. They were carved and wrought by artisans: the carpenter, the joiner, the smith whose main business was houses, shops, wagon wheels, door latches, pots and pans. He used the material he could find, and the images with which he was familiar. With his adze, his jackknife, or hammer he made something which gave him a prideful pleasure. It was natural that vanes were good.

Placed high in the sky the pattern had to be simplified to be seen, all parts subservient to the whole.

Vanes often doubled as trade signs. The Ram vane was the sign of a wool merchant. The Circuit Rider, from Virginia, designated the home of an itinerant parson who would ride to preach a sermon or to comfort his neighbor.

Pennsylvania produced the carved pig. It is not known how he was used - perhaps, not at all. Perhaps he was simply a commentary on what the whittler thought of pigs.

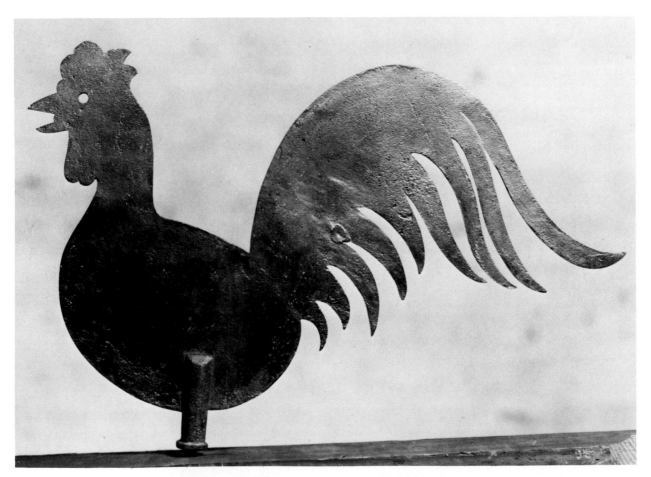

Weathercock. Brass. From Salem, Massachusetts.

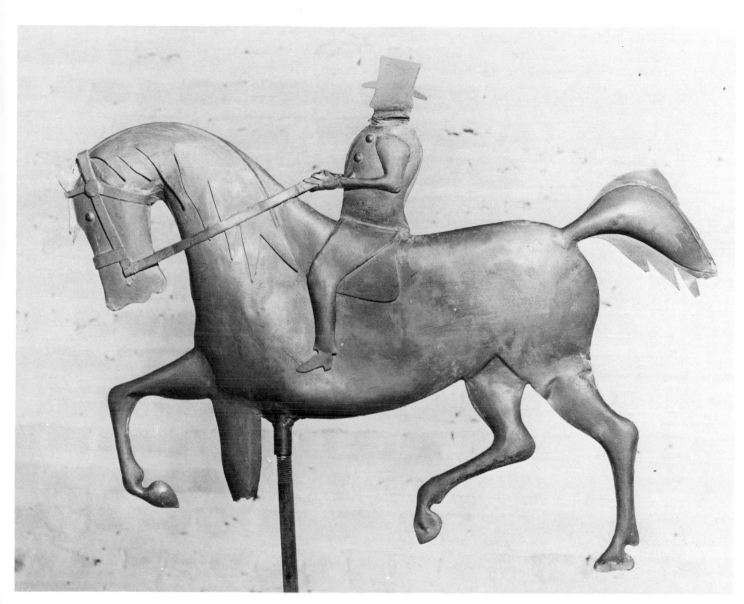

Circuit Rider Vane. Sign of an itinerant parson who would ride to preach a sermon or to comfort a friend.

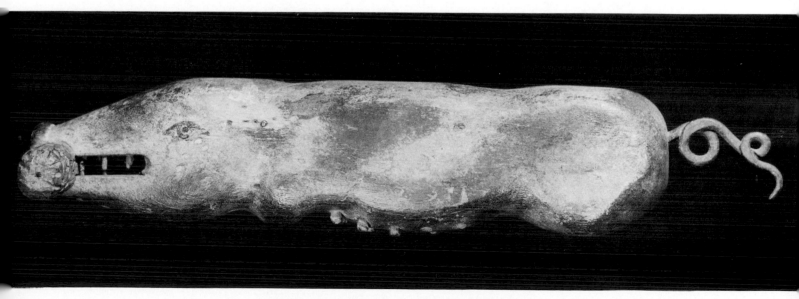

Pig. Butcher's Shop Sign. (Donald Blagden)

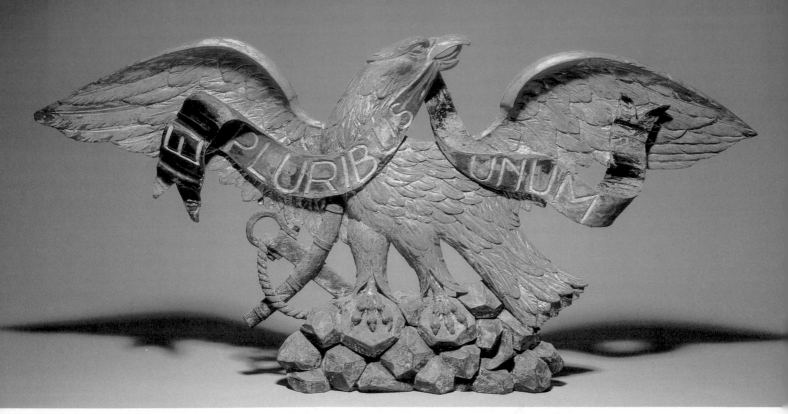

Sternboard Eagle Carving, Polychromed. Banner reads "E. Pluribus Unum". (Photograph courtesy of Shelburne Museum)

Heroic Eagle. Rests on "Beehive" Coil of Rope. Attributed provenance: The N.S. Marine Base. Portsmouth, New Hampshhire. c. 1850. (Photograph courtesy of Shelburne Museum)

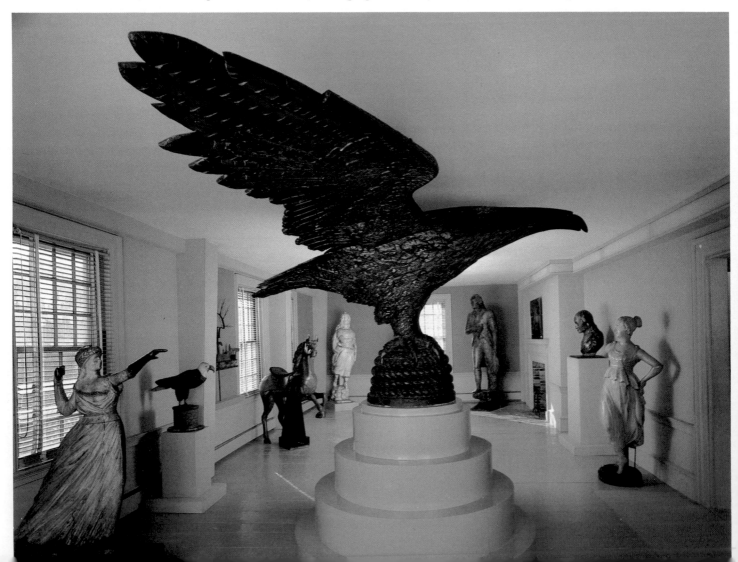

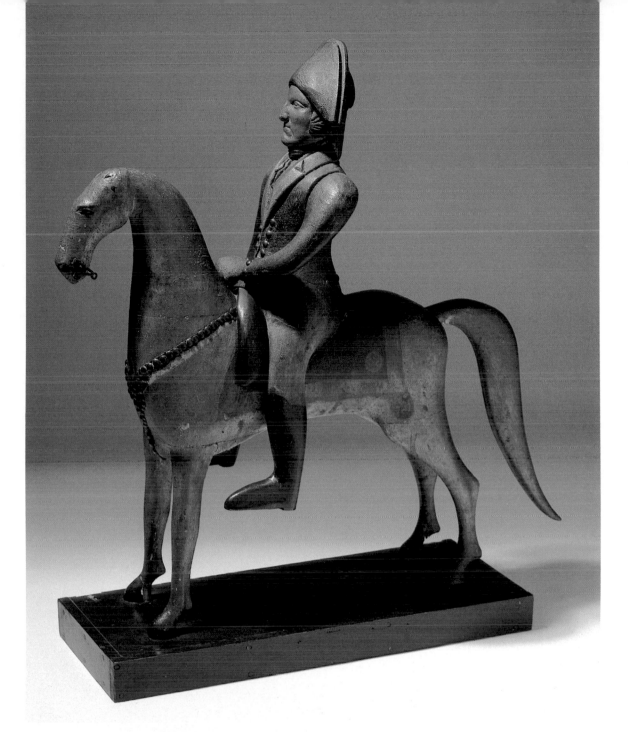

General Washington on Horseback. Wood carving. c. 1780. (Photograph courtesy Shelburne Museum)

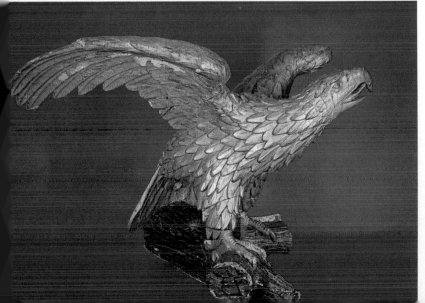

Eagle wood carving, polychromed. From the steamer "General McDonald", built in Baltimore, 1851. Ship conveyed passengers between Cape May, New Jersey and Phiadelphia. Carving exhibited at the Time and Life Center, 1962. (Photograph courtesy Shelburnc Museum)

The Sheaf of Wheat was the sign of a Baker. This wood, painted many times in its life, combines the symbol of Plenty with the other age-old concepts of the Fountain and the Column.

The Stone Bird is a wondrous piece in a category all by itself. Plowed up in 1854 in a field in the Hudson Valley of New York State, this bird was probably cut by a decoy maker who turned his hand to the local granite. Iron for the legs would have been procurable because iron furnaces were operating in the valley from the time of the Revolution. This unknown artist achieved a visual, tactile, and organic perfection which is rare in any art, in any time.

This collection presents a rich accumulation, good in terms of heritage, good in terms of art.

Unfortunately, we have lost track of the "Stone Bird" noted in the traveling exhibition. It was sold, not to a museum but to a private collector who has disappeared. Fortunately, we do have a photograph, and we hope that the present owner may see it and speak up.

Sheaf of Wheat. Sign of a Baker. (Alastair B. Martin)

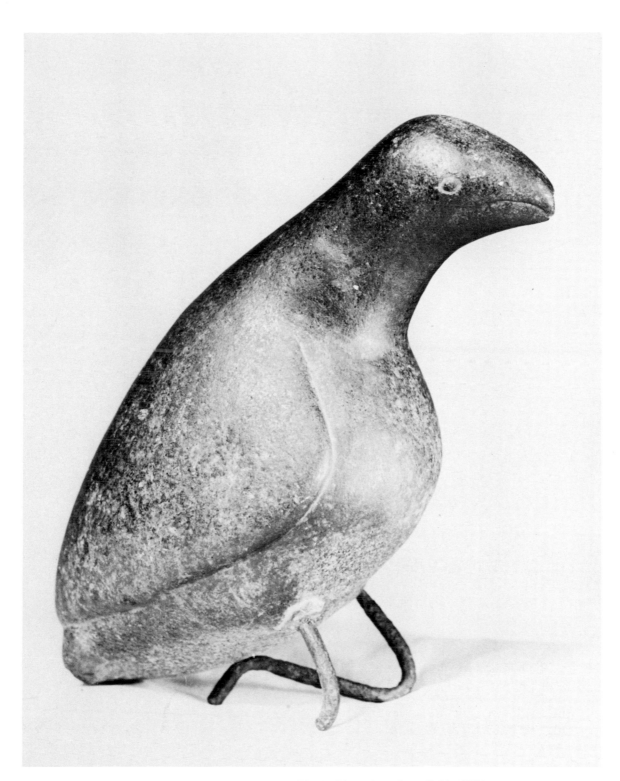

Stone Bird. Tappan, New York. Plowed up in a field. 1854.

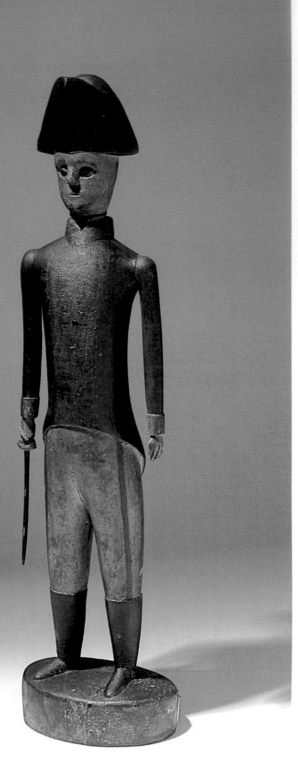

Revolutionary Soldier. c. 1780.(Photograph courtesy Shelburne Museum)

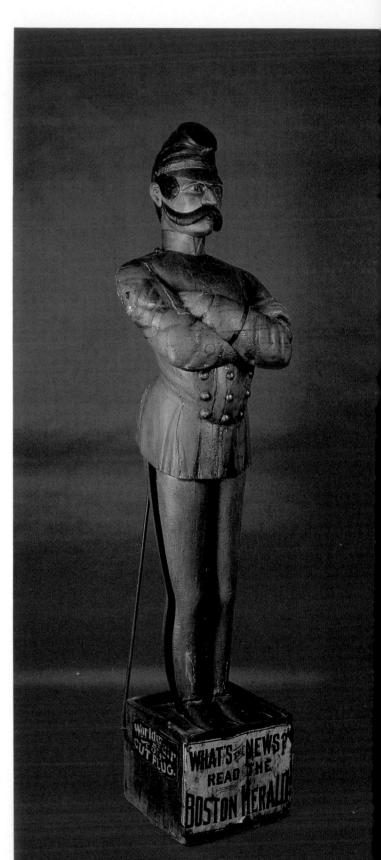

Captain Jinks. Trade Sign. c. 1888. (Photograph courtesy Shelburne Museum)

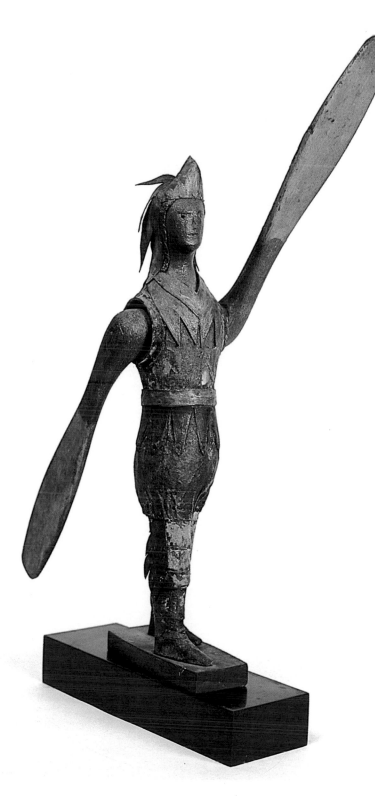

Carved Indian whirligig

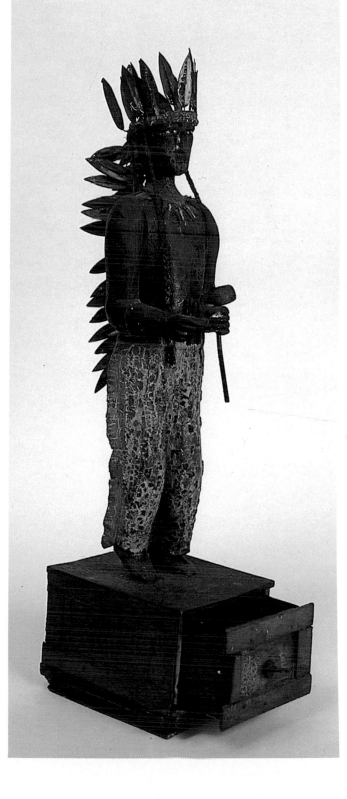

Carved Indian over box for tobacco

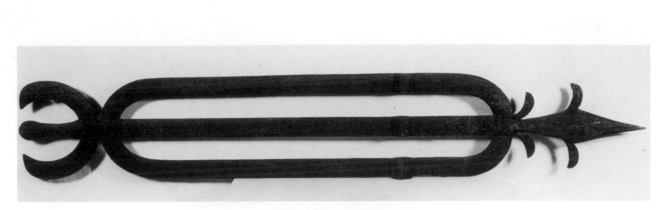

Arrow Vane. Vermont School House.

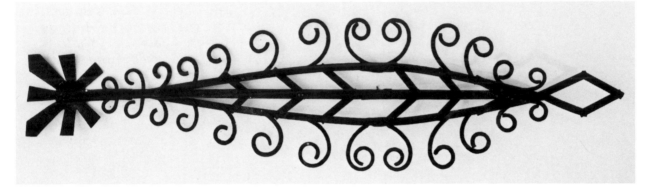

Arrow Vane. (David Rockefeller Collection. Photograph courtesy Chase Manhattan Bank)

Arrow and Sun Vane.

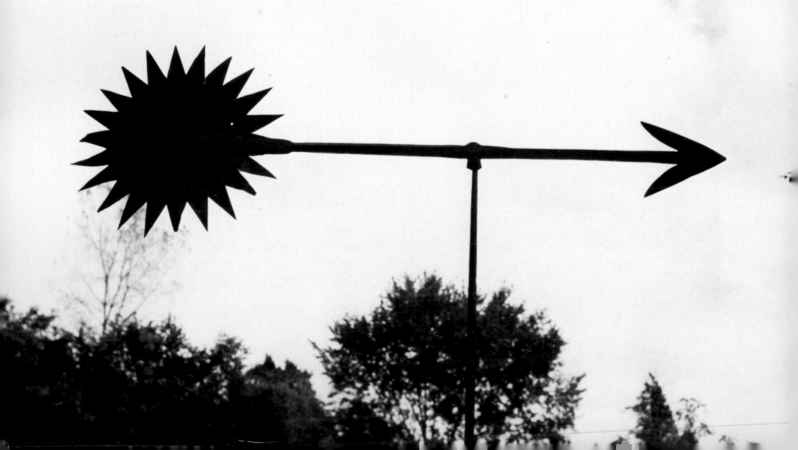

Chapter 9

Arrows and Indians

Over the next several years the Willard Gallery gave us an exhibition whenever we acquired sufficient material for a show. (In 1963 the Gallery moved to a new location on Madison Avenue and 72nd Street). At times we offered a broad survey of folk art in its many manifestations, media, and mixed media. Primarily we concentrated on the sculptural, three-dimensional material rather than the pictorial or the fabric arts. One season we focused on arrow vanes, on the varieties of material, design, and craftmanship. A vane points into the wind to indicate direction. The arrow as a marker, whether drawn in the mud with a stick or blazed on a tree, or mounted high in the sky, is one of man's ancient and universal signs. Another year we concentrated on Indian vanes.

In 1954, flushed by the success of our ventures, we changed our title from the *Stony Point Antique Shop* to the *Stony Point Folk Art Gallery.* Immediately a salvo was received from Edith Gregor Halpert, who threatened to sue us for use of the term "folk art gallery". Our lawyer assured us that the lady had no monopoly on the term, especially since her gallery was called the "Downtown Gallery" even after she moved uptown.

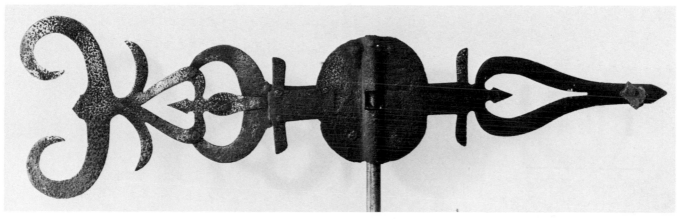

Arrow Vane. Pennsylvania.

Arrow Vane. Vermont Church.

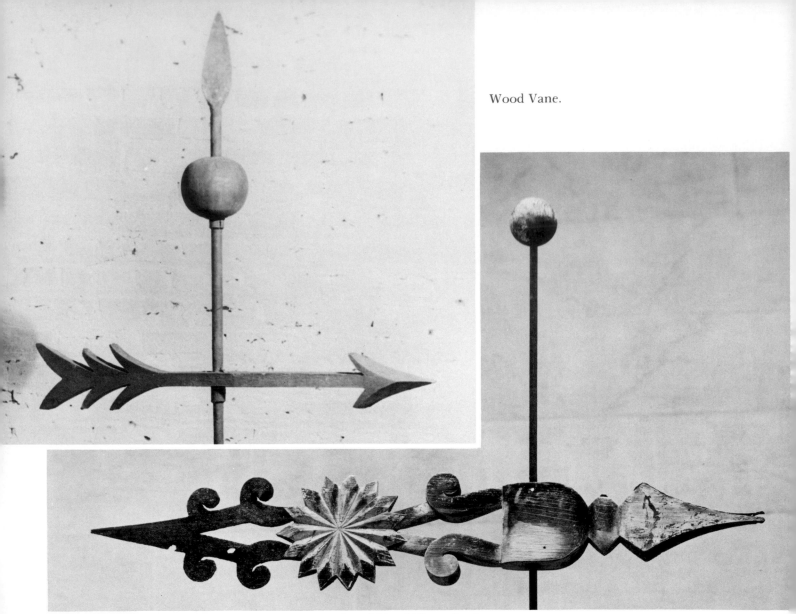

Wood Vane.

Wood and Metal Vane. Sunburst.

Musical Arrow. (Lincoln Kirstein)

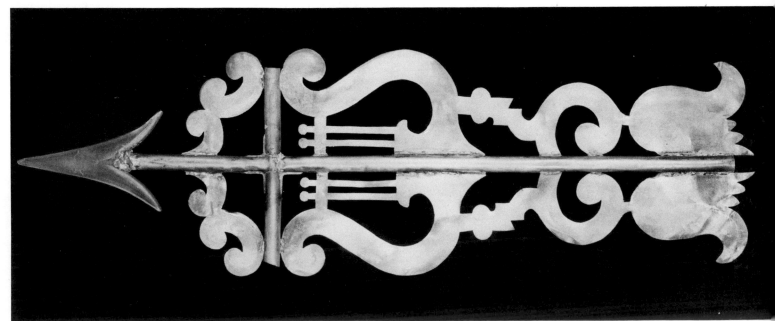

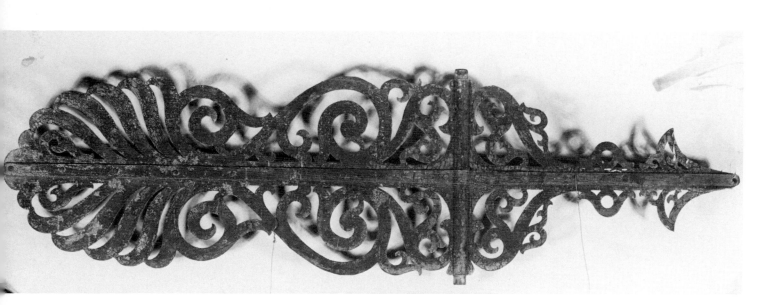

Arrow Vane. Pennsylvania.

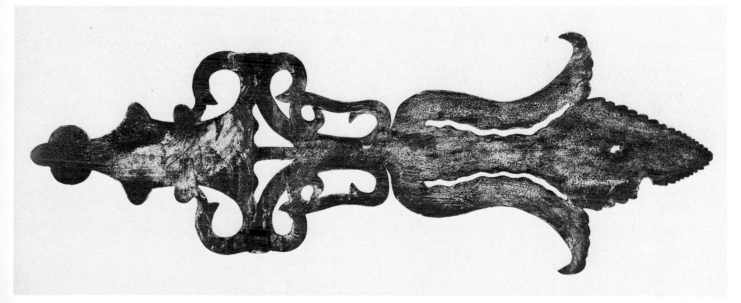

Tulip Vane. Iron. Pennsylvania. (J. Richardson Dilworth)

Early wood arrow vane. Ipswitch, Massachusetts.

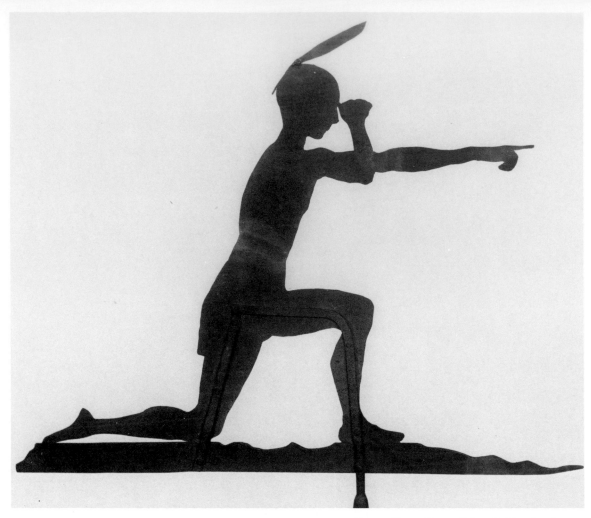

Weathervane of Massasoit. Chief of Massachusetts Indians. Sheet Iron. (Mrs. J. Zurcher)

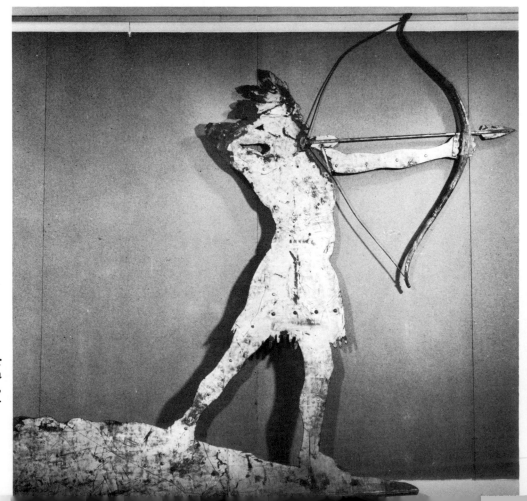

Algonquin Indian Vane. Copper and Iron. Gold-leafed. Used as a trade sign for a cotton mill, Salem, Massachusetts. (Columbus Gallery of Fine Arts, Ohio)

98

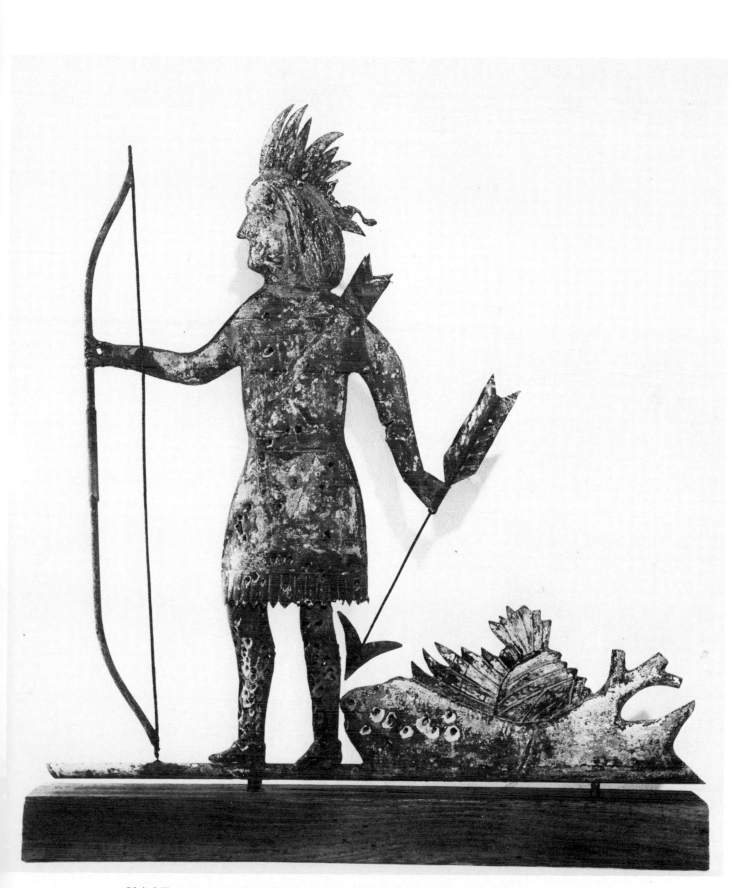

Chief Tammany. Indian Vane. Attributed to W. A. Snow & Co. (Mrs. Eugene Davidson)

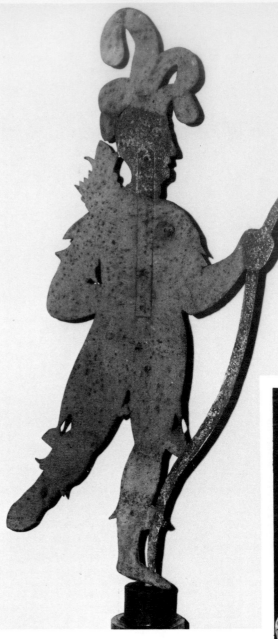

Weathervane of Indian in Ceremonial Regalia. Metal. (George Maas)

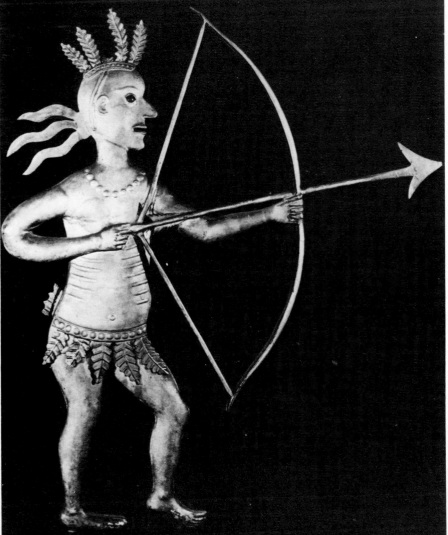

Indian weathervane

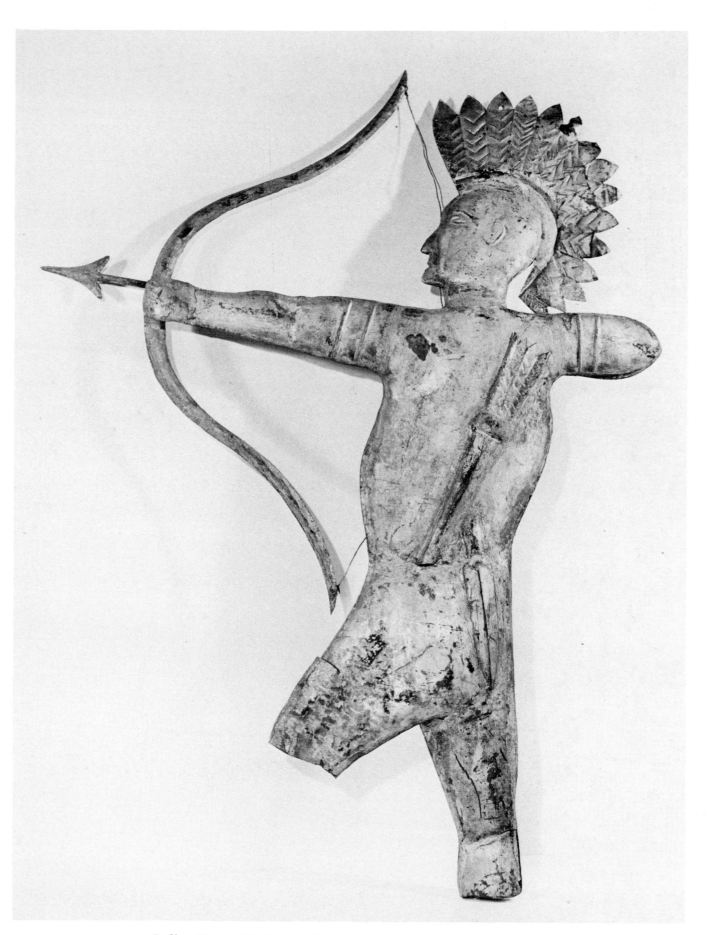

Indian Vane with Arrow. (American Museum. Bath, England)

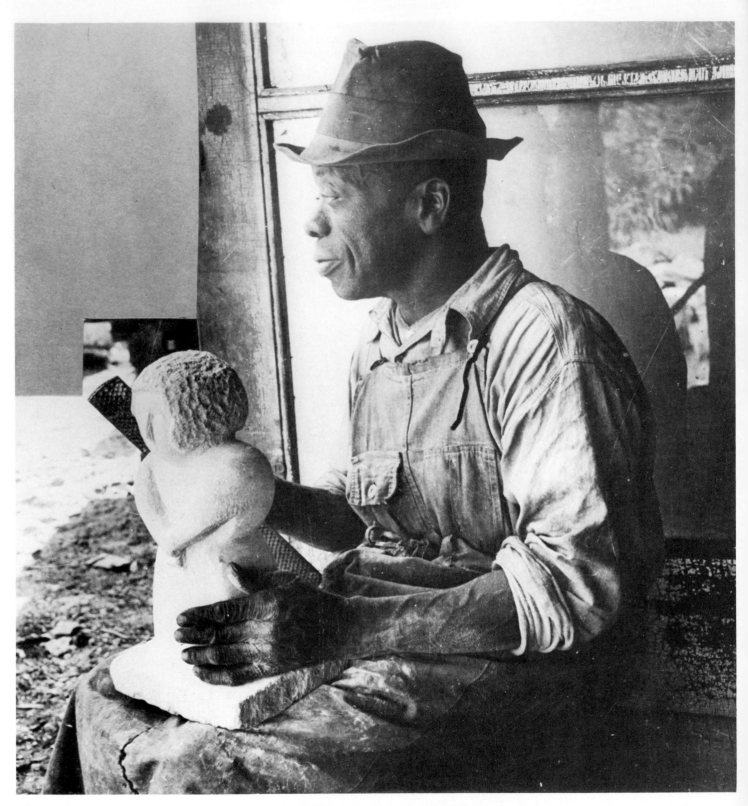

William Edmondson. Stone Carver. Nashville, Tennessee. 1883-1951. (Photograph courtesy Louise Dahl-Wolfe)

Folk Art Carvers

William Edmondson Clark Coe John Scholl

Our greatest pleasure at the Willard was the presentation of distinctive folk artists, previously unrecognized or forgotten. We rediscovered the work of Will Edmondson and Clark Coe. The carvings of John Scholl we introduced and exhibited for the first time in an art gallery.

Will Edmondson, the negro stone carver, was completely unknown to me until I visited the distinguished photographer, Louise Dahl-Wolfe, in Frenchtown, New Jersey. There, along the garden paths, I saw charming, primitive stone carvings of lions, lambs, birds, and little people. Louise said they were the work of a Will Edmondson, a negro who had lived in Nashville, Tennessee. She had photographed him and his work in 1937 for *Harper's Bazaar,* but the editor, William Randolph Hearst, refused to print photographs of a black man. Shocked but undismayed, Louise took the pictures a step higher to the Museum of Modern Art in New York City. There, Alfred H. Barr Jr., the director, was enthusiastic about the carvings. In the fall of the same year, curator Dorothy Miller (Mrs. Holger Cahill) installed an exhibition of twelve stone carvings by Edmondson.

In 1938 one of Will's carvings was shown at the *Jeu de Paume*, Paris, in an exhibit of "Three Centuries of Art in the United States". Edmondson's work was also displayed at the Nashville Art Gallery in 1941 and at the Nashville Artists' Guild in 1951. Edmondson died in 1951 and was forgotten.

Louise was enthusiastic about revitalizing Edmondson by an exhibition of his carvings in a New York City art gallery. She agreed to sell a few of her own pieces, and she introduced me to other collectors who might sell or lend enough material for a show. We visited Elizabeth L. Starr of Nashville, who had the largest collection known. Alexander Brook, the painter, owned a few. The Tennessee Fine Arts Center at Cheekwood had carvings in the basement. There we saw one of Edmondson's most monumental works, *Eve,* fig leaf and all. Had modesty kept her in the basement? In one of her hands she clutches something. Is it an apple or a breast? An advertisement placed in the Nashville newspaper produced one carved bird which we learned later had been stolen from the negro cemetery. In New York City, to our surprise, we located a carving of Eleanor Roosevelt. It was not one of Edmondson's best pieces.

Will could not deal with reality as significantly as he dealt with his "visions", derived mostly from the Bible, the only book he knew. His most poignant carvings featured religious figures: Martha and Mary, whom he called "uplifted ladies", preachers, teachers, animals, critters, and birds associated with the Bible. Edmondson was a true primitive, completely self taught. His materials consisted of limestone paving blocks dumped in his yard. He is quoted as saying, "This here stone and all those out there in the yard come from God. It's the work of Jesus speaking His mind in my mind. I must be one of His disciples. These here is miracles I can do."

Many Edmondson images are rough, barely differentiated; others are completely expressed vital statements in small but monumental sculpture.

Our exhibit at the Willard Gallery in January 1964 revitalized interest in the man's work in New York City, in museums, and in Nashville, his hometown. The Tennessee Fine Arts Center at Cheekwood, re-alerted about the significance of their native son, installed a special display in April and May that same year. Recently in June of 1981, the new Tennessee State Museum in Nashville honored Edmondson with a feature exhibition.

The Abby Aldrich Rockefeller Collection at Williamsburg includes a carved crucifix by Edmondson. Fenimore House in Cooperstown has a group of birds by Edmondson. The Hirscharn Museum in Washington owns an Edmondson.

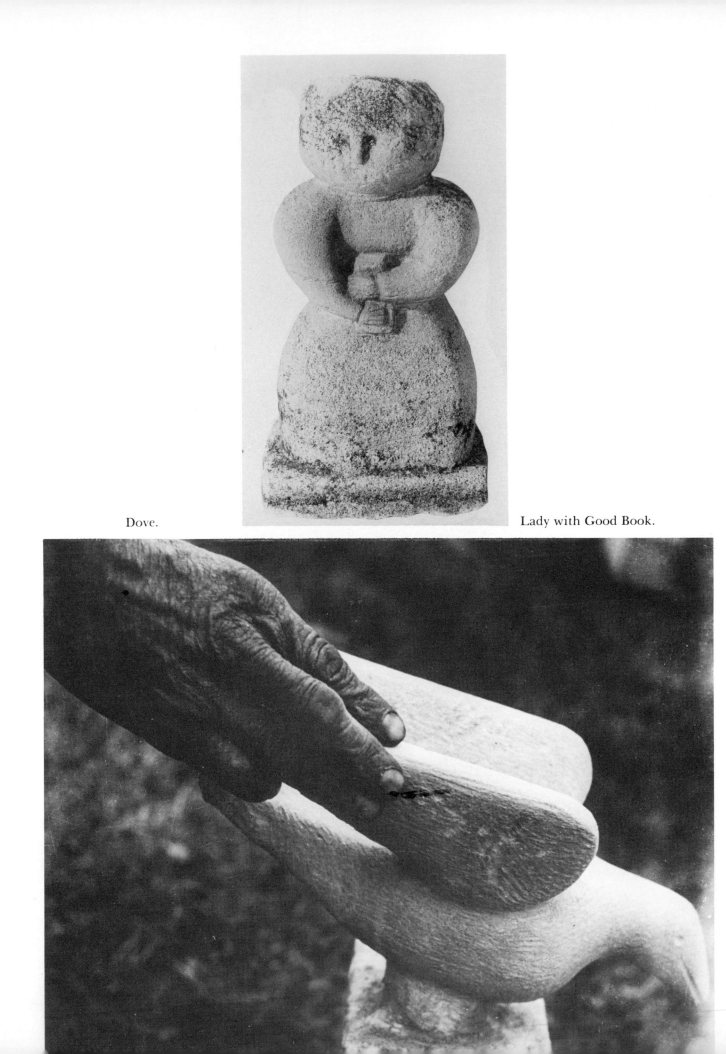

Dove. Lady with Good Book.

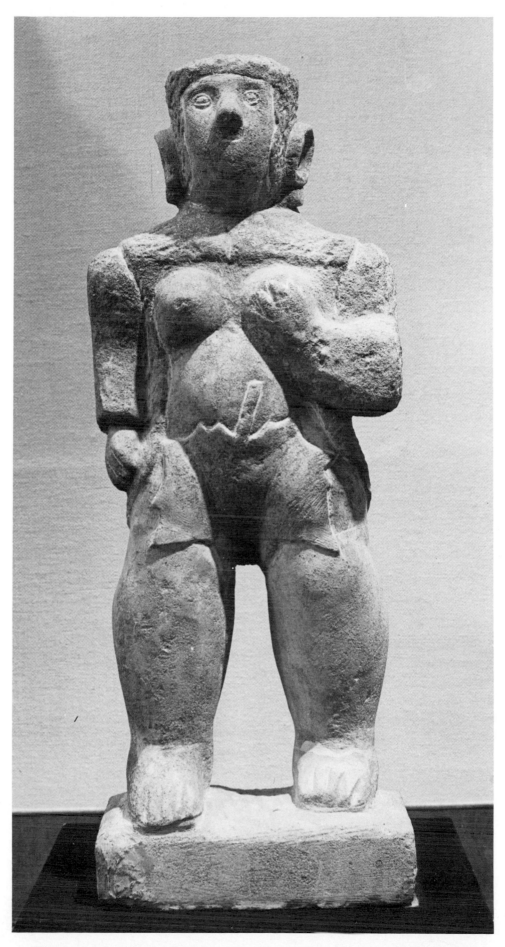

Eve by Edmondson. (Tennessee Fine Arts Center. Cheekwood, Nashville)

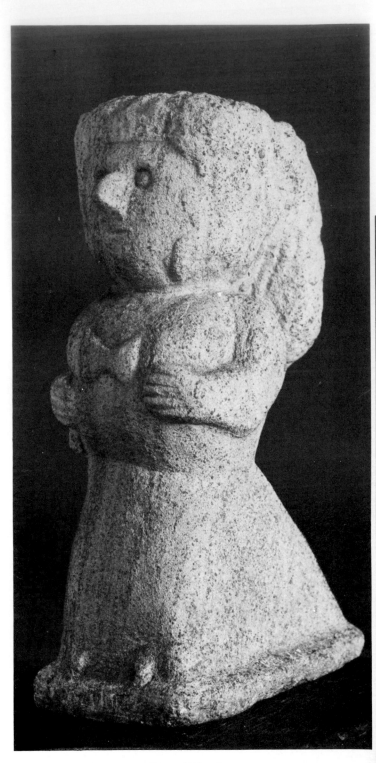

School Teacher

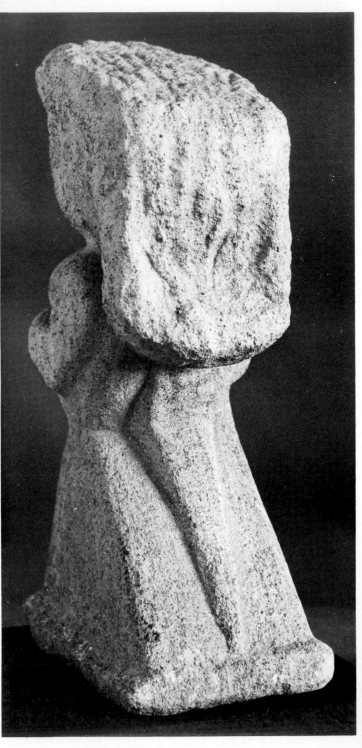

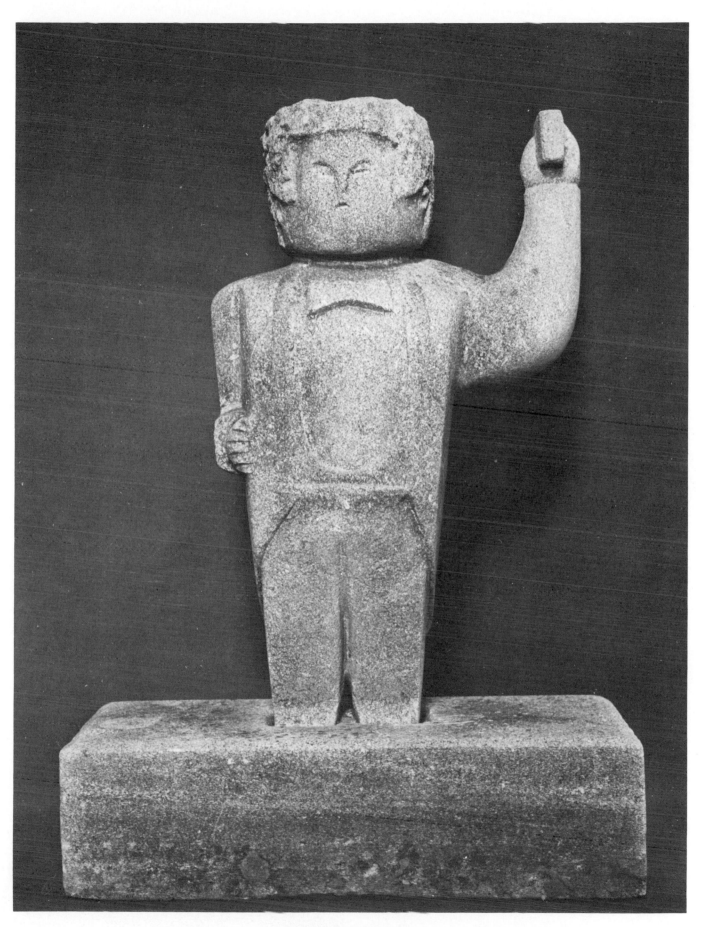

Preacher by Edmondson.

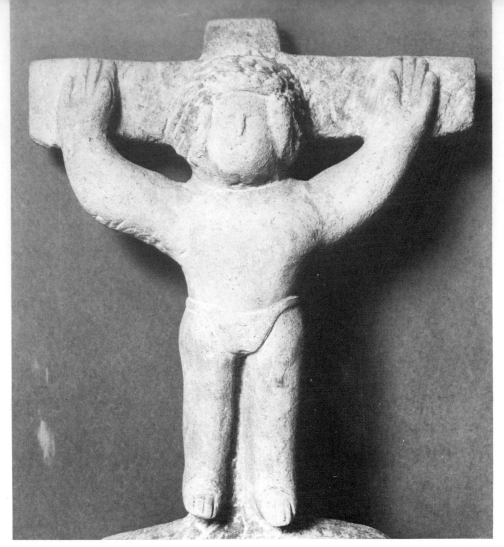

Crucifix (Abby Aldrich Rockefeller Folk Art Collection)

Three Doves. (New York State Historical Association, Cooperstown, New York)

As a companion piece to the show of Edmondson carvings at the Willard Gallery, we presented in the same exhibition in 1964 the work of another primitive, Clark Coe, creator of the "Killingworth Images". Both Edmondson and Coe were originals. But the two men were opposite in terms of motive, craft, and medium.

Coe, a farmer, lived in Killingworth, Connecticut toward the end of the 19th century. A basket and barrel maker by trade, he fashioned his life-sized images (mostly people) out of staves, slats, branches, stumps, bits and pieces. His images, his characters, were created by assembly, by the suggestive power of the union of parts. Edmondson, on the other hand, started with the unit, the limestone paving block, which he cut away to reveal the hidden image. A religious furvor activated Edmondson. Coe seems to have created his images only for private pleasure.

Some forty figures, we have been told, were mounted, originally on a barge on a mill stream running through Coe's farmland. Some figures, jointed with moveable parts, articulated as the water wheel turned. At night when the neighbors drove by in their carriages they could hear the ghostly clicking of the jointed parts. Only five complete Killingsworth images are known to have survived: *Musician with Lute, Boy Riding Hog, Old Jo, One-Eyed Jack,* and *Head of Clown.*

Each man, Edmondson and Coe, translated his inner vision into objective, three-dimensional forms with whatever material and whatever craftsmanship was handy. Both are true folk artists.

Rural Scenes of the Killingworth Images by Clark Coe, Connecticut. c. 1900.

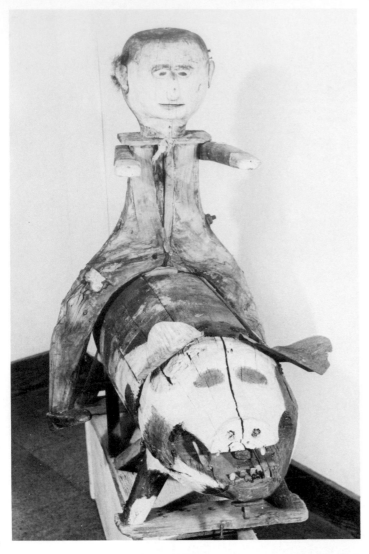

Boy Riding Hog by Clark Coe. (Herbert W. Hemphill Jr.)

Rural Scenes of the Killingworth Images by Clark Coe, Connecticut. c. 1900.

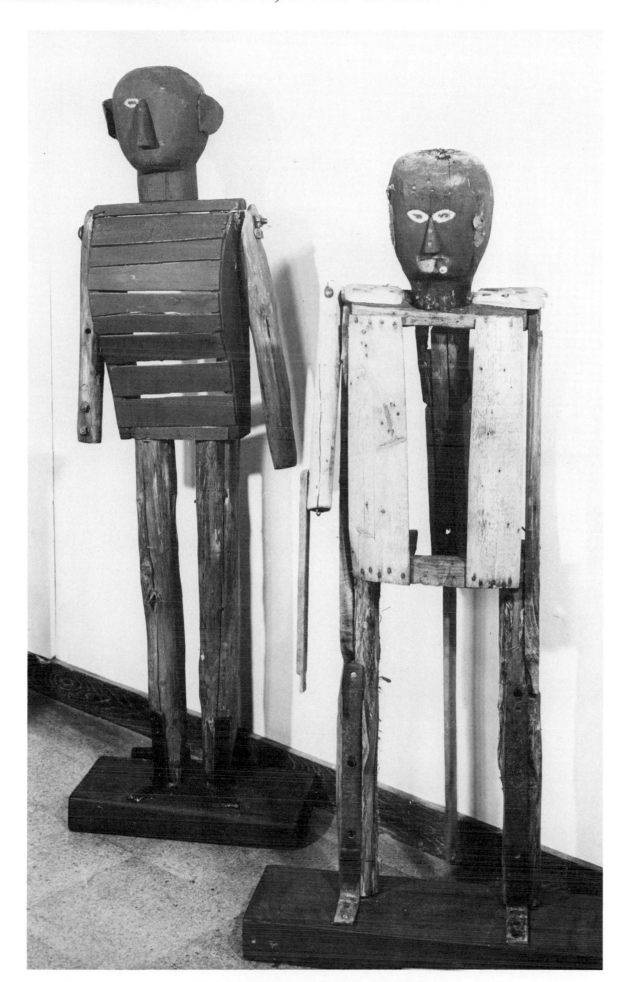

One-Eyed Jack and Old Jo by Clark Coe.

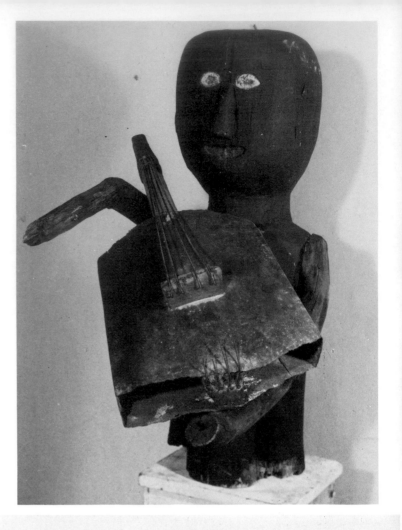

Banjo Player by Clark Coe. (Collection Gordon Bunshaft)

Child's stool in the form of a rabbit. (Alistair Martin)

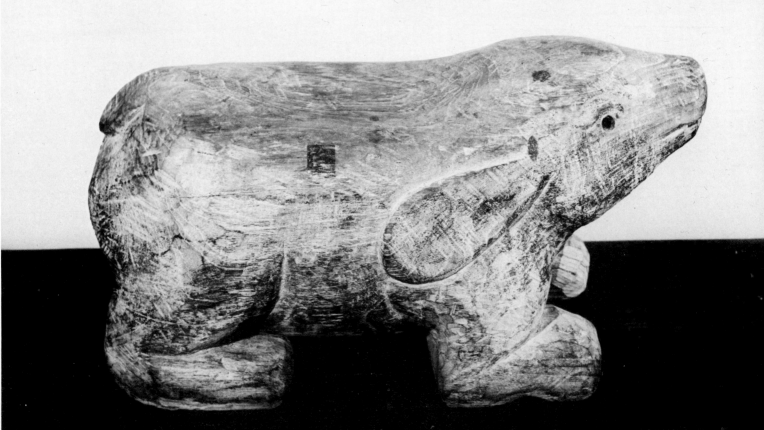

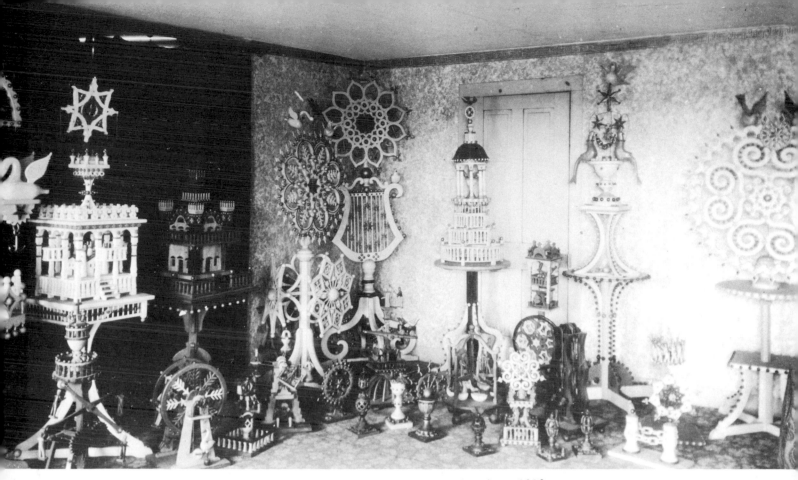

John Scholl's Parlor. Germania, Pennsylvania. c. 1910.

The most extraordinary and prolific "original" we discovered was John Scholl, a Pennsylvania German. Scholl was entirely different from Edmondson and Coe. He was a skilled craftsman, a carpenter. He built houses. He knew tools, structures, design, symmetry, and tradition. Scholl's special genius lay in his unique use and translation of familiar designs into an entirely new decorative expression which incorporated traditional Germanic symbols.

According to one granddaughter, Alma Knecht, Scholl called his work, "Celebrations". Recently more mundane appellations have been used: "wood assemblages", "toys" (to be looked at, not played with), "whittlers' puzzles", and "delights".

The following quotation is from the catalogue of our exhibit of John Scholl's "Celebrations" at the *Willard Gallery*, November 28 - December 30, 1967:

John Scholl was a carpenter by trade. He was born in Wurtenburg, Germany in 1827 but came to America in 1853 settling in the forest region of Germania, Pennsylvania. Here he cleared his own land, built his own house and many others, including the village church, the general store, and the local brewery. This was a time of community living and music was hymnal, literature was the

Photograph of John Scholl.

113

John Scholl's fascinating carvings

Bible and art was household objects and decoration. Yet, within this life were many occasions to celebrate and it was to these celebrations John Scholl turned his attention when he retired at the age of eighty and began his wood carvings.

In his carvings, all done with a jackknife and bandsaw, John Scholl celebrated Christmas, starlight, snowfall, spring with flowers and birds, weddings, circuses and above all - peace on earth. He is remembered as saying, "When a man works steadily and faithfully for sixty years, idleness is an unwanted stranger".

It is difficult to describe John Scholl's work; it is not like anything one has seen although the ingredients are recognizable. The motifs derive mainly from his cultural point of view. He was a Pennsylvania German and he used their traditional symbols: the dove, the bird of paradise, the peacock, the tulip, anchor, crested swan, and the starcrossed circle. The era in which he lived was Victorian. He surrounded his imagery with a framework of delicate tracery and fretwork similar to that on the porches of houses he built, but it was a highly individual concept. "The Wedding", is celebrated by a tier of columns, capped by a blue and white star burst and flanked by a pair of turtledoves, one of which wears a red heart pierced and padlocked.

John Scholl did not sell or even give away any of his works. He simply carved for the pleasure of carving. This exhibition includes the entire known collection, some forty pieces, none of which has ever been shown. All were kept together for years, by Scholl's children and grandchildren.

Fortuitous circumstances allowed us to locate, rescue, and exhibit the major portion of this man's work.

After Scholl died in 1916 his carvings remained in his parlor, as a parlor-museum, until 1930, at which time a member of the family carted them away and stored them in a barn. According to some reports, the carvings were hidden as well as stored and forgotten. Then one day, one member of the family remembered and sold the lot privately to a Philadelphia decorator-antique dealer who transported all to another barn in Buck's County.

We heard about the cache at a Rockland County flea market and drove to Pennsylvania the next day. Before we found the right barn, it was dark. I shall never forget the sight as those double barn doors opened. A phantasmagoria was revealed. Piled high, crowded together were

Fountain with Peacocks by John Scholl. (William Penn Memorial Museum, Harrisburg, Pennsylvania. Gift of Adele Earnest in memory of Mr. and Mrs. William H. Earnest)

delicate colorful stands - some eight feet tall - openwork fantasies, wall plaques, toys. We bought all. The proprietor agreed to truck the collection to Stony Point. We would research the carvings later.

Today a John Scholl carving is featured in the following collections of American folk art: Whitney Museum, New York City; William Penn Memorial Art Museum, Harrisburg, Pennsylvania; Fenimore House, Cooperstown, New York; Museum of American Folk Art, New York City; among others.

Many special and pleasant surprises resulted from our Scholl exhibition at the Willard Gallery. The press was fascinated. Newspapers, reporters, and magazine editors rushed to pick up the story. At last folk art was news! *The New York Times* ran a feature article by Sanka Knox on the front page of the second news section. A rare happening. The Paris edition of the *Herald Tribune* printed a review in its international coverage. (We had a letter of inquiry from Australia!). The Overseas Press of the United States Army phoned from Brussels for a story. In New York City, Jean Lipman ran a feature article on "Art in America". The magazine, *Woman's Day*, asked for photos and permission to print "do-it yourself" patterns.

What was the special appeal in the work of this man who had lived and died fifty years ago in the backwoods of Pennsylvania? Was he another carpenter who made beautiful constructions out of the ingredients of his life: stars, celestial circles, crosses, birds and porches?

Two toys by John Scholl.

Two groups of carvings by John Scholl

Two imaginative carvings by John Scholl

Wedding by John Scholl. (Nancy Lassalle)

Mary's Star by John Scholl. (Whitney Museum of American Art. Gift of Jean and Howard Lipman)

Song of Victory by John Scholl. (New York State Historical Association, Cooperstown)

Civil War soldiers parade at the top of a carving by John Scholl

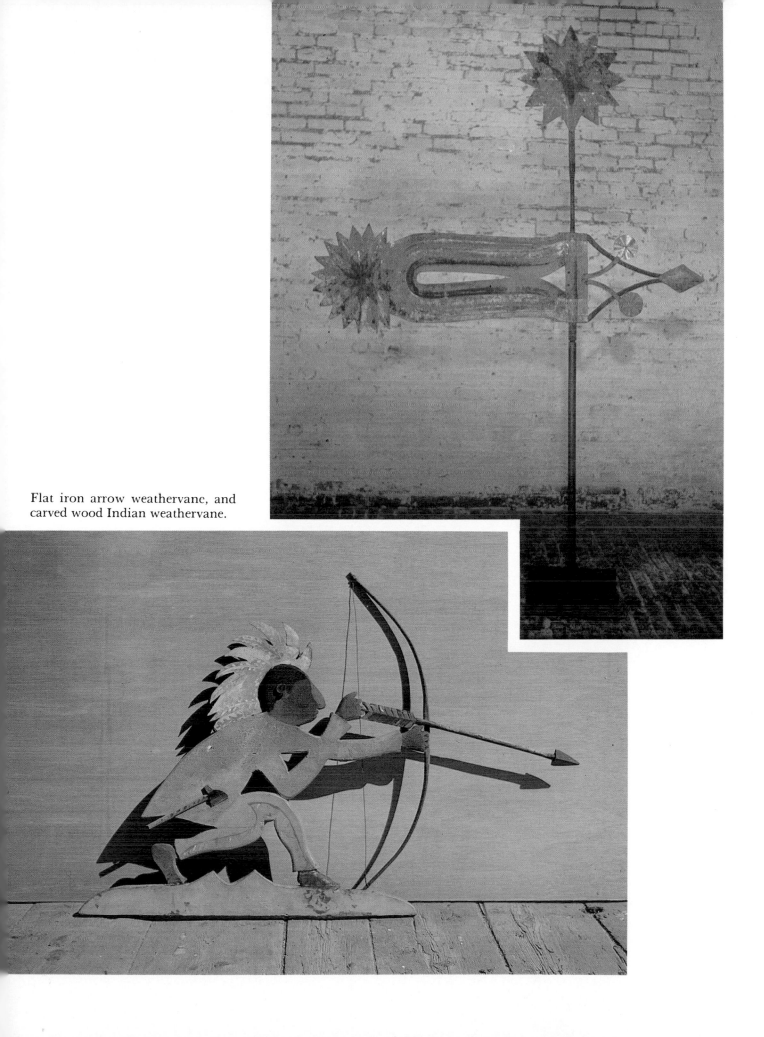

Flat iron arrow weathervane, and carved wood Indian weathervane.

Sunburst Celebration by John Scholl. (Museum of American Folk Art. Gift of Cordelia Hamilton)

Crested Swans by John Scholl. (Memorial Art Gallery of the University of Rochester, New York)

Chapter 11

The Wildfowl Decoy

During the years of reconnoitering for folk art, one particular category began to assume importance, a category not usually associated with folk art, the wildfowl decoy.

Our initial Willard Gallery exhibition in 1953 had included a rare and beautiful pair of heron decoys. And in 1954, in Columbia, Pennsylvania, we had found three extraordinary Canada Geese decoys, which have been a cynosure for collectors ever since. These discoveries did suggest that out there, somewhere along our rivers and coastal waters, in old hunting lodges, sheds, and attics, a world of other fine old bird carvings must exist. Little did I realize that those first findings of the heron and the Canada geese would rarely be excelled. But the fortunate discovery of such fine birds in the very beginning did activate my subsequent devotion to the decoy as an art, as well as a hunting device.

In 1959 the Stony Point Folk Art Gallery presented an exhibition of wildfowl decoys at the Willard Gallery. This was the first time the decoy had been presented as folk art in a major New York City art gallery.

Access to the most renowned collector of the day, William J. Mackey Jr., helped to make that exhibition possible. Before I walked into Bill's home in Belford, New Jersey I had no realization of the diversity, the galaxy of carvings and carvers. By the time I visited Bill he had accumulated over two thousand decoys, which he crammed into baskets or piled high on wall racks in his basement. Upstairs, the birds being prepared for shipment to perspective buyers were spaced provocatively on long tables. He knew each and every bird - its provenance, approximate age, and carver (actual or attributed). And he loved the possession of every one.

Bill's passion for the hunt became an obsession. He was not pleased when another collector crossed his path, entered his territory, discovered and bought from his sources of supply. Bill's incidental business as a salesman for Minwax Corporation took him traveling up and down those eastern

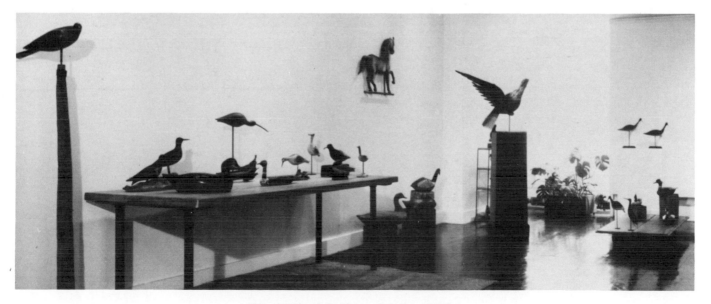

The Willard Gallery. October 1959.

Schoenheider Geese in front of Waterfall, Stony Point, New York.

Ruddy Duck by Lea Dudley.

Canvasback Duck by Lem and Steve Ward.

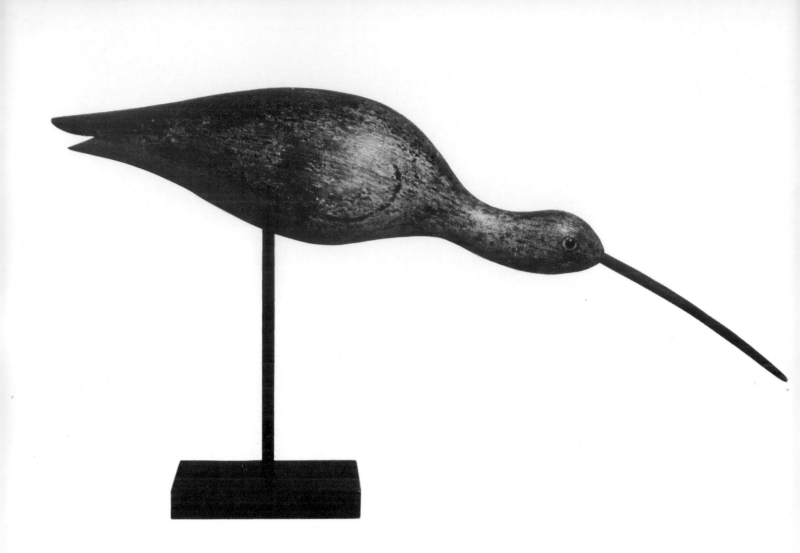

Curlew. Cape Cod, Massachusetts.

shores where the migrating birds and the hunters and the carvers also traveled. Also, Bill's prowess as a sportsman gave him access to the private hunting clubs.

Bill and I got along fine. I didn't look like competition. When I visited, I was all eyes and ears and I brought my own sandwich. His long-suffering wife had moved elsewhere. Competition with birds had been too much. I never questioned Bill's asking price for a decoy I wanted to buy. My point of view was different. Bill liked a good "shooting" decoy. The birds interested me as an art, as a unique, useful, all-American folk art. Bill asked sixty dollars for most any duck by Lem and Steve Ward. (He didn't think much of the Ward brothers). A "Verity" shore bird (attributed at the time to "Birdsall") was usually purchasable for eighty dollars.

The more I discovered new areas of folk art, the more I became convinced that an object of convenience like the decoy, a weathervane, or a quilt could also be a work of art.

In 1965 both Bill and I brought out a decoy

book which emphasized our individual points of view. My book, *The Art of the Decoy,* came out first. Bill was stunned. He read my book and realized the advantage of recognizing the decoy as an art as well as a hunting device. Quickly he added to his book a last chapter on "Folk Art" although the book was already at the printers. I told Bill, "Imitation is the sincerest form of flattery."

William J. Mackey, Jr., died of a heart attack in 1972. After his death I catalogued the major part of his collection for the "estate". I pleaded with the executors to offer a selection of prime carvings to a museum. It was to no avail. The greatest decoy collection of all time was auctioned, dispersed in five separate sessions at the Bourne Auction House in Hyannis, Massachusetts in 1973 and 1974.

The prices at those auctions seemed high at the time but modest compared with contemporary bidding for the best examples of this unique American folk art.

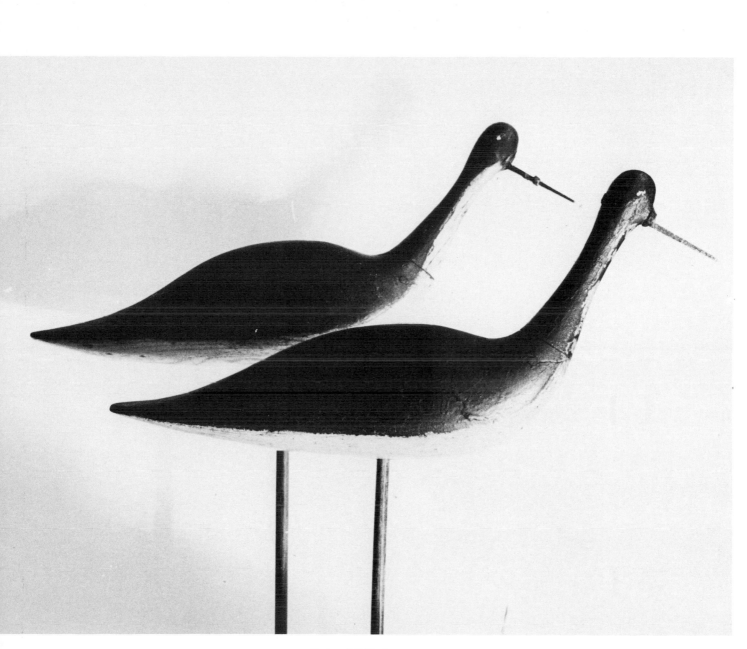

Pair of Stilt Decoys.

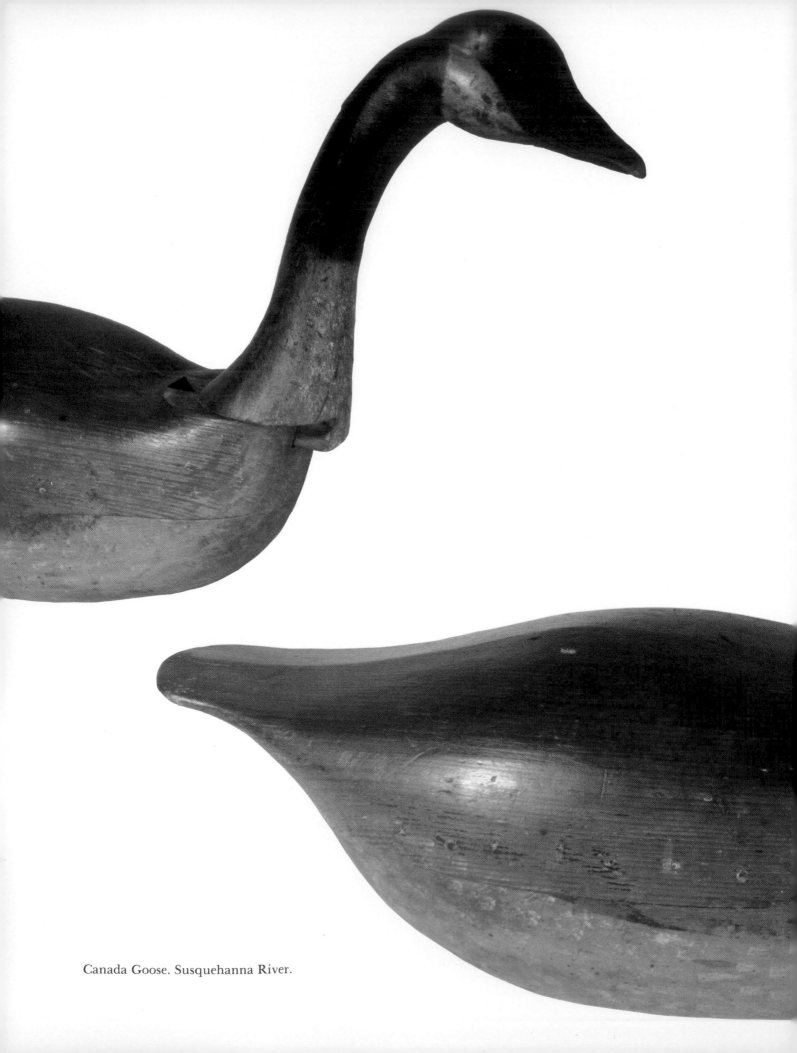

Canada Goose. Susquehanna River.

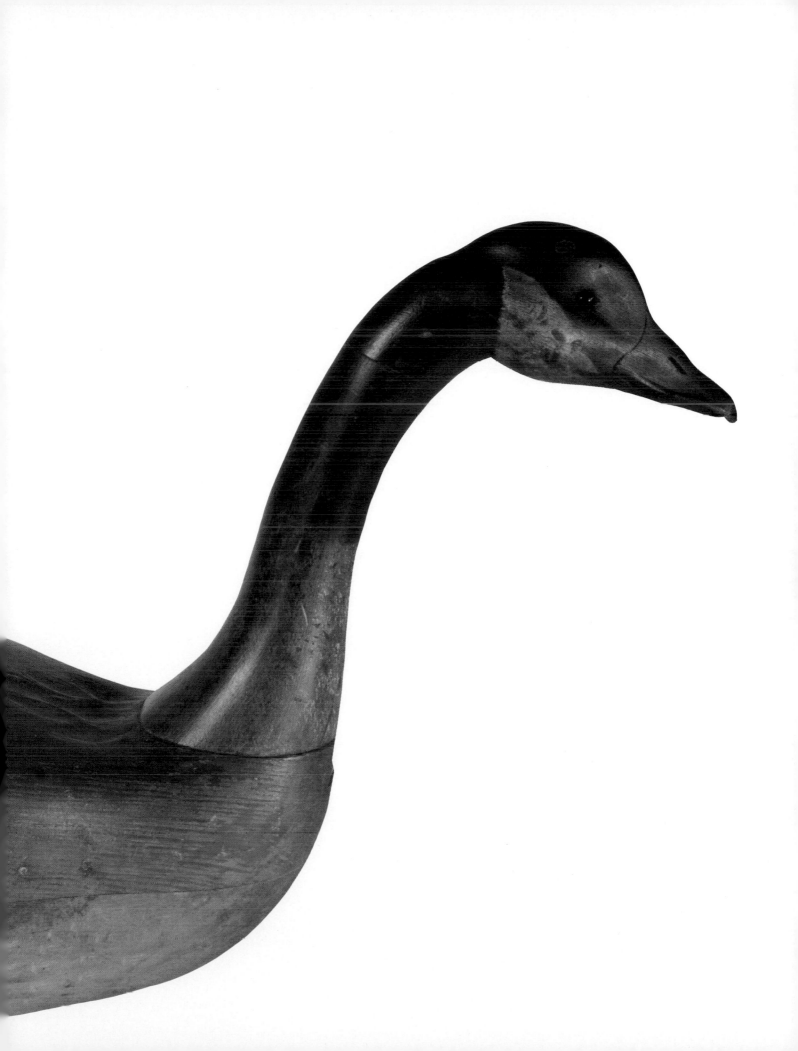

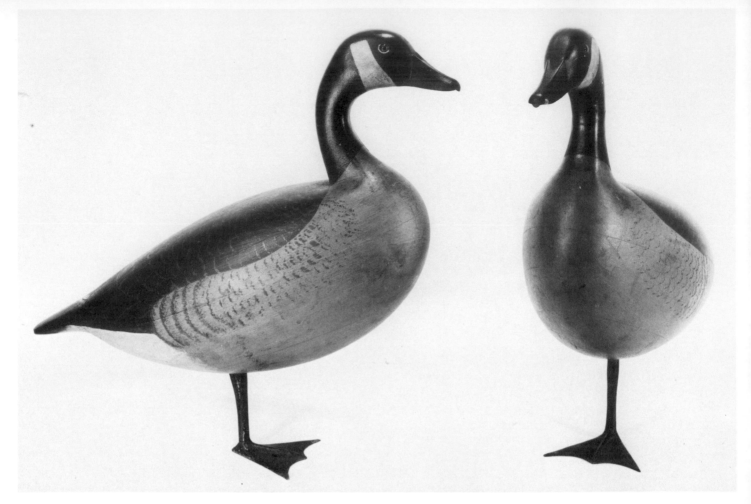

Pair of Canada Geese by Charles Schoenheider.

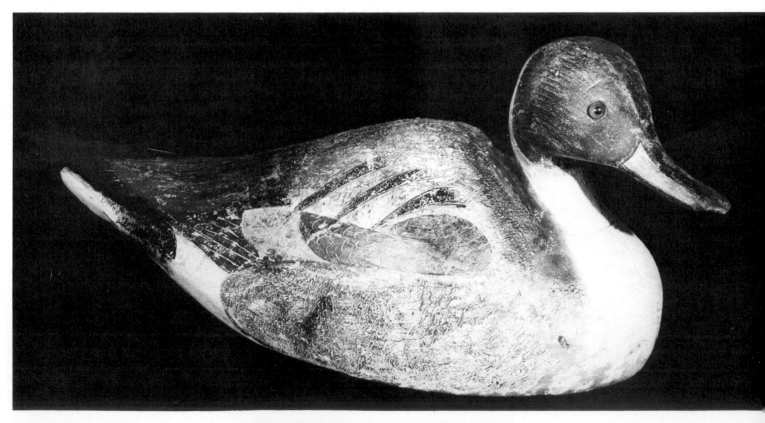

Pintail Duck Decoy by Lem and Steve Ward.

Chapter 12

Fabulous Collections, Auctions and Dealers (1950's & 1960's)

During the years of the fifties and the sixties, Cordelia and I attended many important auctions to keep in touch with collectors, see great pieces of folk art, and buy, if possible.

Mr. Titus C. Geesey, of Wilmington, Delaware, became a friend. Although he preferred farmhouse sales near York, Pennsylvania and at Pennypacker's Auction House in Reading, occasionally he turned up at metropolitan auction centers. No one showed more excitement over a good buy than Titus - even when he was not the buyer. A generous man, he shared his enthusiasms, his knowledge, and his antiques. I am fortunate to have known him. Today, in my home, I cherish several pieces of country furniture from his home: an eighteenth century trestle table, a plank-botton Windsor chair, and a blue Chippendale corner cupboard.

Today the major part of Mr. Geesey's superb Pennsylvania collection is housed in the Philadelphia Museum of Art where it was featured in their 1983 exhibition, *"The Pennsylvania Germans: A Celebration of Their Arts".*

In April of 1954 I attended an auction of antiques from the home of Stanley S. Wohl. The purpose of the sale, at Parke Bernet Galleries in New York City, was to create funds for the restoration of historic Brice House acquired by Mr. Wohl in Annapolis, Maryland. The house, built in 1740, was the largest privately owned residence in colonial America at that time.

Although the Wohl auction advertised china (Gaudy Dutch and Spatterware), "Stiegel-type" glass, and fine furniture, I had been told of Mr. Wohl's fondness for Pennsylvania carvings, birds, and animals. At the sale I talked with Mr. Wohl and showed him a photograph of several Schimmel carvings we had purchased under unusual circumstances.

At a 34th Street Armory Antique Show in 1948 a lady had introduced herself by saying she heard we liked birds. She had a trunkful. She had bought the trunk blindly at a warehouse sale in Brooklyn. Were we interested? She lived way out on Long Island at the last subway stop. I went. The trunk contained four Wilhelm Schimmel roosters, one Schimmel lion, two fantail peacocks, plus an assortment of carvings with Pennsylvania characteristics.

Photographs of these carvings lured Mr. Wohl to Stony Point, and he purchased all, I regret to say. We never saw him again. He was a strange, fastidious gentleman who wore spats and kid gloves which he never removed. Where are the carvings today?

The Walter Himmelreich auction at Pennypacker's on May 30 and 31, 1958 brought all our Pennsylvania friends. Rarely had such fine, early Pennsylvania German antiques been offered at auction. A glance at the catalogue of the sale makes one swoon with envy. I was there, but I sat on my hands. I did not know enough to bid. Mr. Himmelreich's home in the Peter LeFevre Farm, built in 1797 at Strasburg, Lancaster County, had been famous for its collections.

Highlights of the sale included a rare Francis Portzline Birth Certificate of 1811, with its flamboyant flowers, tulip trees, fantastic birds, and a prim lady holding a wreath. The most famous offering was the scraffito Barber Basin by David Spinner, 1791. It read, "Ich weiss nit in der weldt-mein-Bart der ist gar din gestelt 1791". Translated this means, "I don't know why in the world my beard is standing so thin."

The sale prices of most items were unbelievably low by today's standards. Redware pottery plates, small in size but with slip decoration, sold for around twenty dollars each. A pair of handsome wrought iron hinges with tulip decoration by Henry Stole brought only $100; a decorated 18th century candle box, $160; a birth certificate by Heinrich Otto, dated 1768, $180; a Mahantongo chest of drawers embellished with angels, tulips, and distelfinks, $1400.00; a wrought iron rooster weathervane from the LeFevre Farm, $125.

In 1956 the Rudolph Haffenreffer Collection of

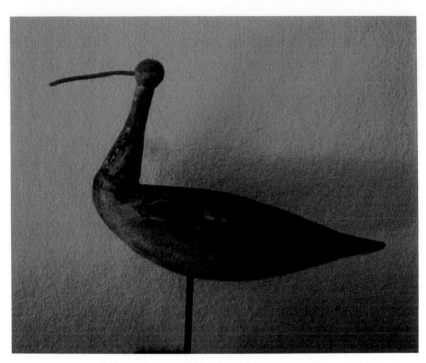

Roothead Snipe. Long Island. c. 1860.

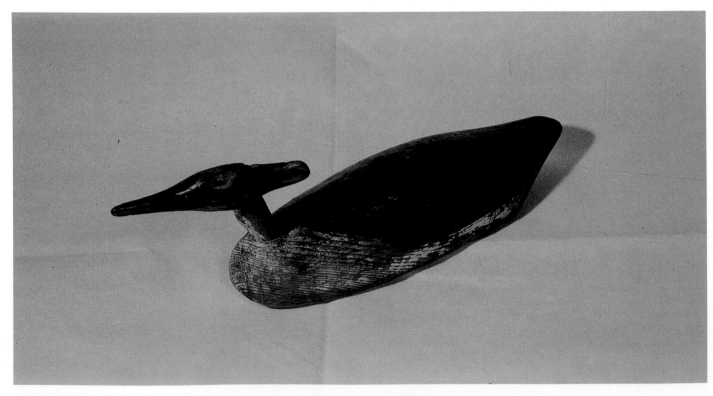

Roothead Merganser.

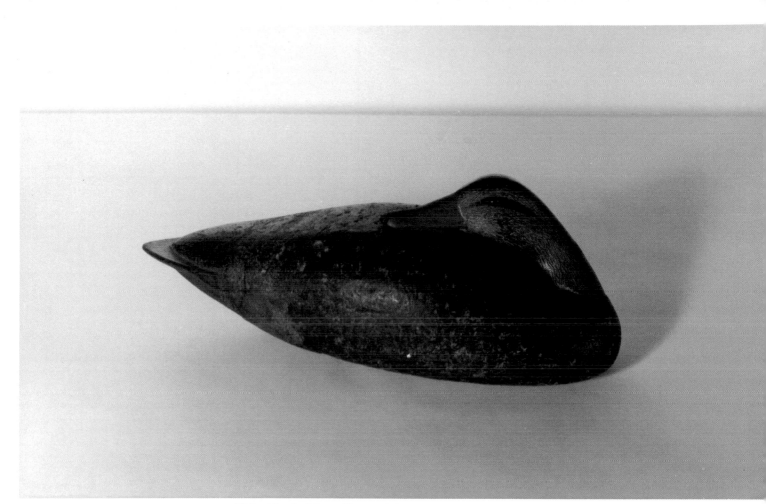

Eider Duck, Musselin Beak by Gus Wilson.

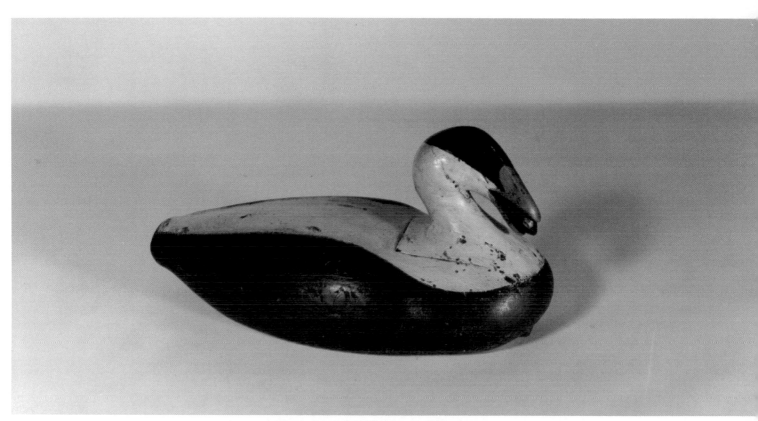

Sleeping Black Duck by Charles E. Wheeler.

164 cigar store indians was auctioned at Parke Bernet Galleries. (The largest single collection of cigar store trade signs that had ever come on the market). The "Princess of the Ottawas" carved by the renowned Julius Theodore Melchers brought $1300. A "Gentleman of Fashion", an impressive standing figure wearing a top hat and a Prince Albert cutaway sold for $1900. Jenny Lind, in a decollete blouse and a short skirt, fetched a mere $850.

In October 1958 came the Arthur J. Sussel sale at Parke Bernet Galleries in New York City. Mr. Sussel had been the major collector/dealer in Philadelphia for years. The sale included important Pennsylvania fraktur work: birth certificates, house blessings, book plates, family records, and illustrated psalms. Scraffito plates and slip decorated jars and jugs were featured. The prize was a George Hubner two-handled sugar jar decorated with birds and tulips.

June of that same year brought to the same auction house the collection of Lillian J. Ullman, who had been a highly respected and knowledgeable dealer in the New York antique world. Typical sale prices were so low by current standards, they are embarrassing to quote:

Two pierced tole lanterns — $30
Duck decoy of Elisha Burr — $30
Four Linsey-Woolsey coverlets — $40
Cross-stitch Alphabetical Sampler
1795, and a Pennsylvania fraktur
Birth Certificate, dated 1825 — $30

The sale most interesting at that time was the Helena Penrose Auction at Parke Bernet Galleries, Inc., in February 1960. For years Helena's shop on Second Avenue in New York had been a mecca for folk art enthusiasts. Her dark, unkempt basement housed cigar store Indians, trade signs, carousel tigers, horses, and lions, weathervanes, gateleg tables, decoys, memorabilia and paraphernalia crammed together for want of space.

Country "pickers" brought their goods to Helena by the truckload. She paid cash. She rarely descended to the lower regions of the shop herself, but presided upstairs in a little alcove in the company of an electric heater and a bottle of gin. She didn't appear in her alcove until eleven-thirty in the morning, Wednesdays and Saturdays. If a hopeful buyer succeeded in finding the premises open, and if he descended to the depths and dug out something he couldn't live without, and if he had the stamina to lug it up the steps to her bower, he still had to persuade her to sell it. Helena was not a student, but she loved "the crazy stuff". She was a pretty woman, who according to gossip, had been one of the chorus girls "adopted" by Daddy Browning. Summer and winter she wore a chiffon gown and a monkey fur cape.

After the many years of dispensing antiques in the city, Helena decided to move to the country, to Connecticut. A major part of her folk art was turned over to auction. The sale reflected the modest market values of that day.

No museum honors Helena Penrose, but she sparked many a collection and collector. She deserves a solid place in the history of American folk art.

Helena Penrose Auction. 1960

No. 40	Painted Pine Tavern Sign On one side, an early steam train; and on the other, a steamboat	$ 300.00
No. 64	Schooner "Angela". Painting signed A. Jacobson, 1912. A two-masted schooner flying the Stars and Stripes	$ 85.00
No. 66	*Portrait of a Gentleman* by Ezra Ames (1768-1836)	$ 130.00
No. 71	Wood Carousel Animals A Cat and a Rabbit (Lot)	$ 125.00
No. 94	Indian Chief. Cigar Store Indian	$ 850.00
No. 99	Mrs. Godey, Shop Figure	$1400.00
No. 221	Candle Box, decorated with tulips and songbirds	$ 55.00
No. 258	Weathervane Columbia 1865	$ 270.00
No. 259	Four Wheel Horsecart Weathervane	$ 575.00
No. 268	Streetcar Weathervane	$ 600.00
No. 272	Carousel Rooster	$ 300.00
No. 287	Admiral Dewey Ship Figurehead (Adopted from a standing cigar store trade sign)	$3300.00
No. 290	Eagle Ship Figurehead	$ 225.00
No. 296	Henry Ward Beecher Wood Carving	$ 425.00
No. 353	Painted and Decorated Dower Chest by Christian Selzer	$1250.00

"Street Car Named Desire". Weathervane. (Helena Penrose Auction. Purchased by Irene Selznick)

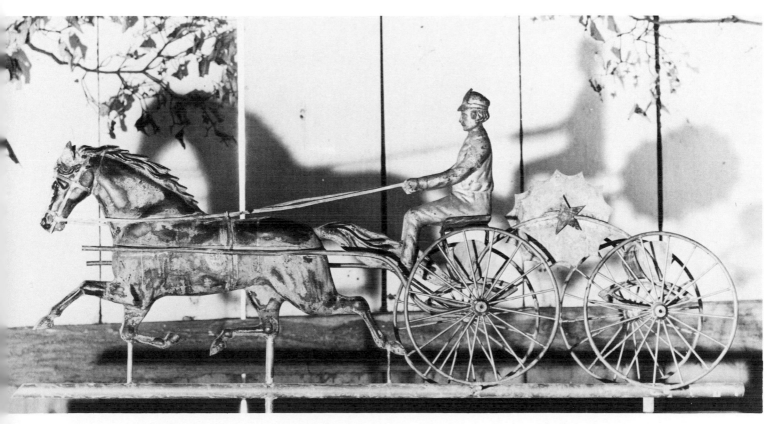

Fireman's Four Wheel Hose Cart Weathervane by L. W. Cushing and Sons. (Helena Penrose Auction)

Crow by Charles H. Perdew.

Snipe Decoys in Notation, North Carolina.

Heron by Elmer Crowell. (Alvin Friedman-Kien Collection)

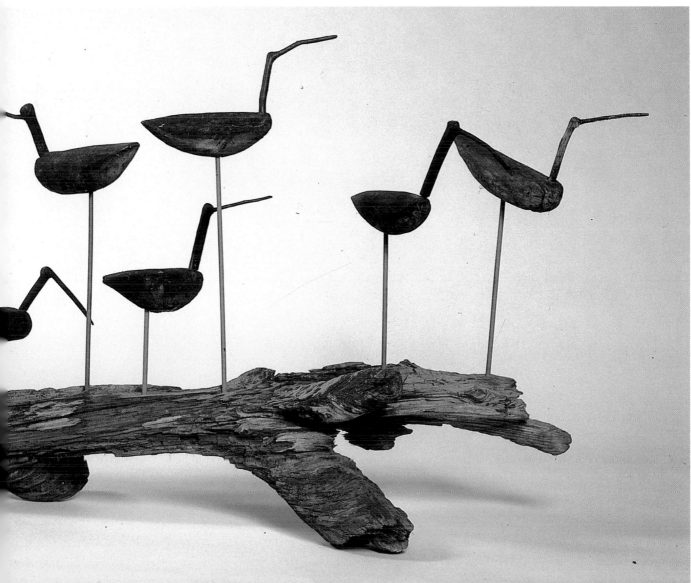

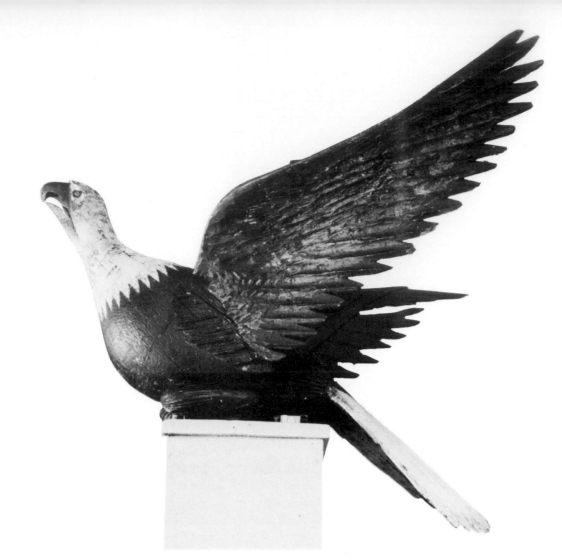

Bald-headed American Eagle. Woodcarving. From Williston Academy. Massachusetts. (Museum of Fine Arts. Boston. Gift of Maxim Karolik)

Rooster Weathervane. Iron. (Museum of Fine Arts. Boston. Gift of Maxim Karolik)

Museum of Early American Folk Art is Born Museum Friends

Much as we enjoyed and learned by attending auctions, and by reconnoitering for treasures to show at the Willard, our over-riding purpose was to attract the mover-doers in the museum world who believed, as we did, that American folk art should be recognized, researched, and honored in the history of American art.

A welcome sight at the Gallery was Maxim Karolik who turned up frequently in his great black coat with the astrakhan collar. That jovial, expansive Russian fell in love with American folk art. The Museum of Fine Arts in Boston is indebted to him and his generous wife, Martha Codman, for initiating the museum's excellent American folk art collection. Thanks to the M. and M. Karolik Fund, several of our fine pieces made their way to Boston. These included the Williston Academy eagle, and a delightful cocky, wrought iron rooster.

Mr. Karolik favored paintings, which we rarely provided, but occasionally he brought his purchases to the Gallery for us to admire. In those days, the 1950s, his feelings were hurt because most art critics made fun of the primitive, rigid portraits and the romantic landscapes he liked. Today 18th and 19th century paintings are recognized as vigorous statements of the men and women who had the vision and courage to create this democracy and hold it together during the Revolution, the Federalist period, the Civil War, and Reconstruction.

Mary Childs Black, director and curator of the Abby Aldrich Rockefeller Folk Art Collection in Williamsburg, made a point of attending our gallery previews. Often she previewed the previews! As a result, the Abby Aldrich Rockefeller Collection at Williamsburg has many of our treasures, including unique, early wood weathervanes, carousel figures, the one and only Shang Wheeler heron decoy, and a charming, small carving of George Washington, owned originally by Robert Coleman of Colebrook Furnace, Pennsylvania. And Mary introduced us to Stewart

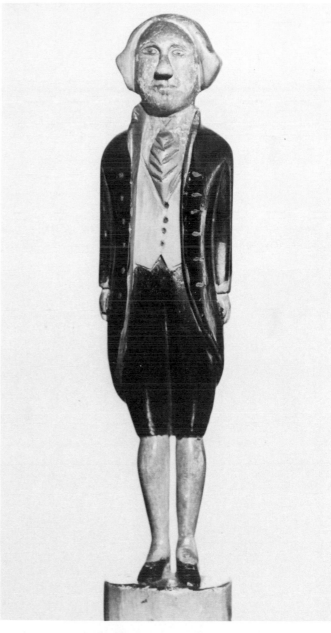

Carving of George Washington. Owned by Robert Coleman, master of Colebrook Furnace, Pennsylvania. (Abby Aldrich Rockefeller Folk Art Collection)

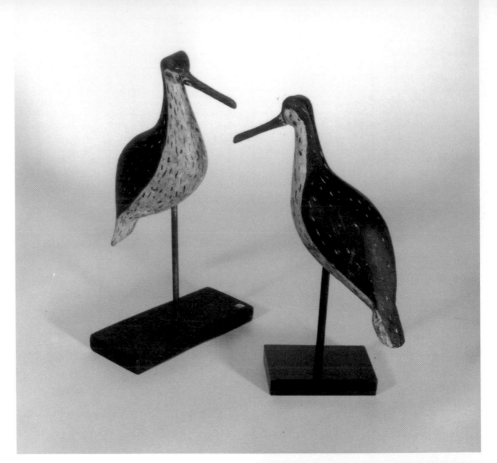

Two Plover

Plover

Penguin. Gatepost Ornament, Nantucket Island. (Robert Eichler Collection)

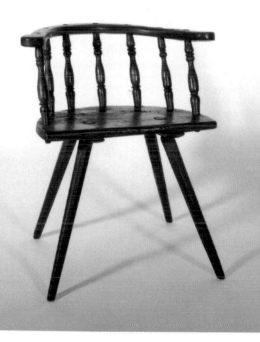

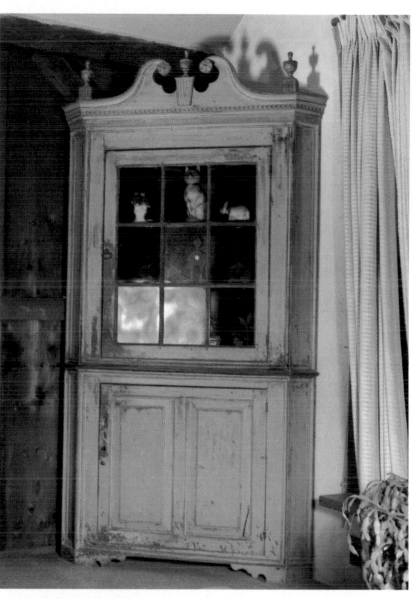

Blue Chippendale Corner Cupboard. Provenance: Titus C. Geesey.
(Collection of Author)

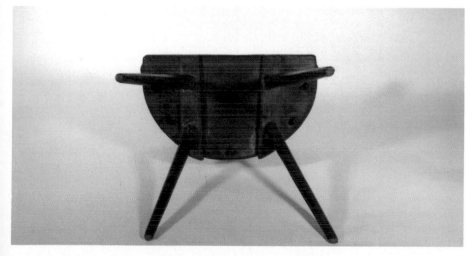

Plank Bottom "Brettstuhl". Pennsylvania c. 1780. Top view and bottom view.
Provenance: Titus C. Geesey. (Collection of Author)

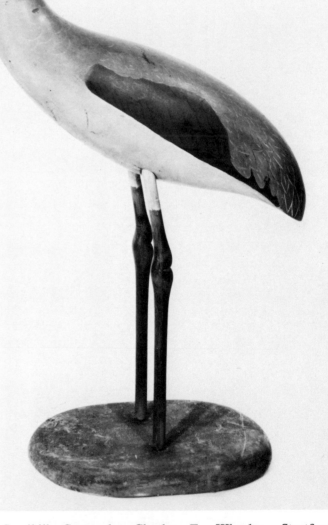

Gregory, who assembled one of the greatest folk art collections in this country. Mary and Stewart became good friends.

Nina Fletcher Little, professional consultant to Williamsburg and to Cooperstown, encouraged us and visited with us when she and her husband, Bertram, came to New York. Bertram Little served as director of the "Society for the Preservation of New England Antiquities", for thirty-three years.

Gertrude Herdle Moore, director of the Rochester Memorial Art Gallery came regularly, as did Richard McLanathan from the Munson-Williams-Proctor Institute in Utica. Dr. Louis C. Jones, Director of the New York Historical Association which includes The Farmer's Museum and Fenimore House at Cooperstown, New York attended our openings and became a wise counselor. Jean Lipman, as editor of *Art in America* magazine, reviewed our openings. Harry Peters, son of the well-known Currier and Ives print collector, liked weathervanes for his barns in Orange, Virginia. Cordelia made a special trip to Orange to advise him.

Sandhill Crane by Charles E. Wheeler. Stratford, Connecticut. c. 1928. (Abby Aldrich Rockefeller Folk Art Collection)

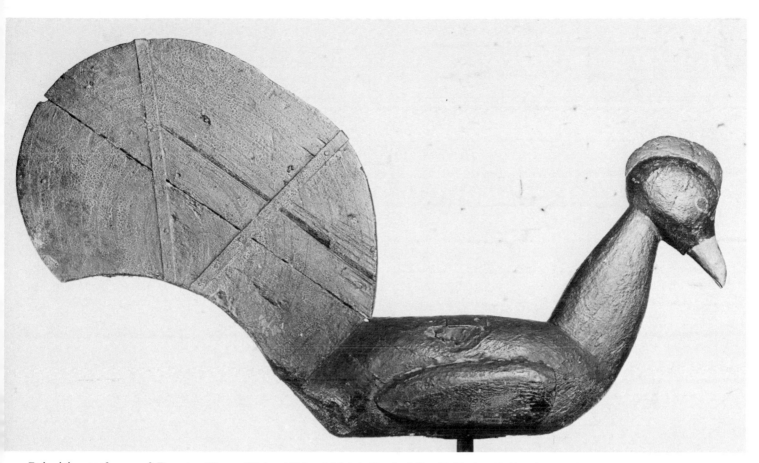

Primitive early wood Rooster Vane. Ohio. (Abby Aldrich Rockefeller Folk Art Collection. Williamsburg, Virginia)

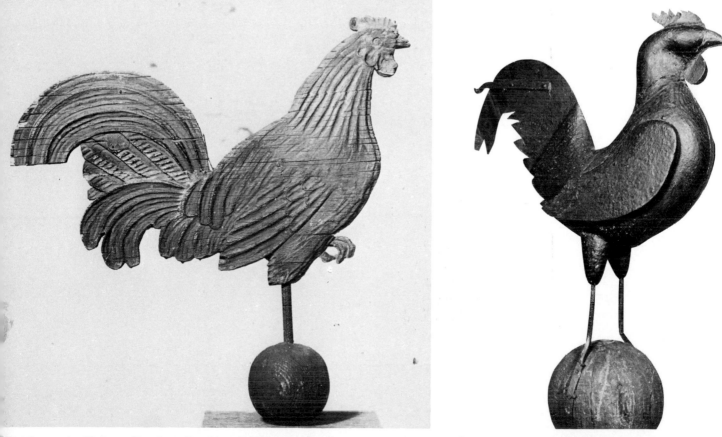

Weathercock. Unique Feather Carving. Early church vane. Connecticut. Abby Aldrich Rockefeller Folk Art Collection)

Carved Rooster Weathervane. Connecticut. c. 1800. (Abby Aldrich Rockefeller Folk Art Collection. Williamsburg, Virginia)

Dorothy Miller (Mrs. Holger Cahill) attended regularly and a shy, young man by the name of Joseph B. Martinson.

During the exhibition years at the Gallery we enjoyed the friendship of Marian Willard, her encouragement, and the widsom of her eye. But it was disturbing for all of us to see important unique folk art vanish from the scene when purchased privately. Where is our marvelous stone bird? Museums do keep records, do exhibit, and do offer sanctuary for treasures of esthetic and historical importance. But all the museums interested in folk art were located at some distance from us in New York. Here, in New York City, the art center of the United States, and the cultural capital of the world, there was no museum of American folk art.

Wasn't it time to establish a museum of American folk art in New York City?

One spring Sunday, in 1960, Cordelia and I drove over to Mr. Martinson's country residence in Oscawana-on-Hudson to talk over the situation. Would he be interested in helping to start such a museum? Heavily committed financially and morally to the New York City Ballet Society, Burt said he would think about it. He had retired actively "from trade" as he put it, from his father's "Martinson Coffee". He was eager to apprentice himself to the arts.

Back we went again in June. On a beautiful summer day Burt agreed to be our anchor man. He would pledge one hundred thousand dollars which could be used over the next five years, as needed, to cover any deficit at the end of each calendar year.

First we must create a Board of Founding Trustees, set forth our purpose, and apply to the New York State Board of Regents for a provisional charter. Marian Willard Johnson agreed to serve as a trustee. Herbert W. Hemphill, a connoisseur of contemporary and early American folk art, joined us. Arthur M. Bullowa, a friend, offered his services as our lawyer.

This original board, which included Cordelia Hamilton and myself, was granted a Provisional Charter by the University of the State of New York on June 23, 1961. The charter reads:

> The purposes for which such corporation is formed are to establish a museum, library and educational center in the City of New York to foster, promote and increase the knowledge and appreciation of early American Folk arts and their development.

The Museum of Early American Folk Art was born.

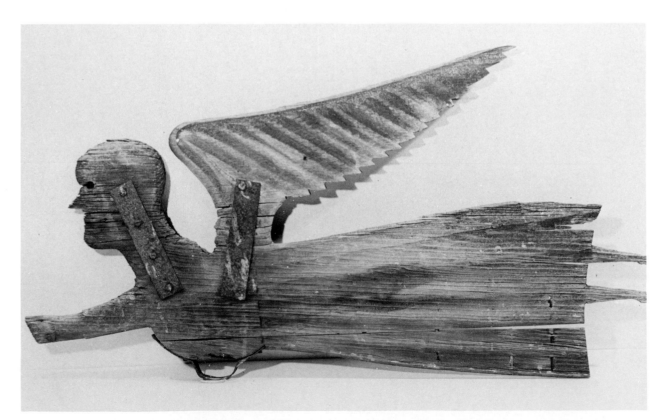

Angel Weathervane. Wood carved. c. 1820. (Munson-Williams-Proctor Institute, Utica, New York)

Ship Carving. Coat of Arms of the Derby family. Salem, Massachusetts. (Memorial Art Gallery. University of Rochester, New York)

Museum of Early American Folk Arts

in the City of New York

Annual Membership $15
Contributing Membership $100
Founding Membership $1000

for further information: 130 west 56 street, room 903
New York 19, New York. Plaza 7-9694

Brochure for Museum's Initial Loan Exhibition. Time and Life Building. New York City. 1962.
Design by Cipe Pineles Brutin.

Initial Loan Exhibition

Time & Life Center. 1962

The museum charter granted, we went our separate ways for the summer. Come fall, the six founding trustees met at Burt Martinson's city apartment to plan the next move. How to announce our great project? A museum of folk art in the city! How arouse public interest? How stimulate financial support? From experience at the Willard Gallery I knew that our folk arts were recognized mainly by specialized collectors in the upper income brackets, and by subsidized country museums. How could we win support for these arts from the people for whom and by whom the folk arts had been made?

One obvious answer was a block-buster exhibition of carvings and paintings which would show what we were talking about, would attract a public, and generate publicity. To accomplish this purpose we organized a committee, "For an Initial Loan Exhibition." On January 23, 1962 a prestigious group of forty-five collectors, dealers, and museum personnel were invited to Burt's apartment.

Burt explained our project and the fact that we had received a five-year provisional charter from the Board of Regents of the State of New York which incorporated the museum as an educational non-profit institution. (Our museum status as a tax-exempt organization was also confirmed by the U.S. Internal Revenue Service).

Katherine Prentis Murphy asked the inevitable question, "What is folk art?" Burt lobbed the question as if he had never been coached. The term, he said, referred to those works of art, hand-crafted, and uniquely American in character, which do not relect the influence of formal academic principles or mass production techn-niques. And he added that the main purpose of our initial loan exhibit was to show precisely what we meant by folk art.

The next question was where could such an exhibit be staged? All agreed that a perfect location was the Exhibition Center, the grand foyer, of the new Time-Life Building on Sixth Avenue at 50th Street, in the heart of Manhattan near Radio City Music Hall. Would Mr. Henry Luce, the awesome editor and opinion maker be interested? Burt agreed to confront the lion in his den.

Mr. Luce was interested. Furthermore he had a suggestion. He offered to help our cause by entertaining a select list of guests at a dinner party, hosted by him, in his private quarters upstairs, the evening before "our" show opened to the public. The guests would include the lenders to the exhibit, our Board, his own staff, and dignitaries in the art world.

A jubilant Burt brought back the news. Now "we" had to organize a show! The "we" meant "us chickens", Burt's favorite name for his board members.

During the next months we worked hard. The Exhibition Center was booked full until the fall of 1962. Mary Allis, a recognized authority on 18th and 19th century American painters, agreed to head that department. Cipe Pineles Burton, a friend of the museum and one of our foremost graphic designers, prepared the brochure and a handsome exhibition catalog of the one hundred and six carvings and paintings we had rounded up. The brochure announced the place and date (October 5 - November 18, 1962) and stated the purpose of the museum.

A Museum of Early American Folk Arts has been formed in New York City. Its aim is to establish here, in the cultural and travel center of the country, a museum where people may see historical America in terms of what we have done and what we stand for as shown in the work of our hands, our arts, tools, products, signs and symbols. New York is rich in museums but no museum exists here, which is devoted exclusively to this exciting and important aspect of our culture.

The cover of the brochure featured a photo-graph of Angel Gabriel blowing his celebrated

trumpet. This weathervane, featured here for the first time, has become the permanent insignia of our museum.

The first day our shipments arrived and were unpacked we knew we had a hit show. Even the workmen were fascinated by objects, the like of which they had never seen. There, on Sixth Avenue, were ship figureheads that had sailed the China seas; and weathervanes of whales, horses, angels, and roosters that forecast weather without the help of radio or television. There were portraits of ancestors, grim pioneers, who had the courage to come to this new country and pursue the dream of life, liberty and pursuit of happiness.

A tentative floor plan had been worked out with Margit Varga, art director of the Center, and with John Wingerter, supervisor of the physical installation. During the next few days of installation the street windows of the foyer became crowded with passers-by peering against the glass. We had to draw the curtains. Many of the paintings and the sculptures shown publicly here for the first time have now become bright stars in our firmament. This initial loan exhibition included the following carvings as numbered in our catalog, and as listed with name of owner at that date.

1. American Flag Gate
 Gift of Herbert Waide Hemphill, Jr.
3. Rooster. Wood, painted red. Trade Sign
 Joseph B. Martinson
4. Indian Maiden On Horse - Weathervane
 Mrs. Paul Moore
5. Arrow Weathervane
 David Rockefeller
6. Flying Goose
 Stewart E. Gregory
9. Horse. Carved Toy. Cumberland Valley
 Holger Cahill
10. Horse. Carved Toy. Cumberland Valley
 Cordelia Hamilton
12. Whale and Whalers. Wood carving
 Mr. and Mrs. Robert Hallock
14. Hackney Horse. Weathervane
 Joseph Verner Reed
20. Giraffe. Iron Ornament
 Mr. and Mrs. Louis C. Baker
22. Iron Man
 Adele Earnest
23. Goat. Weathervane
 Van Alstyne-Marsh
25. Henry Ward Beecher, Wood Portrait
 Abby Aldrich Rockefeller Collection
27. Man With Grapes. Carving, Polychrome
 Alastair B. Martin
28. Lion Circus Carving
 Colby College Art Museum

31. Columbia Carved Wood Ship Figure
 Mystic Seaport
37. Robin Figurehead
 Shelburne Museum
38. Eagle, Ship Carving from Steamer "General McDonald"
 Shelburne Museum
47. Hound Dog, Copper Tradesign from "Hare and Hound Tavern," Syracuse, New York
 David Ash
49. Sheaf of Wheat
 Mr. and Mrs. Erwin D. Swann
54. Hog. Wood Trade Sign
 Adele Earnest
58. Wool Winder
 Mr. and Mrs. Howard Lipman
61. Collection of Whirligigs
 Joseph B. Martinson
63. Loon. Wild Fowl Decoy
 Winsor White

Rooster. Carved, painted red. Trade Sign. Ohio. (Joseph B. Martinson)

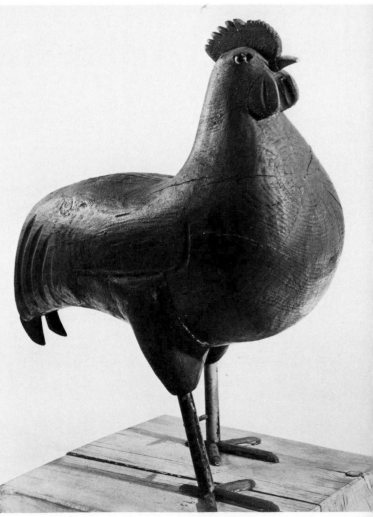

American Flag Gate. Jefferson County, New York. c. 1876. (Photograph courtesy of Museum of American Folk Art. Gift of Herbert W. Hemphill, Jr.)

The evening of our preview it rained, but the exhibition area was crowded and festive. I changed from work clothes to high heels and a long dinner gown, and I carried a tin cup, figuratively speaking. A late delivery trucker had refused to unload his cargo (an eagle) until he was paid sixty dollars for the transportation. I had no money with me, and I discovered that other people travel light to cocktail parties. Stewart Gregory reached into his tuxedo pocket and paid the bill.

At the appointed hour the house lights dimmed off and on to signal the close of the preview and the time for invited quests to take the elevator upstairs to the Luce private reception and dining area. That afternoon Burt, placecards in hand, had supervised the seating arrangements at the proper tables. The 100 guests included Mrs. Vanderbilt Webb; Alice Winchester, editor of the *Antiques* magazine; Roy Moyer, director of the American Federation of Arts; Oliver Jensen and Joan Kerr from the magazine *American Heritage;* Sterling Emerson, director of Shelburne Museum; Dr. Louis C. Jones, New York State Historical Association; William Warren of Old Sturbridge Village; Lloyd Goodrich, Whitney Museum of American Art; Mitchell A. Wilder, Amon Carter Museum, Texas; Dr. Richard P. Wunder, National Collection of Fine Arts, Washington, D.C.; Roy R. Neuberger, Harry Shaw Newman, James Grote VanDerpool, and Jean and Howard Lipman.

I had the honor of being seated at the head table between Mr. Luce and Mr. Laurance Rockefeller. Also at our table sat Mrs. Jacob Javits, Laura Harding, and Mr. Roger L. Stevens, who became Chairman of the John F. Kennedy Center in Washington. Carl Carmer, the speaker of the evening, sat at Mrs. Luce's table.

Just before Mr. Carmer started his speech about the historic Hudson River, the salad course was served. Most guests abstained from eating during the speech. Not Mr. Luce. He ate promptly and signaled the waiters to serve the next course. Salad was whisked away, mostly untouched, and replaced by a confection. Speeches bored Mr. Luce.

A color print of *Angel Gabriel,* by Allen Saalburg, was presented as a gift of remembrance to each guest.

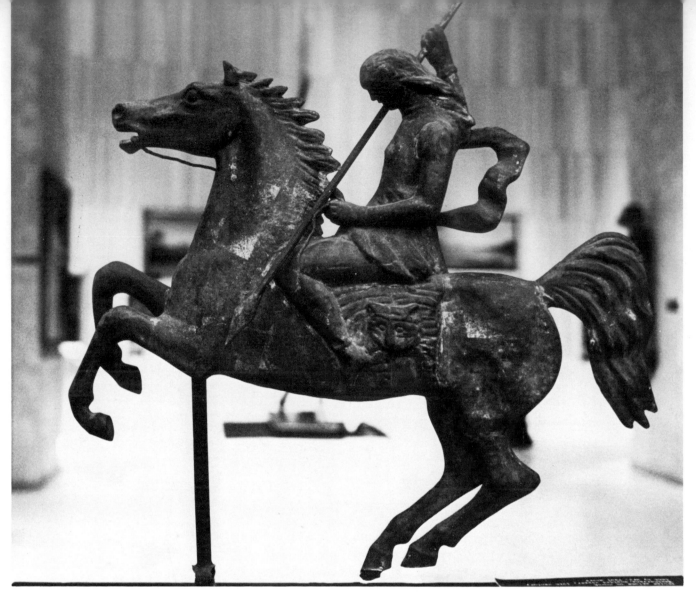

Indian Maid with Spear, on Horseback. Also known as Diana. Weathervane. (Mrs. Paul Moore)

Goat Weathervane. Wood. (Van Alstyne-Marsh Collection. Smithsonian Institute, Washington, D.C.)

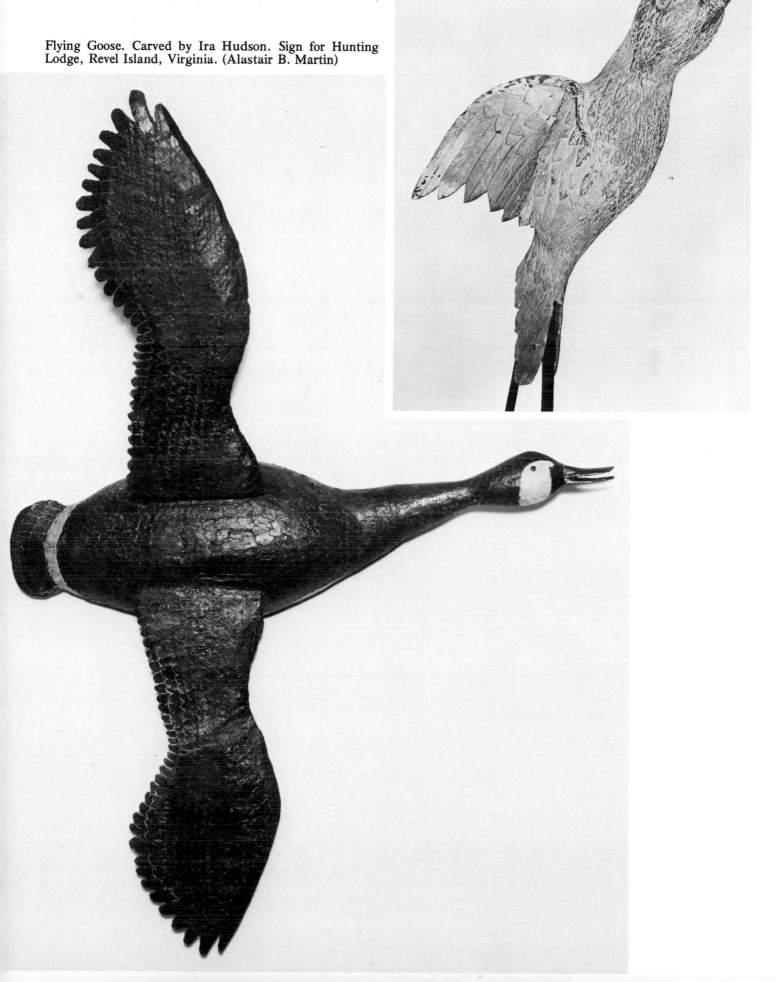

Robin. Ship Figurehead. (Shelburne Museum)

Flying Goose. Carved by Ira Hudson. Sign for Hunting Lodge, Revel Island, Virginia. (Alastair B. Martin)

Columbia. Ship Figurehead. (Mystic Seaport Museum, Connecticut)

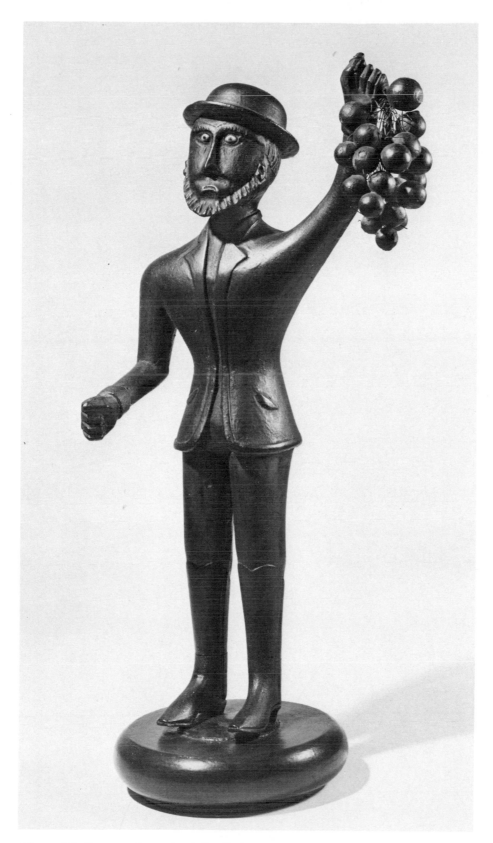

Man with Grapes. Owned originally by Robert Laurent. (Alastair B. Martin)

Following pages:
Collection of Whirligigs. (Joseph B. Martinson)

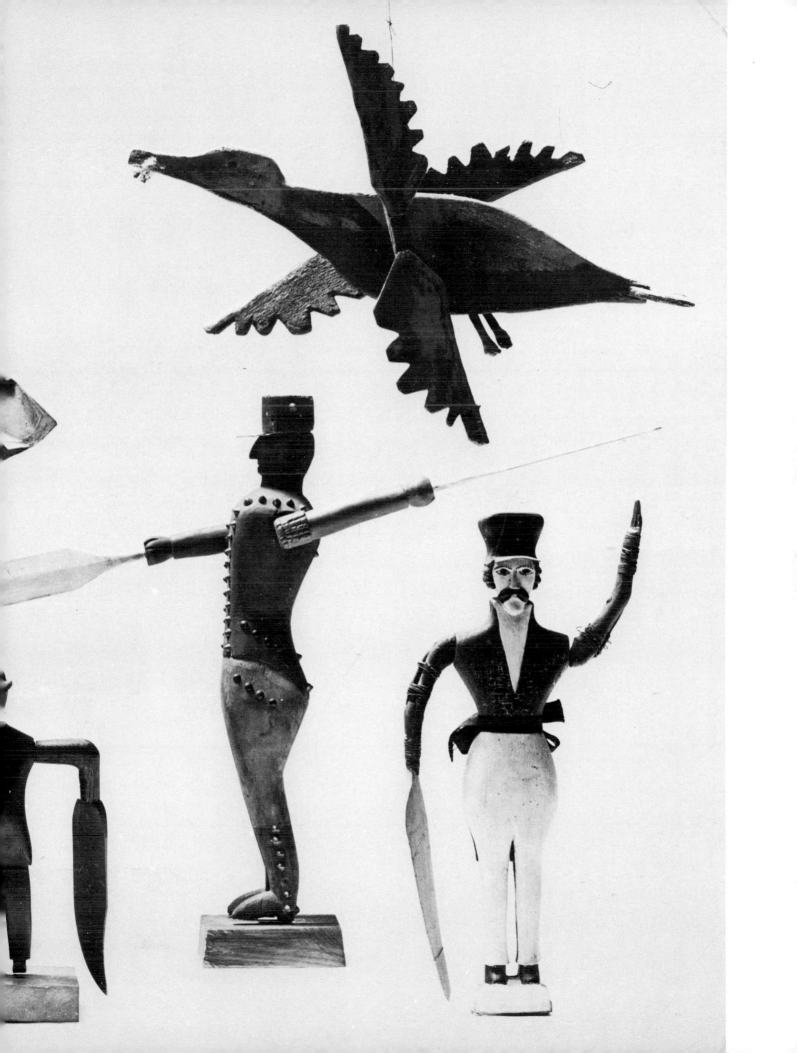

Hound Dog. Sign for "Hare and Hound Tavern", Syracuse, New York. (David Ash)

Lion. Circus Carving. (Colby College Art Museum, Maine. Gift of Willard and Helen Cummings)

Chapter 15

First Years of the Museum

Shortly after the close of our exhibition at the Time-Life Center, our original Board of Trustees met at the Carlyle Hotel to celebrate the success of our show. By rough count over fifty thousand people attended. Denny Beach, Burt's secretary, had organized a group of volunteers to keep count, answer questions, and distribute membership applications. *Time* magazine reported: "If there was one fault with the show, it was this: it would be hard to beat."

After lunch we walked over to 53rd Street. Burt paused in front of number 49, a three-story brownstone. "What do you think of this location for our museum?" The street, in the center of Manhattan, was already museum oriented. The Museum of Modern Art and the Museum of Contemporary Crafts were located practically next door.

We climbed a flight of steps to the first floor where a real estate representative waited with a tentative lease. Our exhibition galleries have been located at this original site for over twenty years.

The premises had to be remodeled. Burt talked several of his affluent and professional friends into joining our Board and helping. Edward A. Bragaline, a collector of contemporary art and a distinguished fabric designer, offered his services in the remodeling of our quarters. New flooring was laid down and stained a driftwood gray. Partitions were removed to open up a continuous space for two galleries with a reception area in between. Walls were covered with burlap. Two ceiling tracks in each room accomodated spot and flood lights. In these friendly but small quarters our museum has presented over eighty definitive exhibitions of American folk art.

Burt also brought other friends to our Board. Mrs. Nancy Lassalle, a prime mover in the New York City Ballet Company, came aboard. Lincoln Kirstein, art connoisseur and father figure to the ballet, lent his prestige and wisdom to our cause.

Usually we convened at lunch time at some delectable restaurant. Often Marian Willard offered the hospitality of her gallery for a get-together over soup and salad.

Early on, as they say, Burt gave another prestigious cocktail party for tentative backers at his apartment located high above East 57th Street. Mainly we tried to interest Mrs. DeWitt Wallace, editor of the *Readers Digest* and patron of the arts. She came - a delectable lady, a vision in blue: blue gown, blue shoes, blue hat, gloves, and jewelry. But the homey folk arts were not for her. The lady was already involved in the restoration of beautiful Boscobel, an historic scenic estate up river along the Hudson.

Our first director, George Montgomery, came to us from the Museum of Modern Art. George was well acquainted with museum procedures but unfamiliar with folk art. Our trustees carried the responsibility of selecting and authenticating the exhibition programs.

Originally we planned to offer the public a series of "loan" shows, secured from recognized collectors and out-of-town museums. Also we planned to start and build our own permanent collection through gifts and bequests. Millia Davenport Harkavy, an authority on costume design, started and catalogued a reference library.

Howard Graff photographed our early shows. Walter Lewisohn initiated a film library by recording shows. Betty Chamberlain volunteered to head up the publicity department.

George worked out of a small office room rented down the street. (At that early date the top floor at 49 West 53rd Street was not available). George's time was spent on the run. After an exhibit was decided upon, George filled out the loan forms, picked up the material in his car, transported all well-packed, lugged it up the steps and supervised the installation. A part-time secretary typed, but George handled all phone calls. He was indefatigable. Every morning George swept down the steps, opened up the gallery for our hostess shopkeepers and closed the premises at night.

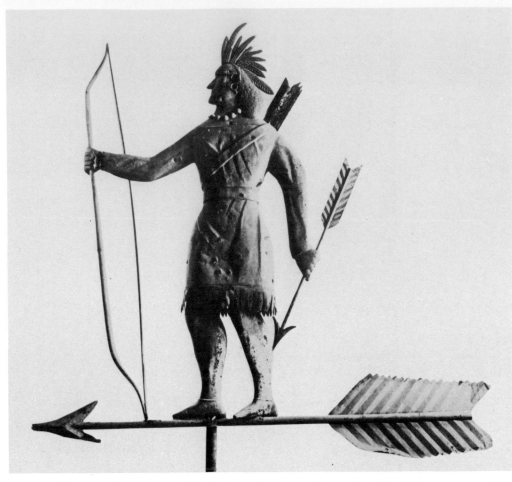

Tammany Indian Weathervane. Chief of the Delaware Indians. Symbol of the "Improved Order of Redmen". Used on a lodge building in East Branch, New York. (Museum of American Folk Art)

During George's tenure our exhibits were well reviewed by the press, especially "Collector's Choice" which opened October 24, 1963. Even a partial listing is impressive and indicative of the enthusiastic support our new museum received in the very beginning, from important collectors.

Portrait of Jane Hutch of Bath, New Hampshire
by Zedekiah Belknap (1781-1858)
(Loaned by Mr. and Mrs. Bertam K. Little)
Portrait of a Man with Sickle
by Hope, (c. 1840)
(Col. and Mrs. Edgar W. Garbisch Collection)
Liberty (Painted Wood Carving)
(Herbert W. Hemphill Collection)
Portrait of Miss Gilmore, with Doll
By Joseph Whiting Stock (1815-1855)
(Dennison Hatch Collection)
Painted and Decorated Chest
(Mr. and Mrs. M. Taradash Collection)
Indian Princess, Tobacconist Carving
(William Engrick Collection)
Portrait of a Woman in Black
by Ammi Phillips (1783-1865)
(Mrs. Jacob M. Kaplan Collection)
Angel Gabriel (Painted Wood Carving)
Hung originally over entrance to Angel Tavern,

Guilford, New York (Max Hess Collection)
Landscape, Residence of Lemuel Cooper
of Plain, Wisconsin. Watercolor by P.A. Leifert
(Howard and Jean Lipman Collection)
"Liberty" Weathervane, copper
by Cushing and White, Waltham, Mass.
Label dated 1865 (William Engvick Collection)
Eagle Carving by William Schimmel
Pennsylvania, c. 1890
(Holger Cahill Collection)
Chalk Cat
(Mr. and Mrs. Wilbur Arthur Collection)
Portrait of a Woman in Pink
(Mrs. Samuel Schwartz Collection)
Two Pastel Portraits, Elizabeth Ann
and Ellen June Hubbard
Artist, Ruth Henshaw Bascom
(Mrs. L. Mitchell Collection)
Curlew Decoys
(Stewart E. Gregory Collection)
Carved Wood Owl
(Joseph B. Martinson Collection)
Tammany Indian with Bow and Quiver.
Weathervane.
East Branch, New York, c. 1880
(Museum of American Folk Art Collection)

Original site of Tammany Weathervane. East Branch, New York. (Photograph courtesy Museum of American Folk Art)

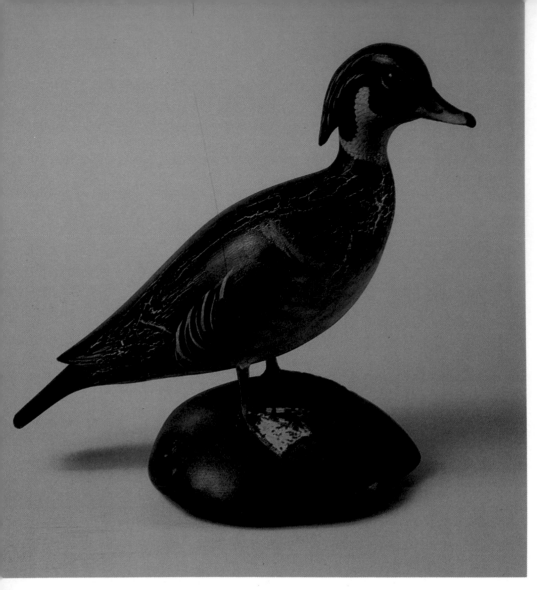

Wood Duck by Elmer Crowell. (Photograph courtesy Alastair B. Martin)

Loon. (Photograph courtesy Robert Eichler)

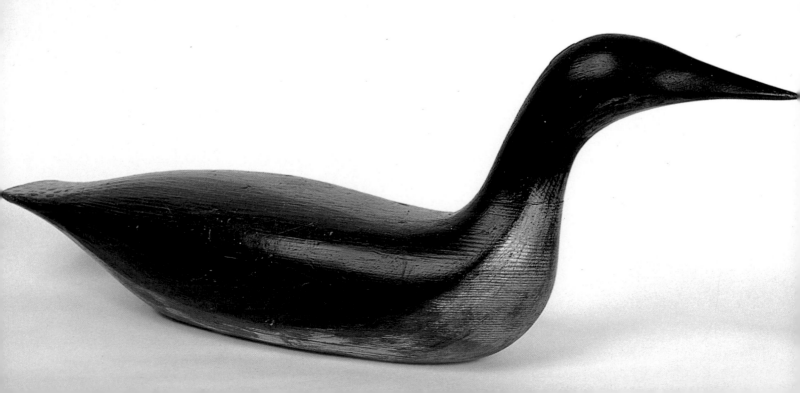

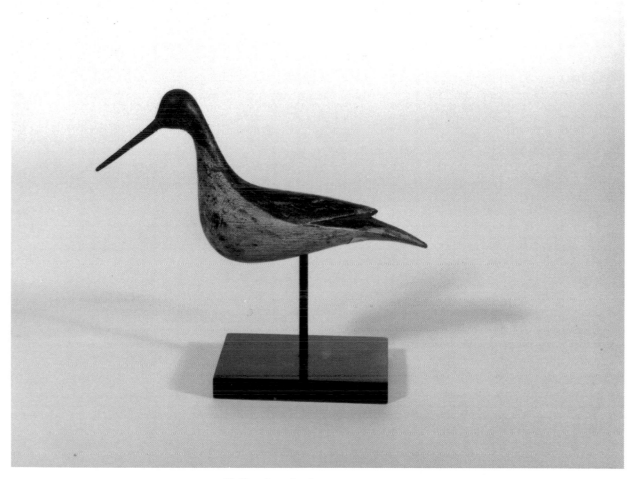

Yellowlegs by Ira Hudson.

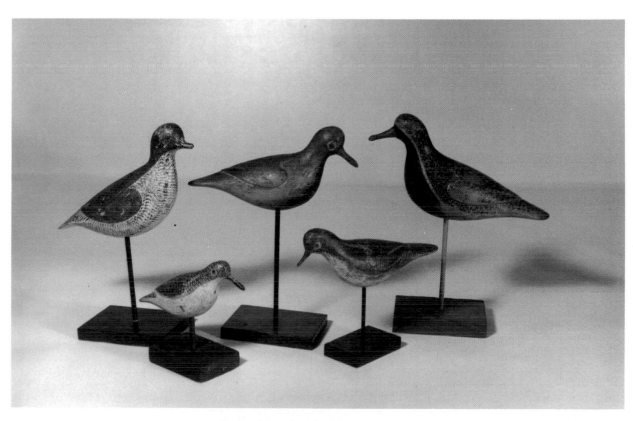

Gathering of Shorebirds.

Our Tammany Indian Weathervane portrayed in the image of Indian Chief Tammany, patron of the Loyal Order of Redskins, presided for years on the turret of a lodge meeting house in East Branch, New York.

Cordee and I saw him first during one of our early trips to Cooperstown, New York. We were driving along a country road that followed a meandering trout stream when suddenly there it was, an Indian vane, visible between the tree tops against the sky. A small bridge took us across the stream to the site. The building on which the vane sat was empty. On inquiry we learned that the place was for sale. The building had to go with the vane. We did not want the building!

The following year we passed again. The vane was gone. Someone had been more persuasive than we. Within the next few weeks an antique dealer in Connecticut offered the vane to our museum for a staggering price. Burt wanted it. The accession was made possible by way of a dinner-dance benefit sponsored by the Lord and Taylor department store.

Chief Tammany has been our pride and joy ever since. He has made many heroic trips on behalf of our museum - to the World's Fair at Montreal, Canada; to far away Osaka, Japan; and recently to Albany, New York for the state's Centennial celebration.

The Chief's hazardous travels begin right on 53rd Street at our own quarters whenever the vane has to be loaded and packed for shipment. He is too big (ten feet tall) to go down our narrow hall stairway. A large pane of glass in our front window has to be removed for his passage. While a breathless street crowd watches, the Chief is hoisted ignominiously out of the window through the air by a crane and lowered gently into a waiting truck below.

The original Tammany, chief of the tribe of the Delaware Indians, was known to earlier Americans for his courage!

In 1964 Dorothy Miller, Mrs. Holger Cahill, honored us by joining our Board of Trustees. Stewart Gregory agreed to serve as Vice President. Stew was well acquainted with all categories of folk art: paintings, furniture, fabric, pottery, trade-signs, ship carvings, weathervanes, and decoys. His home, a remodeled barn, was a collector's dream. And he enjoyed the pursuit of quarry as well as the possession.

Occasionally Stew phoned on a beautiful weekend to say there was a house auction in some little town in Maine. Folk art was advertised. Would we like to go with him? He'd fly over in his plane, a Cessna, and pick us up at our local Spring Valley airport, around eight in the morning. We would be in Maine at the auction by eleven! Twice we flew with Stew to Hyannis on Cape Cod to attend the sale of the William J. Mackey decoys at Bourne's auction house.

I am a nervous Nellie when it comes to flying in a small, light plane, but Stew was a steady reassuring pilot. He flew well. Everything he did, he did well.

Through Stewart we met collector-neighbors, Effie (Mrs. Wilbur) Arthur and Eve Meulendyke. Both became good friends of the museum. Also Stew introduced us to Thomas J. Watson Jr., whose private plane was bigger and faster than the Cessna. One weekend Tom flew us from the Westchester Airport to Rockport, Maine in two hours. Tom had a summer home on an island in the bay where he enjoyed his children, his grandchildren, his plane, his boat, his ship carvings, wildfowl decoys, and lobsters.

The Elie Nadelman Adventure

Mary Childs Black, Director

One day at a board meeting, Lincoln Kirstein suggested that we look up Mrs. Elie Nadelman who was still living in the family residence, "Aldenbrook", located at Riverdale-on-Hudson. Nadelman, prestigious Polish-born sculptor, had lived and worked there until his death in 1948. He had collected American folk art in the early years, in the 1920s, even before the artists of the Orgunquit School became interested. Might something from those early days be left? Mr. Kirstein was working on a definitive study on Nadelman sculpture. He phoned and made an appointment for Cordee and me to visit Mrs. Nadelman and ask about folk art.

We drove to Riverdale. We found the house, a somber Victorian Gothic structure, hidden in overgrown lilac bushes. We knocked and a housemaid ushered us into a dimly lighted sitting room. She said Mrs. Nadelman would join us shortly.

The room was already occupied. On a sofa sat three ladies in the nude, three white plaster ladies in the nude........Nadelman sculptures. Cordee and I joined the eerie company. Soon Mrs. Nadelman arrived and invited us to join her for coffee in the dining room, a confortable room filled with the reassuring light of day.

Yes, there was folk art she said. (Outside in a garden we could see a cast iron figure of George Washington). Upstairs she said were paintings, marine seascapes. She didn't climb stairs more often than necessary. We ascended.

The "painting room" was empty except for a large cracked and torn canvas rolled up on a table. It was a whaling scene. Empty picture frames were stacked against the wall. Evidently the Nadelman collection had been disposed of some time ago. We thanked Mrs. Nadelman and left that strange haunted house where reality had lost its presence.

Later we learned that a good portion of Nadelman's folk art had been sold to the New York Historical Society in the 1930s when Nadelman's finances had been wiped out by the

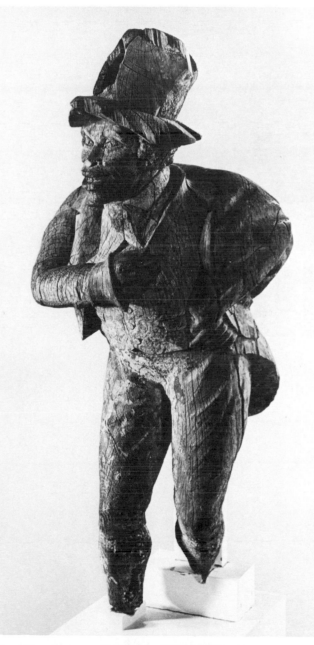

Dancing Negro. Carving. (1825-1850) From the Elie Nadelman Estate. (Photograph courtesy of New York State Historical Association, Cooperstown, New York)

Heron by Thomas Powall.

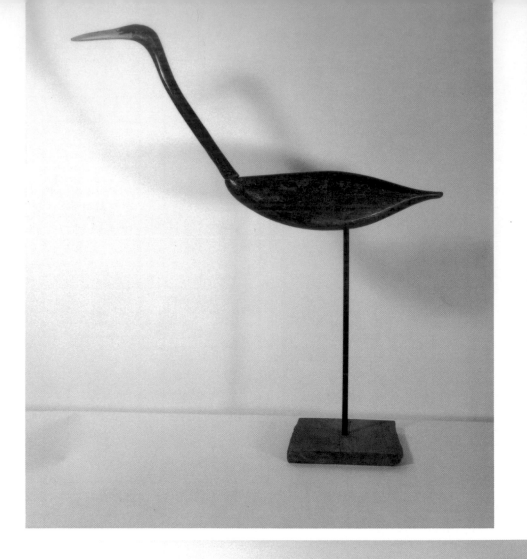

Canada Goose by Nathan Cobb.

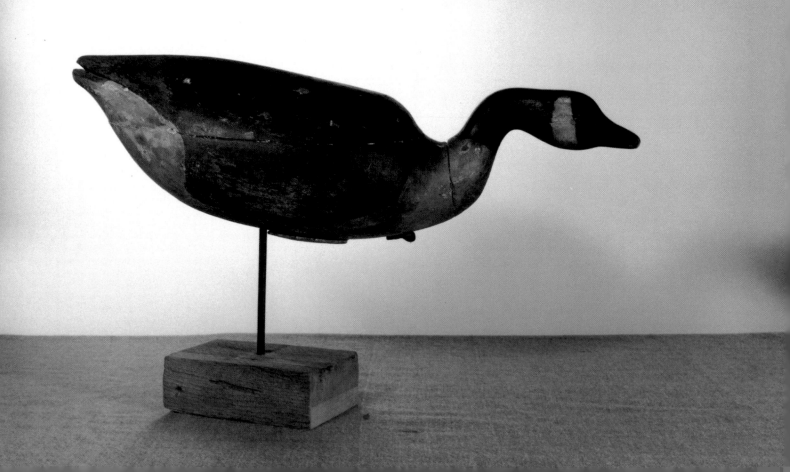

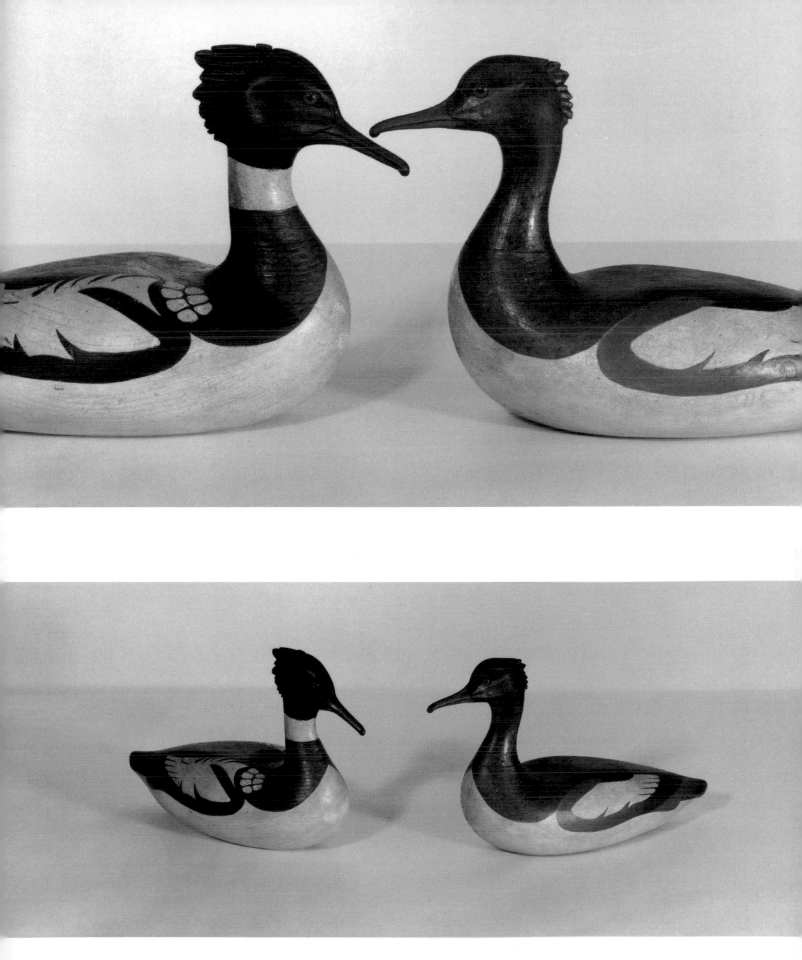

Pair Mergansers by L.T. Holmes.

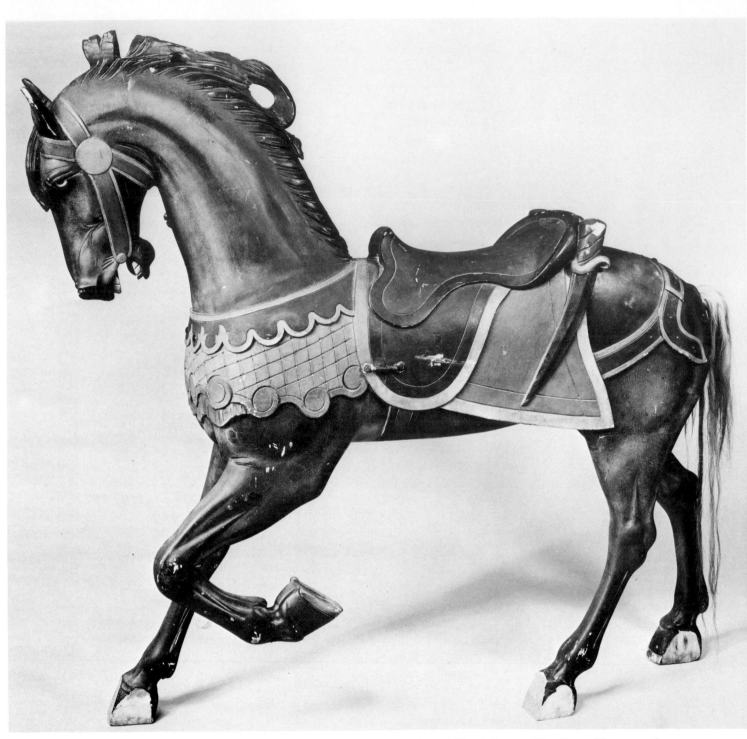

Carrousel Horse. By D. C. Muller & Co., Philadelphia. (Gift of Laura Harding. Photograph courtesy Museum of American Folk Art)

Depression. Also, at a more recent date, Mr. Stephen Clark and Dr. Louis C. Jones had visited and purchased fifteen pieces of sculpture and paintings for the folk art collection at Cooperstown.

By the year 1964 our museum had established an identity and a reputation for quality. We realized it was time to hire a director who had definitive knowledge, experience, and prestige in the field of folk art. And, not incidentally, the

Board members needed relief from the many chores we carried.

For some time my eye had been on Mary Childs Black, director and curator of the Abby Aldrich Rockefeller Collection at Williamsburg, Virginia. Mary was a recognized authority on eighteenth and nineteenth century paintings. And I knew from our acquaintance at the Willard Gallery she had a great eye for the three dimensional sculptural folk art.

Head of Ceras, by Simeon Skillen, Jr. c. 1820. Nadelman Estate. (Photograph courtesy of New York State Historical Association, Cooperstown, New York)

Mary was interested. But she had writing commitments she wished to honor. Could she work with us part time as a starter? She could give us two five-day weeks every month, or a hundred days a year. (We closed during the summer). She would commute from Virginia. The salary offered was meager but Mary believed in our project and looked forward to working in New York City.

An arrangement was worked out - a boon to all parties. In 1967 Clarkson N. Potter published *American Folk Art* by Mary Black and Jean Lipman. In 1968 Potter published *Ammi Phillips: Portrait Painter* by Mary Black and Barbara C. and Laurence B. Holdridge. Each publication was keyed to exhibitions at our museum and at the *Albany Institute of History and Art.*

At Mary's suggestion one publication was given free to each museum member each year as a special bonus. The gift book proved to be a great incentive during our drive for new members. All worked well. Jean Lipman, Mrs. Andrew

Norman, and Mrs. Samuel Schwartz joined our Board of Trustees.

Under Mary Black's leadership the museum established a solid reputation for scholarly, exciting exhibitions. "Religion in Wood: A Study in Shaker Design" (based on the Faith and Edward Deming Andrews Collection) was the first major show of Shaker furniture and furnishings held in the city. The work of painters, Erastus Field, and brothers, John and James Bard, was researched and presented. "Santos, The Religious Folk Art of New Mexico," on loan from the Amon Carter Museum of Western Art in Fort Worth, Texas continued our policy of exchanging shows with other museums. An exhibit, "Rubbings from New England Gravestones," toured museums throughout New York State.

The two shows, "Art of the Carousel" (curator, Frederick Fried) and "The Art of the Decoy," brought a parade of wooden horses, camels, frogs, seals, and one bison up our narrow flight of steps, as well as a flock of sandpipers, ducks, swan, and geese. The decoy show attracted many a business-type sports addict who had never ventured up our stairs. After the decoy show closed the birds were cushioned and crated to migrate to other museums.

Another happy result of our decoy exhibit was acquaintance with Mr. Alastair B. Martin who purchased the nucleus of the show, the famous Winsor White decoy collection, and presented a major part (over a hundred decoys) to our museum as a gift.

In 1966 the New York Historical Association, through the good graces of friend, Dr. Louis C. Jones, sent us a loan exhibit culled from their impressive holdings.

Cooperation with other museums and with collectors was happy and healthy on all counts.

Early in 1966 Time-Life Inc. offered their exhibition center again for another display of American folk art. Mary organized a prestigious presentation. Paintings dominated. Again private collectors and museums cooperated. We hoped these two shows at the Center would set a precedent. What better partnership than a major publication, a street floor walk-in exhibition area, and a fledgling, hearty museum of American folk art? Why not plan for a blockbuster exhibit at the Center every four years? In the time between we could focus on small but definitive, scholarly presentations in our own pleasant, if cramped quarters, until the day we had our own museum building.

In our rooms on 53rd Street Mary planned special shows on "American Needlework," "Pennsylvania Folk Art," and "Hunt for the Whale."

169

Curlew from Massachusetts

Plover by Elmer Crowell. Sandpiper by Nathan Cobb.

Group of Sandpiper decoys

The latter introduced us to Barbara Johnson. For Christmas, Mr. and Mrs. Bernard Barenholz, devoted supporters, brought us a delightful gathering of "Dolls and Tin Toys," the latter from their own collection. Fifteen hundred happy children came free of charge. There was no fee for prearranged groups. A charge of twenty-five cents was required for non-members of the museum. Students paid a dime. Our admission fees were too low. We had to learn. But at that date the yearly museum budget was under fifty thousand dollars. In 1966 in recognition of the museum's "usefulness and character", the University of the State of New York granted us a permanent charter in the name

of Museum of American Folk Art. The word "early" was deleted.

Our February 1970 show on tinware, "The Tinker and His Dam" brought a glowing review, written by Jean Lipman for *Life* magazine (February 27 issue).

If you are a folk art enthusiast, you must be aware of the mecca for those of your persuasion, the *Museum of American Folk Art* on West 53rd Street in New York. Its current show is *The Tinker and His Dam,* a play on the two meanings of "dam", a scrap of mud used by the tinker while soldering a pot (as in "I don't give a tinker's dam".), and the

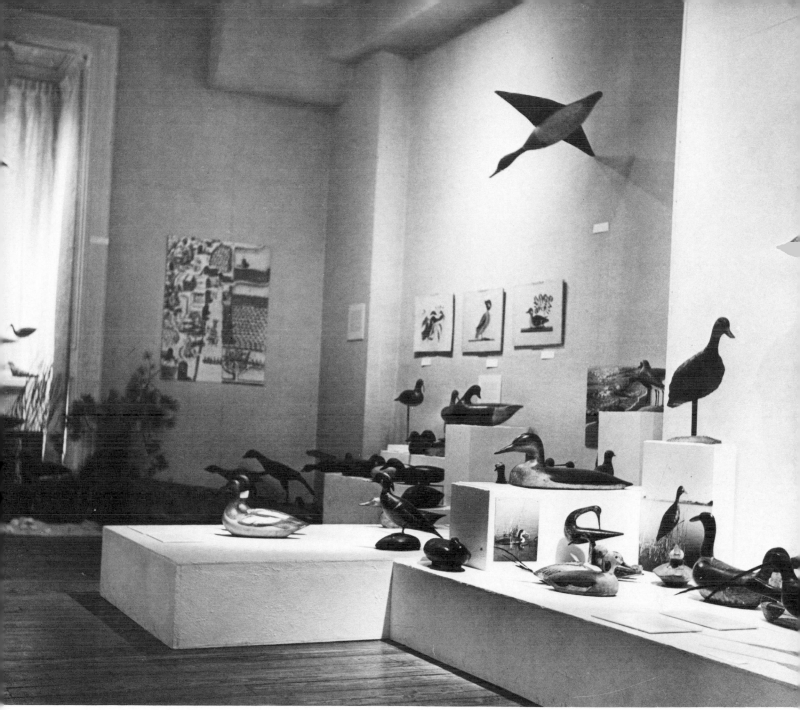

The Art of the Decoy, Museum Exhibition, 1966. Two views. Curator, author. (Photograph courtesy of Museum of American Folk Art)

female creator, in recognition of the fact that tinsmiths' distaff relations helped decorate the raw tin that the men had molded and soldered and beaten into shape...Never before have so many examples of decorated tin been brought together in a single exhibition.

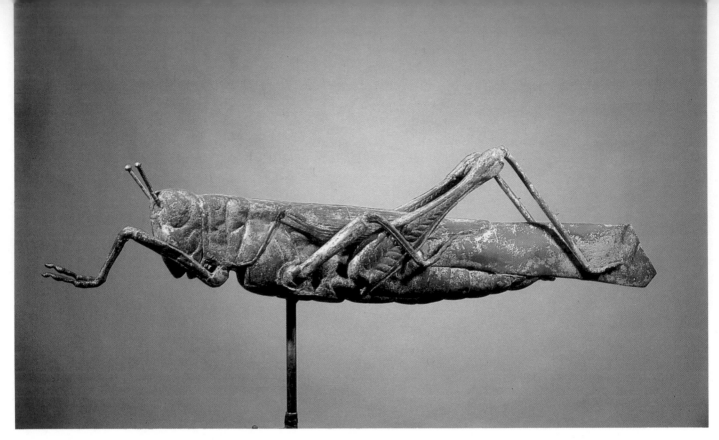

Grasshopper Weathervane. The Gregory Collection. (Mrs. Jacob M. Kaplan)

Curlew, Massachusetts.

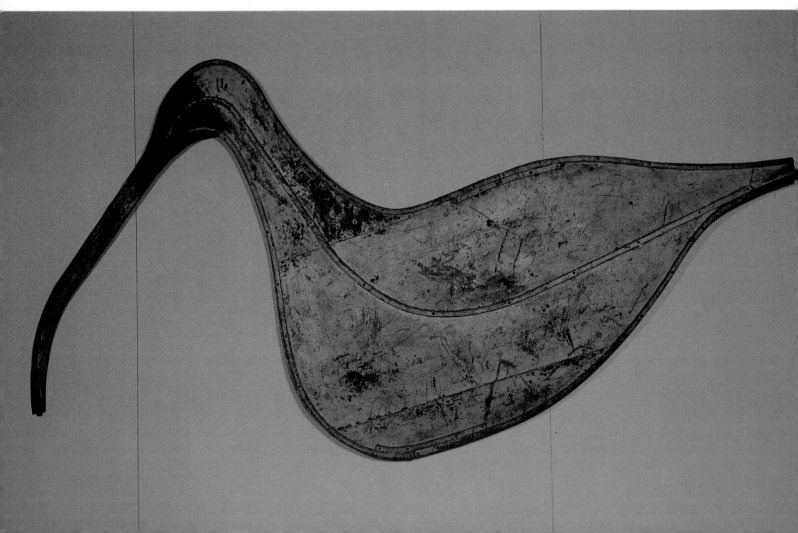

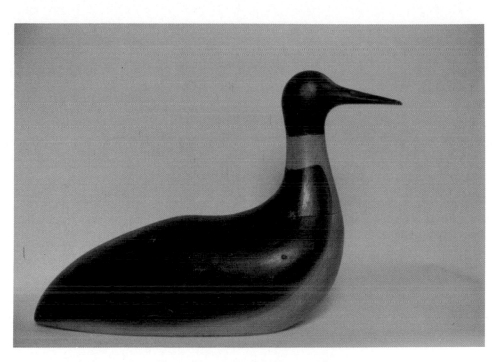

Decoy courtesy Robert Eichler

Stewart Gregory in Stony Point, New York, 1975

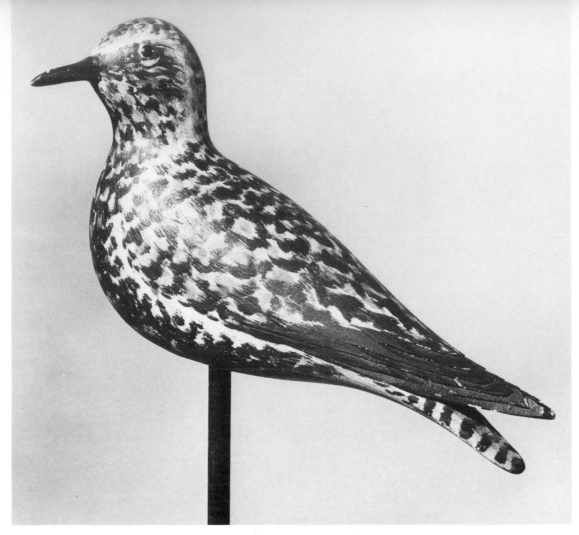

Black-breasted Plover by Elmer Crowell. (Gift of Alastair B. Martin. Photograph courtesy Museum of American Folk Art)

Curlew by Mason Decoy Company. (Gift of Alastair B. Martin)

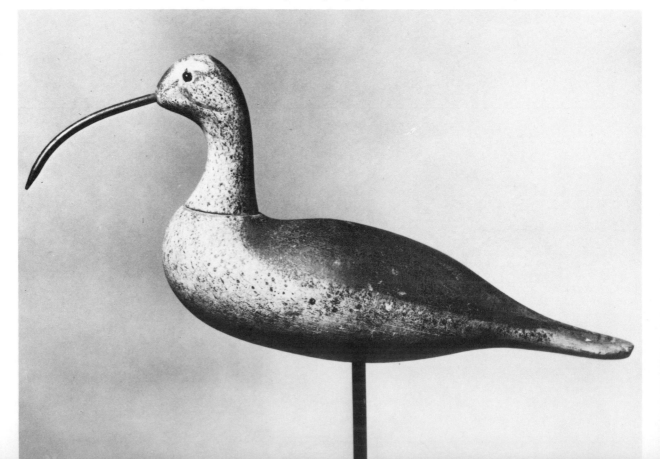

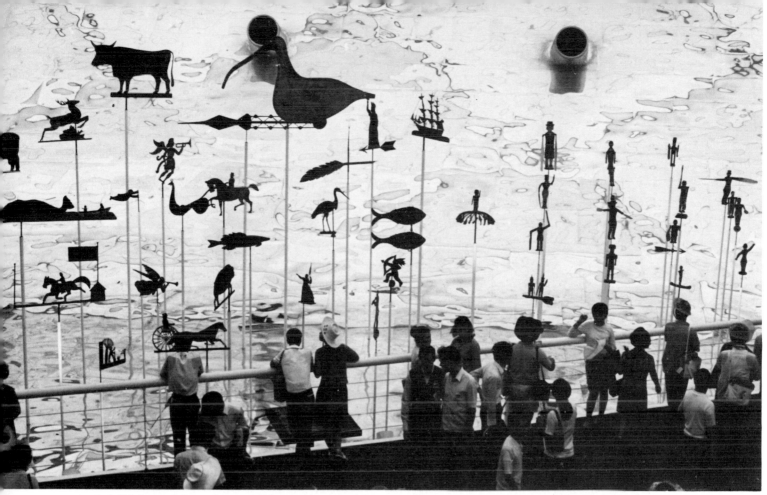

Exhibition of American Folk Art. Presented by our Museum at Expo '70, in the United States Pavilion, Japan Exposition, Osaka.

Sleeping Black Duck by Charles Wheeler. (Gift of Alastair B. Martin. Photograph courtesy Museum of American Folk Art)

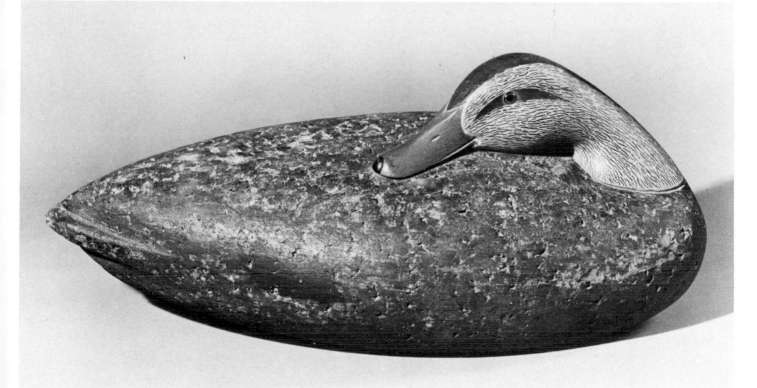

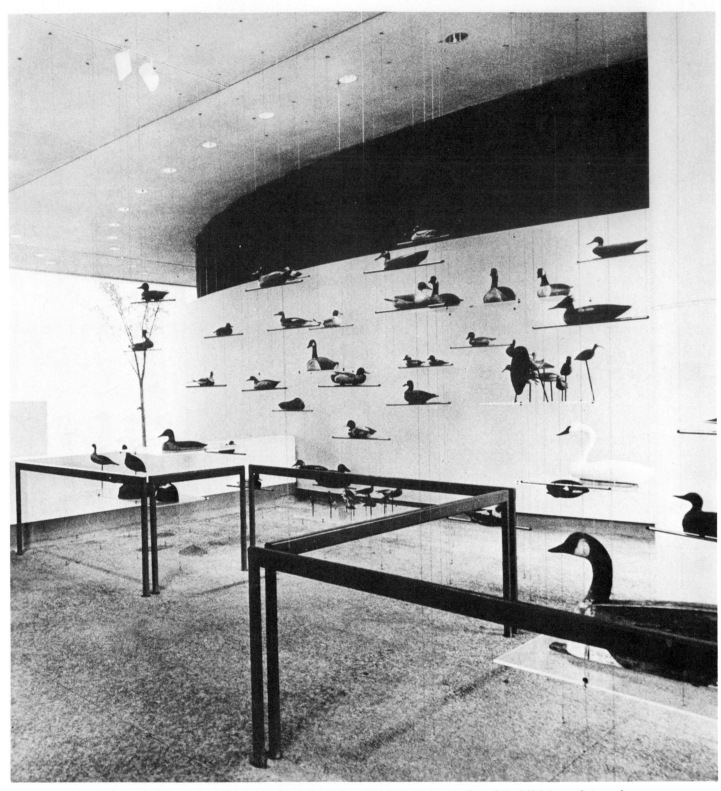

United States Pavilion. Montreal World's Fair, 1967. First International Exhibition of American Wildfowl Decoys. Organized by author, from museum and collectors.

Chapter 17

Dark Hours

All rolled well except our finances. Membership increased as well as attendance at our gallery. Several foundations backed us including the Kaplan Fund, the Norman Fund, Old Dominion Fund, the Rockefeller Brothers Fund. However, the Burt Martinson original pledge of basic support for five years was running out. No Mellon, Frick, Morgan, duPont, Webb or Lila Wallace had stepped forward to take his place. Was it possible to run a museum of folk art dependent on many, good helpful hands rather than a bountiful angel? Folk art is the art of the people.

In 1969 Burt resigned as President and became Chairman of the Board. Mr. Charles Grace, long a friend and supporter, assumed the presidency. Mrs. Lionel Rockefeller Coste and Charles Carpenter joined the Board.

To activate attention to our plight we decided upon a bold course of action. Why not organize a fund drive to obtain more adequate backing and a building of our own? The Community Counseling Service was hired to conduct a survey of public opinion and to initiate a drive for funds. Under their auspices a "benefit" was undertaken, the first public New York City showing of Sir Kenneth Clark's film, *Civilization*. The film was superb, but the theater was mostly empty of patrons. Adequate promotion for the sale of tickets had been lacking. And another national "recession" dampened the economic scene.

But ever optimistic, we located a building that dazzled us with its possibilities. Just off Madison Avenue, at 36 1/2 East 75th Street was a handsome, four-story private residence for sale, practically next door to the Whitney Museum of American Art. The Whitney featured twentieth century art. Our interest centered on American art of the eighteenth and the nineteenth centuries. What a neighborly combination! Several board members thought it more prestigious for us to be located uptown rather than downtown.

The owner of the 75th Street residence agreed to rent the ground floor on a trial basis to let us feel out the situation and show the building to potential museum backers. Nelson A. Rockefeller agreed to serve as Honorary Chairman of a fund drive. We aimed for a mere one million two hundred and ten thousand dollars. The sum would include purchase price of the house, renovation and an operating base budget for three years. We moved our office equipment and our expectations. Gallery space remained on 53rd Street until new quarters could be available.

The recession hung on. After a year of experiment we gave up the 75th Street project. Back we trotted with our equipment and our hopes to good old 53rd Street. Little had been gained but debt, sweat and tears. And yet- we had tried.

In 1970 Mary Black, our director, resigned to accept a position with the New York Historical Society. The move was understandable in the gloom of our situation. Mr. Michael Gladstone was appointed as a temporary director. Mr. Gladstone had been assistant director of publications at the *Museum of Modern Art* and publication advisor to the *New York State Council of the Arts*. Recently he had assisted Mrs. Black at our museum. He was acquainted with our procedures and exigencies.

Our darkest hour was the sudden death of Burt Martinson on October 30, 1970. Burt died of blood poisoning contracted while swimming off an island on the China coast where he had been visiting. He had brushed against a poisonous coral reef.

Joseph B. Martinson (Burt) had been a leader in the recognition of our arts. He had been Chairman of the Board of the New York City Shakespeare Festival, President of the Ballet Society, Inc., and Chairman of the New York City Ballet Production Fund. Also he had served on the boards of the New York City Center, the Saratoga Performing Arts Center, the Theater Development Fund and the Dance Theater of Harlem.

But of all the art projects he sponsored so

Joseph B. Martinson.

generously, our museum was his own, founded by him and fathered by him. Our museum was "his" museum.

In February of 1971 M. Knoedler Co., Inc. presented an exhibition of American paintings in a tribute to Joseph B. Martinson and for the benefit of the museum he founded. Mary Black organized the exhibit and prepared the catalog with the help of Mr. Gladstone. Lloyd Goodrich wrote the introduction. One hundred and fifty-five paintings were assembled under the title, "What is American in American Art?" Recognized masterpieces were brought together. Artists ranged from the eighteenth century limners to Andrew Wyeth. The galaxy included Stuart, Hathaway, Brewster, Fisher, Cole, Catlin, Hicks, Field, Prior, Fitz Hugh Lane, Kensett, Catlin, Field, Mount, Heade, Eakins, Homer, Remington, Sloan, Hartley, Sheeler, Kane, Luks, Shahn, Pippin, Wood, Hooper, Avery, O'Keefe, and Joseph B. Martinson.

Barbara Johnson, President
Wallace Whipple, Director

Mr. Grace moved to California in the spring of 1971 and resigned as President. The museum had suffered so many blows of heart and substance that its life was at stake. Barbara Johnson, a recent board member and a distinguished collector of America's whaling arts, agreed to assume the presidency. Her optimism and determination revived our morale. Friends stood by, especially Mrs. Jacob Kaplan, president of the *American Federation of Arts;* Bernard and Edith Barenholtz; Stewart Gregory, and Richard and Maureen Taylor. Mrs. Lionel R. Coste became Vice-President.

During the summer of 1971 we asked Wallace Whipple to become our director. The United States Information Agency and the National Endowment for the Arts had recommended him. Under Mr. Whipple's guidance we presented a series of shows on the general theme: "Rediscovery of Grass Roots America." Two of the exhibits, "Macrame" and "Tattoo," brought attendance by young people, whom we were eager to reach. Both shows activated wide newspaper and magazine publicity. All three major networks, ABC, NBC, and CBS filmed the exhibits for nation-wide viewing. Attendance at our galleries mounted. Both shows were funded in part by a grant from the National Endowment for the Arts.

Also the New York State Council of the Arts awarded us a grant for a series of Bicentennial

Barbara Johnson, President; Wallace Whipple. Director; Bernard Barenholtz, Patron. (Photograph courtesy of Museum of American Folk Art)

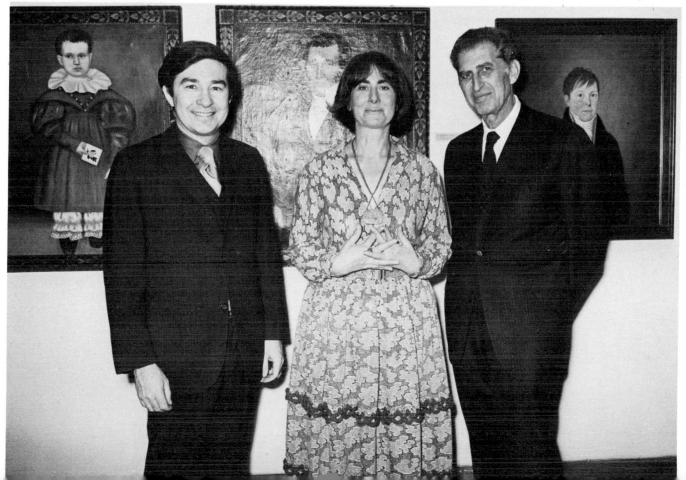

exhibits. As chairman of the Exhibition Committee I had presented to the Council a request for the backing of five yearly exhibits. Each year one show would outline and present the development of one of the household arts as evidenced in one medium: metal, wood, clay, fabric, and paper. The program series was planned to culminate in 1976. The first, the "Fabric of the States" (curator, Herbert Hemphill; catalog by Julia Weissman) opened May 23, 1972. This scholarly exhibition of 212 objects including a fascinating, wide range: crewel work, quilts, rugs, samplers, embroidered pictures, lace, printed cotton, needlepoint, shawls, towels, a wood winder, a loom, Shaker bonnets and Brethren clothing, flags, leggings, a wedding dress, a christening dress, and a pair of breeches from the Van Rensselaer family. The show travelled happily across the state.

Governor Rockefeller had been a prime mover in the formation of the New York State Council of the Arts, which he had established in 1960. The National Endowment for the Arts, also promoted by the governor, initiated its program in 1965.

During the winter of 1971 Mr. Whipple developed a new project of his own devising. The first issue of a folk art "newsletter" in the form of a modest magazine appeared under the title "The Clarion", naturally enough. Our Angel Gabriel, our insignia, was at it again, blowing his own horn.

Despite the high quality of our exhibitions and the devotion of our staff and our board, finances floundered. The yearend bills which Burt had shouldered in previous years went unpaid. The trial move to 75th Street had been costly; the film *Civilization,* a loss. Staff, utilities, insurance, rent for our gallery, and our storage vaults had to be paid. Storage vaults! We did have assets in vaults, gifts of folk art donated to the museum during the past years.

Was the answer to our financial problem an auction? All gifts to the museum had been presented and accepted with "no strings". We had the right to de-accession, but donors would be shocked by such a desperate move. No alternative presented itself. If we folded, all assets would be liquidated. The donor of each gift was contacted, explanation given. Many donors offered additional gifts of paintings and carvings specifically for sale at the auction.

Items taken from our own collection were mostly paintings and carvings, replaceable in kind. But we had to include a number of prime possessions "rare and important", as they say in the auction circuit, in order to stimulate bidding.

The "Benefit Auction" held March 3, 1972 at the New York Colosseum cleared our debt. Ninety objects were sold. Every hammer sound of the auctioneer was a blow to the heart.

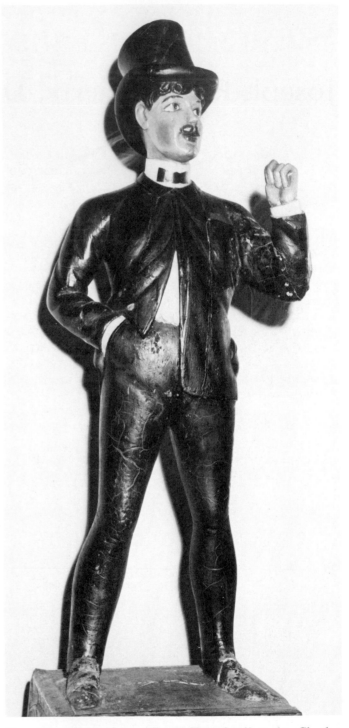

Race Track Tout. Carved Trade Sign. Attributed to Charles Dowler. c. 1870. (Stewart E. Gregory Collection)

Stewart E. Gregory Collection

Joseph P. O'Doherty, Director

Before the auction, Stew Gregory had said, "When this misery is over, let's have a great folk art show, bring back the glow, cheer friends and reassure creditors." What could be better than an exhibition of the Stewart Gregory collection of folk art! Stew agreed.

On March 12, 1972 the preview of "An Eye on America" opened to a packed house. Masterpieces everywhere! What a privilege! Jean Lipman wrote in our catalog, "Stewart Gregory's collection embraces every major aspect of American folk art — paintings and drawings, decorated furniture and accessories, trade and tavern signs, weathervanes and whirligigs, decoys, ship figureheads, and ornaments, toys, hooked rugs - everything!"

Little did we know that the exhibition was in many ways a final performance. After a long illness, Stewart Gregory died on January 11, 1976. His folk art, one of America's greatest private collections, was sold, dispersed at auction at Sotheby Parke Bernet, Inc. on January 27, 1979.

Civil War Toy. Wood carved. Activated by a rachet mechanism. Note: When this carved toy was first shown at the Willard Gallery in December, 1971, Hilton Kramer, art critic of the New York Times wrote: "This marvelous Civil War Toy shows us we are a long way from integrating the great accomplishments of our native folk art into the history of American art as a whole".

Heroic Eagle Ship Figurehead. (Photograph courtesy Alvin Friedman-Kien)

Late in 1972 our director, Wallace Whipple, returned to Washington to accept a government post. His leadership had held us together during difficult times. We were grateful.

In the new year of 1973 Barbara Johnson introduced us to Joseph P. O'Doherty, an optimistic promoter and organizer who was sure he could help us to a more stable financial position. He'd take a chance on us if we'd take a chance on him as director. We agreed.

Our third "Grassroots" exhibition on the subject of the "Occult" had been scheduled. Jo researched and produced a popular exhibit. The second Bicentennial show, "The Metal of the State" was due. Bert Hemphill agreed to serve as curator. Ruth Andrews prepared a handsome catalog with an informative text and an impressive checklist of one hundred and ninety-six exhibits which ranged from bedwarmers, firemen's hats, andirons, tea kettles, ear trumpets and toys to our own great Tammany weathervane.

During this season Ruth Andrews also prepared and chaired a ten-session course on folk art offered by our museum in cooperation with the Division of Liberal Studies at New York University.

Jo, as a director, was efficient but unhappy with the small size of our exhibition space on 53rd Street. He, as a promoter, wanted a big show accessible to more people, out-of-doors, maybe, in the summer. Not enough of a public climbed our stairs to suit him. Folk arts should be taken to the people where the people are. We agreed.

Often Burt Martinson had told us how the Japanese promote art galleries in department stores in Osaka and Tokyo. Shopping malls featured both the fine arts and the popular arts. Could we work out something in New York City's deluxe shopping mall, Rockefeller Center? An open court adjacent to the McGraw Hill building on Sixth Avenue was a perfect setting in which to combine a hospitable plaza, a street scene, and an exhibition hall freely open to the public.

The Public Relations Department at Rockefeller Center was interested. We proposed a series of exhibits to be called "Celebrate America". The first would focus on fabric and be titled "The Whole Cloth of America". Arrangements were made for a summer opening. A grant from the New York State Council on the Arts sweetened the package.

Wood Rooster. Trade Sign.

Jo was really charged by the opportunity. He wanted to tell the "whole" story of cloth, so he had to start at the very beginning - sheep! On opening day Jo trucked live sheep, ready for shearing, into the plaza. An Jo produced a man who sheared the sheep and a man with hay and a manure scoop. Also Jo brought a maid who combed and spun the wool. Another very pretty maid wove the wool into cloth.

Every day a crowd gathered on Sixth Avenue, especially at the noon hour. Workmen with beer and sandwiches, and gentlemen in pin-striped suits sat on the curb, fascinated as they saw wool pass from sheep to cloth! Many a spectator realized for the first time that his suit of clothes had not appeared immaculately conceived in the Sixth Avenue garment district.

Tobacconist Trade Sign. Indian on bale of tobacco. Cast zinc. (W. Demuth & Co., New York) c. 1850.

Bruce A. Johnson

Jo O'Doherty worked hard as director of our museum but in 1974 he left for greener pastures. His assistant, Bruce Johnson, Barbara's son, took over as acting-director, then as director. Bruce, an art student, brought up in the environment of American folk art, suited the job as the job suited him. Also, three prestigious gentlemen with experience in the arts and with business acumen joined as board members: Lewis Cabot, Ralph Esmerian, and our good friend of long standing, Dr. Louis C. Jones.

The inadequacy of our gallery and office space still plagued us. We were growing in every way but in space. Room was needed for student classes, lectures, files, and enlarged staff. Our collections, expanding again, were stored in costly warehouses, inaccessible for study.

At Columbus Circle was an empty museum, the Huntington Hartford Museum. It was for sale! In an attempt to judge its merit we arranged to hold our board meetings in their elegant (but empty) board room, situated high above the scuttle of traffic, with a delectable view of Central Park West.

Functionally the building seemed to have everything. The location was accessible: opposite a huge parking garage, handy to subway and to bus transportation. The entrance hall boasted of two elevators - one for passengers, one for art and service. (We remembered our narrow stairway). On four floors, five exhibition areas, replete with mahogany panelling and carpeted floors, waited - empty. The top floor contained a dining room with full kitchen equipment. The basement housed a small, intimate auditorium complete with audio-visual equipment.

The asking price for the building sounded reasonable. The Huntington Hartford estate had financial problems. But there were a few questions. What did the elaborate interior decor have to do with folk art? Would a cigar store Indian look well standing against a brocade wall hanging? Art deco ladies, painted decorously on murals along the hall, looked very disapproving when we talked of bed quilts and Shaker bonnets.

A real problem arose when we looked at the monthly upkeep expenses - the bills for light, heat, insurance, janitor service and guards (unionized!). A tower is not an economical edifice sympathetic to the needs and uses of a museum. Built on an island of real estate in the middle of Columbus Circle, the building had no way to go but up! The result was a series of rather small galleries located on different floor levels. A public museum, to function aesthetically and economically, needs large open spaces adjustable to the requirements of changing exhibits and to easy surveillance of art and people.

We, as a board, decided against the proposition. But the possibilities have haunted me ever since.

Under the leadership of Bruce Johnson, the museum grew in liveliness and scope. Bruce was a charmer with laughing blue eyes, curly hair and a ready smile. His exhibition programs included the "Edith Barenholtz Folk Art Collection"; the second of the "Celebrate America" series at Rockefeller Center; the third exhibit in the museum's Bicentennial series, the "Pottery of the State", (curator, William Ketchum, Jr.); and the fourth, "Wood Sculpture of New York State", (curator, Marna Brill). April 1976 brought "Paper of the State", the fifth and last of the series.

Bruce served as his own curator for his two favorite shows: "Why Not Learn to Write" (calligraphy) and the "Cat Show". He also established courses in rug making, quilting, and basketry. He believed that we learn by doing as well as by seeing.

Calligraphy fascinated Bruce. He decided that writing at a desk, pen in hand, was a lost art, usurped by other means of communication - the telephone, the typewriter, and various electronic media. If the medium is the message, a personal human quality had been lost. Calligraphy, loosely

defined, is elegant penmanship developed under the tutelage of 19th century teachers, mainly Platt Roger Spencer. "Spencerian" writing and drawing is characterized by formal flourishes of the pen in accepted decorative patterns. Our museum exhibit included school copy books, samplers, frakturs, and pictorial rendering of smiling lions, friendly eagles, whales, doves, Indians, etc. One fascinating drawing depicted man as starting life as a fish - a shocking Darwinian notion not popular at the turn of the century.

The "Cat Show," staged by Bruce early in 1976, was a smash hit! Visitors waited in line to get in. *Antiques and the Arts Weekly* reported the following:

> Cats have taken over the *Museum of American Folk Art* in New York City. Since opening day a great howl of pleasure and appreciation has gone up.
>
> The cat, long a popular subject of artists, is shown in oil and watercolor, in the hands of a child, eyeing a string of mackerel, holding a mouse, entangled in knitting, in a boat, drinking milk, sitting in a window, contemplating a fish bowl, and on and on.
>
> Off the canvas, the cat is there in the form of a weathervane, a carousel figure, a cookie-cutter, a door stop, a ball toss toy, a nutcracker, on a walking stick, incised on a Paul Cushman crock, as a squeak toy, on a quilt, in a hooked rug, and carved in wood. And, of course, the famous large chalk cat measuring 17 1/2 inches high, the property of the Museum, is on hand and overseeing the many new faces in his regular haunt.

The "Cat Show," attended by nineteen thousand visitors, exceeded all previous records for its three months run.

In June 1976 Bruce Alexander Johnson died as the result of a motorcycle accident. The shock was too much. He was so young; his time with us brief. But during his leadership at our museum he gave us life. He rode tall in the saddle.

Chapter 21

A New Beginning

A New Museum. Ralph Esmerian, President. Robert Bishop, Director.

Good friends stood by during the difficult weeks that followed. Karen Schuster, who had assisted Bruce, served as acting-director. Helaine Fendelman became chairman of the newly-formed Friends Committee. Lucy Danzinger, a devoted trustee, organized a corp of docents who volunteered to work as guides in the gallery. Frances Martinson, eager to continue family support for our museum, joined the board. Cyril I. Nelson of E.P. Dutton & Co., Inc., the publishing house, offered his editorial experience. Kenneth Page and Richard Taylor served as legal consultants.

In October of 1976 we held a memorial exhibition, titled "Best of Friends," in honor of Bruce Johnson. Barbara Johnson, our president, held fast in her resolve to continue Bruce's work and vision. Ralph Esmerian agreed to act as executive administrator as well as treasurer.

When first I walked into Ralph's New York City apartment for a board meeting, I could not believe my eyes. Sir Ralph championed folk art not only in word and deed but also in his home.

His living room was appointed not with the usual Park Avenue decor. The largest and most conspicuous furnishing was a rabbit, a five foot tall rabbit, a carrousel carving by Gustav Denzel. On top of a large blue-green Pennsylvania cupboard perched two carved eagles by Wilhelm Schimmel.

The cupboard shelves held rows of Pennsylvania pottery, plates in slip and sgraffito ware. There was Mahantango Valley furniture; a decorated desk, a bench, and a tall case clock painted vibrant salmon red and green (c. 1840). Pictures, mostly watercolors and frakturs, crowded the walls. Dominant was a painting of *The Peaceable Kingdom* by Edward Hicks (c. 1847). Sir Ralph had created his own peaceable kingdom in a New York City apartment.

The museum's first order of business that Fall was the question of a new director. Who? Robert Bishop, all agreed, would be an ideal choice. He

had made an impressive record at the Henry Ford Museum and Greenfield Village in Dearborn, Michigan, where he served as museum editor. Before going to Dearborn, Mr. Bishop had resided in New York City where many of us had known him as a knowledgeable collector-dealer of American folk art and antiques.

On March 1, 1977 Dr. Bishop became director of our Museum of American Folk Art. He was eager to return to the New York scene and apply his experience to our project. Our museum had established a record of quality and achievement in spite of great personal loss. Now we must work for an enlarged membership, wider Foundation support, more corporate funding from the business community and continued backing from the National Endowment for the Arts, and the New York State Council of the Arts.

The government, when pushed, does believe that support for the arts is a public good. Years ago Holger Cahill made it clear that learning about art, especially folk art, is learning about ourselves, our heritage, our history, our values and dreams. That premise is our premise.

At our first show at the Time and Life Building we placed, center stage, the magnificent eagle carving from the good ship, General McDonald. The eagle was and is the insignia of the greatest democracy on earth, the United States of America.

Our Tammany Indian weathervane has travelled in the name of American folk art to many distant cities, including Osaka, Japan in 1975. Asia and Europe have long been in love with the image of the Indian as the noble savage, as a symbol of America. Our "Tammany" represents the Chief of the Seneca Indians, the original Americans who lived, hunted, fished, and cared for these hills and streams long before the white man sailed up the Hudson River and "discovered" America.

The three-petaled tulip design on the Pennsylvania pottery in Hattie's kitchen and in Ralph's

cupboard, is more than decorative. It, also, represents the Trinity of life. Man does not live by bread alone.

Folk art has meaning as well as being.

The most urgent, long range project our new director faced was the necessity of a new home for our museum, a building of our own. It was time. All facilities were outgrown: gallery space, office space, storage and study areas. At exhibition openings our members had to wait in line on the stairs to get in.

Several possible locations for a new building had been considered on the west side of Manhattan, the east side, and all around town. But the ideal location seemed to be right where we were, on 53rd Street where we started on the memorable day with Burt Martinson in 1963.

The project of building our own museum would be formidable. Funds must be raised to purchase adjoining real estate and finance costs of construction. An architect must be hired, plans designed. We must tangle with building codes, legal and civic issues, demolish the old brownstone structures, and erect, from a hole in the ground, a multi-storied, handsome, workable, friendly, prestigious Museum of American Folk Art.

One vexing question arose. Would our new museum, no matter how grand, be overshadowed by the great, high tower the Museum of Modern Art was planning to construct practically next door? The prospect did not bother us. The Modern features art of little more than a hundred years, international art. Our museum features art of three centuries - American art.

At the present writing, the ground work for our new museum building has been laid - on paper. Plans and projected costs are faced with confidence. Under the leadership of President Ralph Esmerian, our Board of Trustees, Director Robert Bishop, and Assistant Director Gerald Wertkin, we shall see the dream.

When I climb the hill near my home in Stony Point, I will look straight down the Hudson River, thirty miles to New York City where our Museum of American Folk Art shall stand. On that triumphant day, our Angel Gabriel will blow his horn, loud and clear, in honor of all who have served our cause, and especially for those who have served and have passed through the pearly gates.

BLOW! GABRIEL! BLOW!

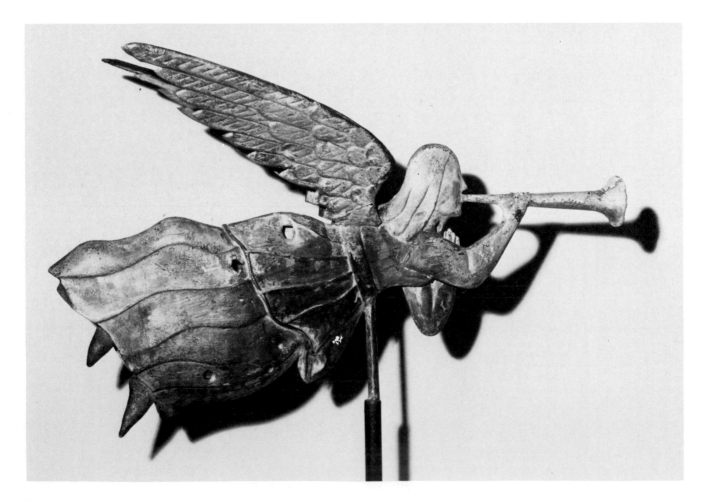

Index